MW00339644

Best wishes!

Robb Hellquist

GEORGIA
unforgettable

PHOTOGRAPHY BY ROBB HELFRICK AND JAMES RANDKLEV

Text by Robb Helfrick

FARCOUNTRY
PRESS

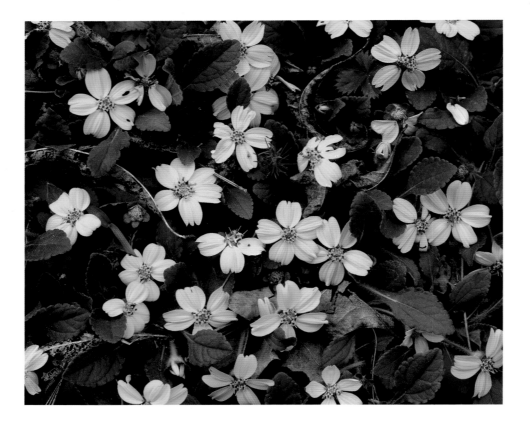

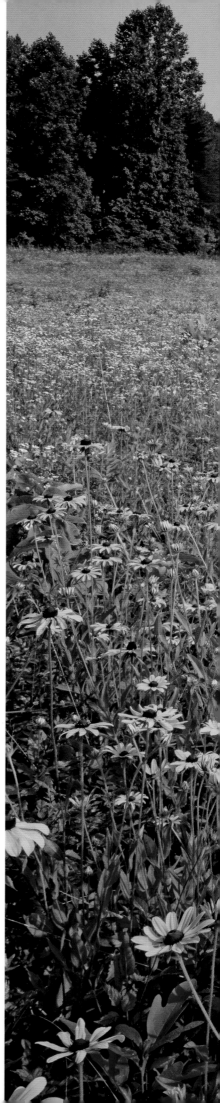

Above: A natural flower arrangement is seen along the banks of Panther Creek in the Chattahoochee National Forest. JAMES RANDKLEV

Right: Black-eyed Susans fashion a summery yellow carpet at Warwoman Dell near Clayton. JAMES RANDKLEV

Title page: A sunrise accentuates the horizon as the surf breaks on the beaches of St. Catherines Island. This island is ten miles long and has more than 14,000 acres. JAMES RANDKLEV

ISBN 10: 1-56037-526-4 (Cumberland Island version)
ISBN 13: 978-1-56037-526-5 (Cumberland Island version)
ISBN 10: 1-56037-541-8 (Minnehaha Falls version)
ISBN 13: 978-1-56037-541-8 (Minnehaha Falls version)

© 2012 by Farcountry Press
Photography © 2012 by Robb Helfrick and James Randklev

All rights reserved. This book may not be reproduced in whole or in part by any means (with the exception of short quotes for the purpose of review) without the permission of the publisher.

For more information about our books, write Farcountry Press, P.O. Box 5630, Helena, MT 59604; call (800) 821-3874; or visit www.farcountrypress.com.

Created, produced, and designed in the United States.
Printed in China.

17 16 15 14 13 12 1 2 3 4 5 6

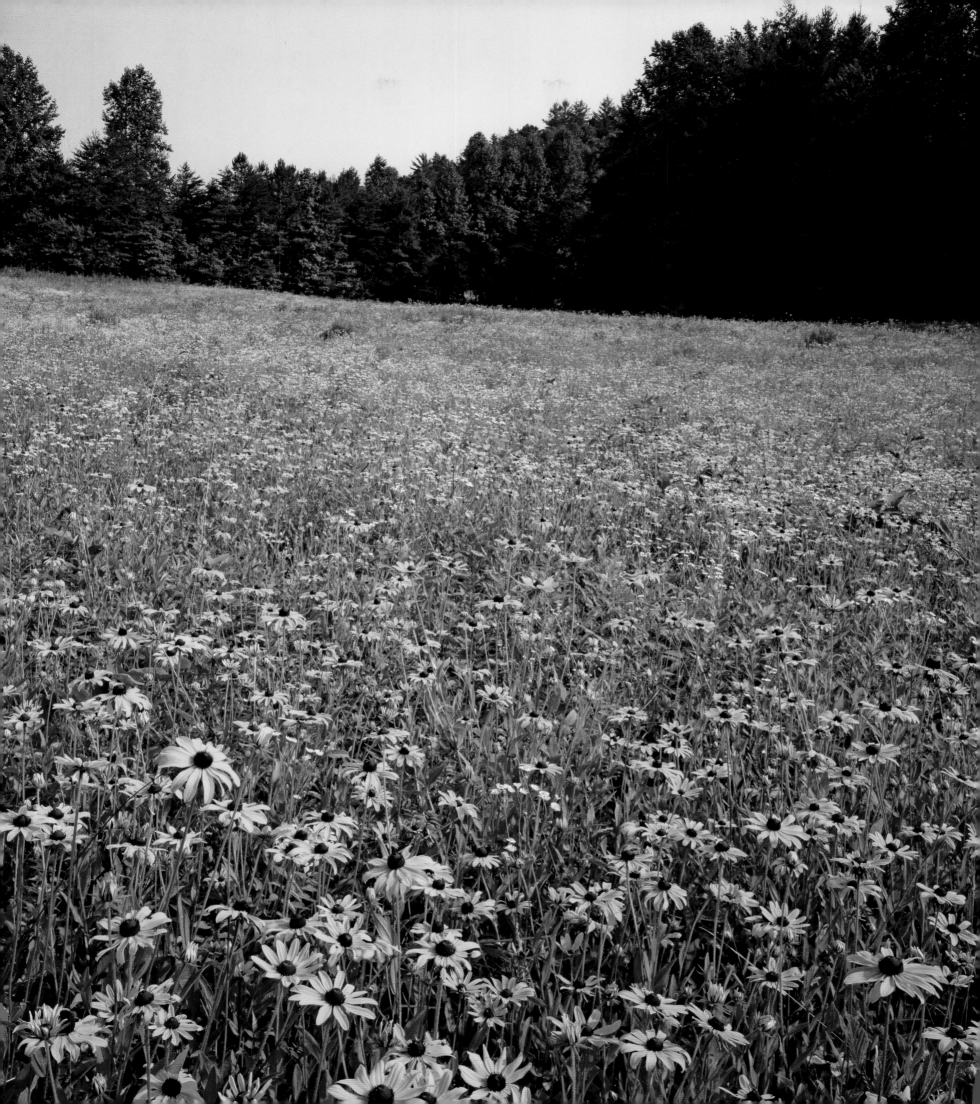

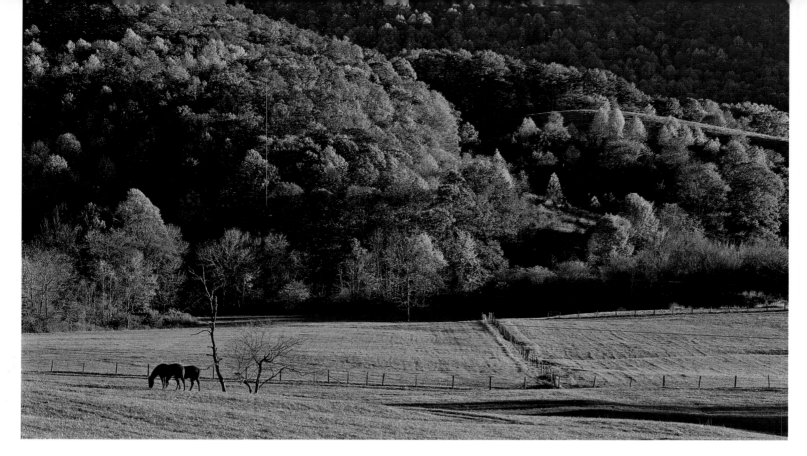

In the mountain town of Suches, a pair of horses enjoy a crisp fall day in a pasture surrounded by a vibrant mountain backdrop. ROBB HELFRICK

FOREWORD | *By Robb Helfrick*

GEORGIA'S RICH HISTORY, stunning natural beauty, and unique culture have long been the subject of song and literature. With modern cities and genteel small towns, vast forests and subtropical barrier islands, it is a state with a fascinating variety of people and landscapes. These captivating and contrasting traits make Georgia a place that defies easy description, and because of this, it is a land full of surprising discoveries.

For those who have traveled the state, the first surprise is how large Georgia actually is. There are 159 counties here—second in number only to Texas. It is the largest state in land area east of the Mississippi River, and all that territory means there is plenty of wide-open space for farming. Georgia leads the nation in the production of the three "Ps": peaches, peanuts, and pecans. A botanist would tell you there are so many habitats in Georgia, each hosting a multitude of plant species, that it's like taking a botanical trip from Florida to Canada—all within the boundaries of one U.S. state.

Savannah is the birthplace of Georgia, and it is the ideal starting point to converse about the state's cities and towns. Bestowed with a preserved historic district that includes twenty-four beautifully landscaped squares, this lovely and refined city is a time capsule of architecture, history, and graceful Southern living. It's a wonderful place to explore on foot with a leisurely stroll. The

city of Atlanta is quite the opposite; fast paced and full of citizens from around the globe, the city is a bubbling stew of business and commerce. With world-class venues for science, art, and entertainment, this capital city has a can-do spirit that won it the honor of hosting the 1996 Summer Olympic Games. The cities of Augusta, Macon, and Columbus are known respectively for the Masters Golf Tournament, homegrown musical icons, and water-powered industry. These five cities constitute a large majority of where Georgia's nearly 10 million citizens live and work.

Travel away from the big city, and you'll find a contrasting style of Georgia living. Explore in any direction and the road will pass by or through the charming small towns of Georgia. Madison and Rome, Thomasville and Washington, Americus and Milledgeville— they all have their own unique identities, with thriving Main Streets and quiet tree-lined avenues. Georgia has many urban delights, but small-town living just feels right to folks in these smaller communities. Athens, home of the University of Georgia, has a few more citizens but retains a small-town feel nonetheless, and it is the quintessential college town. Every autumn, football fans flock here to watch their Bulldogs battle "between the hedges."

Step away from civilization and Georgia offers a timeless landscape. The astounding splendor of these natural environments may

just be the state's greatest resource. Mention the word Okefenokee and it conjures up visions of an ageless place. There are alligators and snakes there, of course, but as forbidding as it might seem initially, this is a place of solitude and serenity. This land of black water and cypress forests is not only a Georgia treasure, but it is also renowned as one of the most unique freshwater ecosystems in the entire world. Also nearby is the Altamaha River, one of the last great rivers in the East that still runs freely all the way to the ocean. East of Atlanta, Stone Mountain astounds all who visit with its mass of exposed granite.

Travel east from Okefenokee to find the gateway to Georgia's string of barrier islands that are fondly called the "Golden Isles." Tybee Island and Jekyll Island have had a constant human presence, but Tybee has always been the commoners' beach. Jekyll is where the Rockefellers and the Carnegies built "cottages" back in the late 1800s. Their idea of a cottage was grander than most; these wealthy families erected imposing mansions that still wow visitors today. Finally, there is St. Simons Island. This might be the most charming and tranquil beach community found anywhere on the Atlantic Coast.

In between these populated islands, the wilder barrier islands defend the coastline. Accessible only by boat, with names like Blackbeard, Wassaw, and Ossabaw, they have been wisely preserved and protected. Some serve as wildlife sanctuaries, others as places for environmental research. There are beaches along this chain of islands where one can simply walk for miles and not see a single soul. Like a precious stone hanging at the end of a necklace, Cumberland Island occupies the southern end of this string. This island is a pleasant mixture of wilderness: Wild horses can be seen here on the windswept dunes, and Sea Camp is a striking place to pitch a tent. A hike

Blooming rhododendron dangles over a rushing creek
on a May day at Cloudland Canyon State Park.
ROBB HELFRICK

along the main road, with its ancient live oaks dripping Spanish moss, might provide the most evocative view in all of Georgia.

One can't feel much farther away from these islands and their subtropical flora than when exploring the North Georgia Mountains. The Appalachian Mountains are not like the Rockies; they are rounded and much older, which gives them a lush and less forbidding appearance. The summit of Brasstown Bald, at 4,784 feet, is the rooftop of Georgia. From this vantage point one can see an undulating tapestry of forested hills and coves that stretches to the horizon. Hidden from sight beneath the hardwoods are rare wildflowers, roaming black bears, and hundreds of waterfalls. The Appalachian Trail starts at Springer Mountain, the beginning point for a 2,000-plus-mile woodland journey north to Maine. When summer transitions to autumn, the latent colors of sourwood, maple, and tulip poplar leaves reveal themselves in a riot of fall color. Driving or biking along the serpentine mountain roads in late October is a treat for the senses.

If Georgia is challenging to characterize in the confines of the written page, then perhaps the photographs that follow will tell a more complete story. It is very gratifying to share these pages with photographer James Randklev. His artistic talent and sensitive eye have earned him the reputation as one of the nation's finest photographers, and so it is an honor to have his inspiring images paired with my own. James has said that "Georgia is a land of gentle spirit," and when looking at his photographs, the viewer will clearly understand this most apt statement. Georgia is a place that remains indefinable; it is both urban and rural, dynamic and serene. It is a state of pleasant contrasts and diverse landscapes. So explore *Georgia Unforgettable*, and let the elusive land called Georgia reveal itself to you.

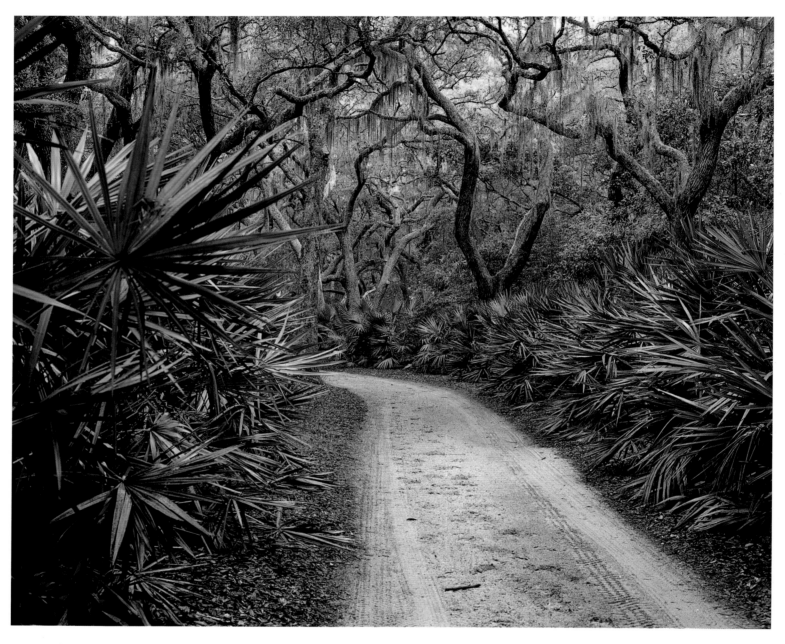

Above: A pleasant half-mile hike along this road leads visitors to Sea Camp, a striking spot to pitch a tent on Cumberland Island. ROBB HELFRICK

Facing page: The Old Mill is found on the grounds of Rome's Berry College, the largest college campus in the world. This wooden overshot waterwheel measures forty-two feet in diameter and is thought to be the largest of its kind. ROBB HELFRICK

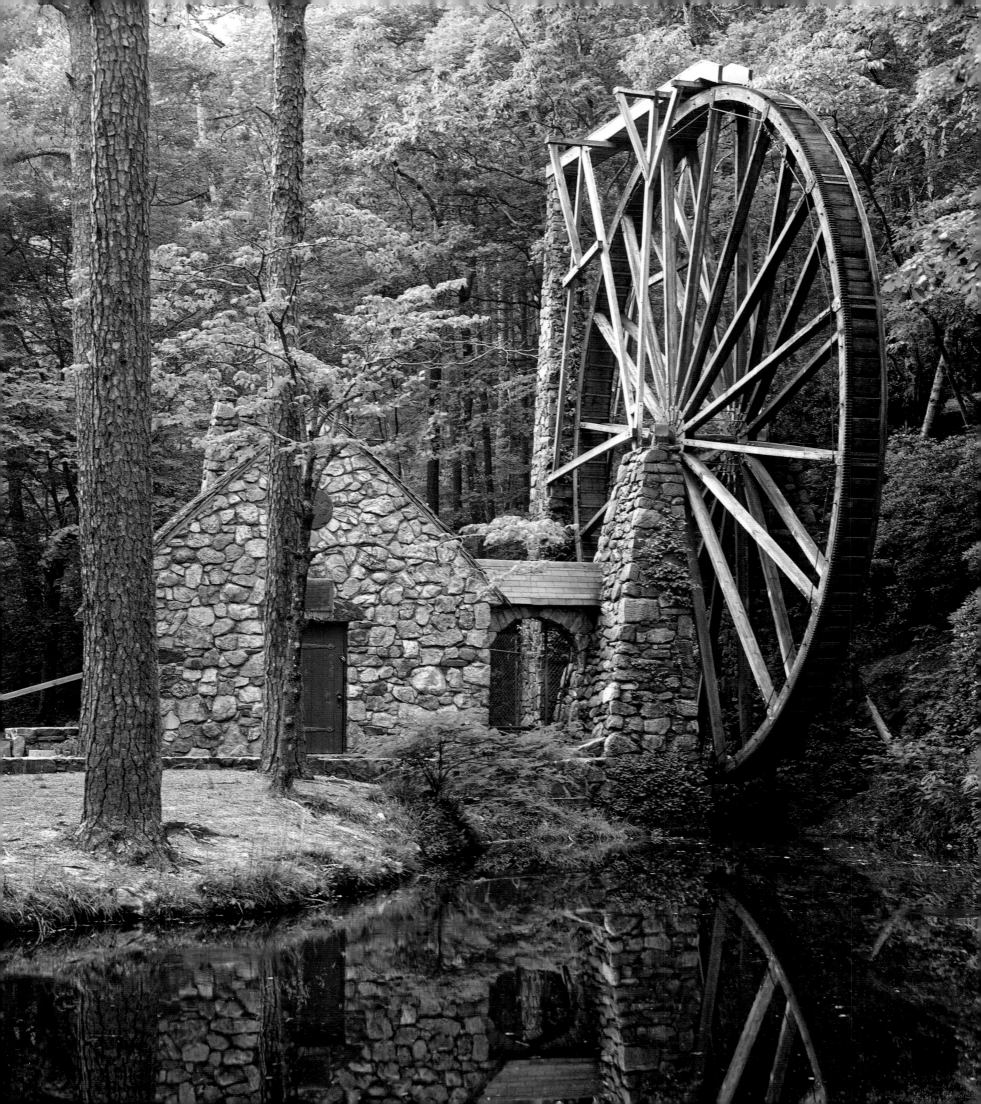

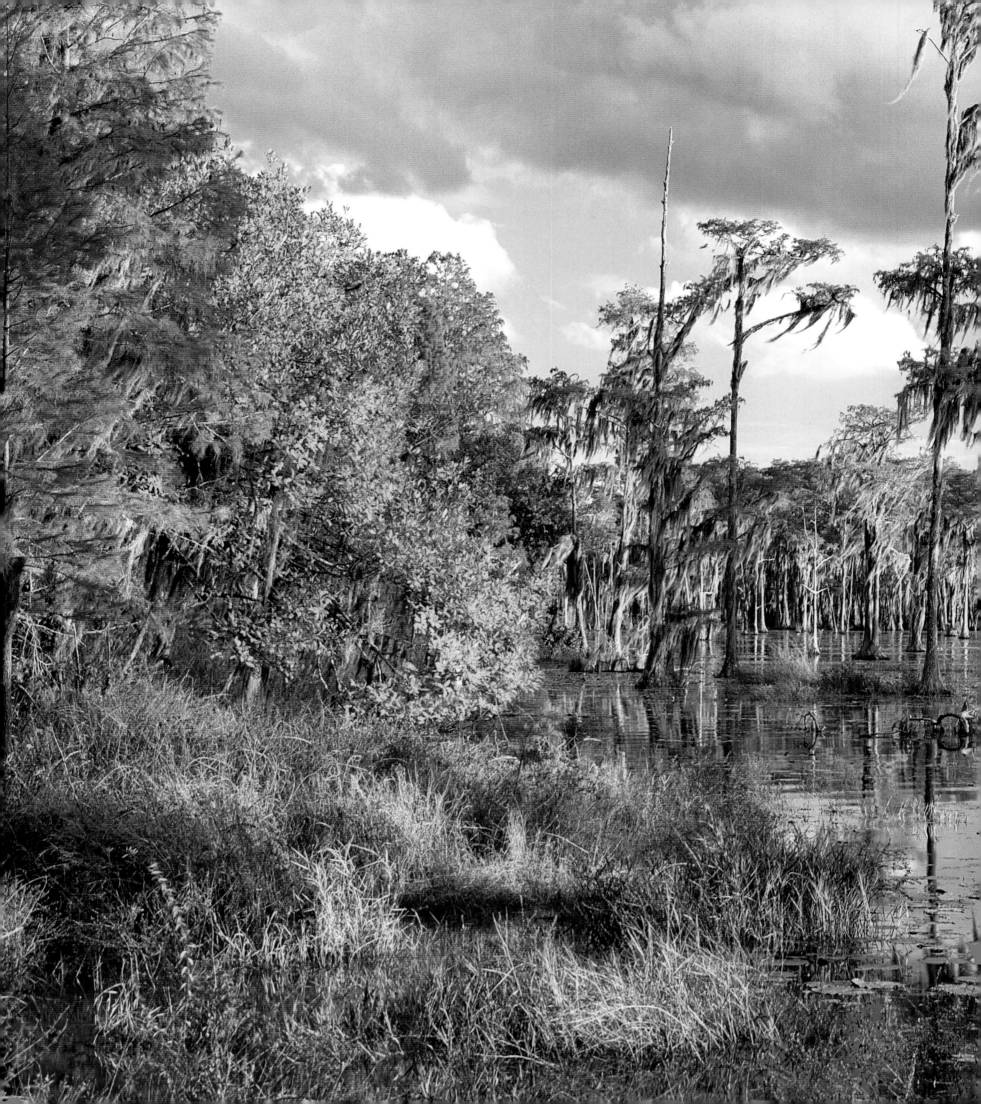

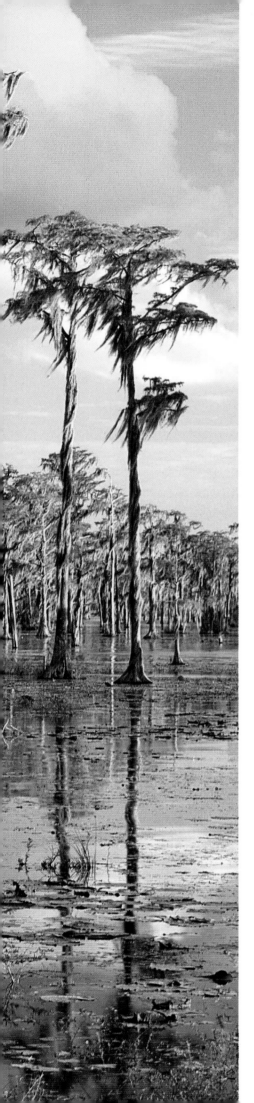

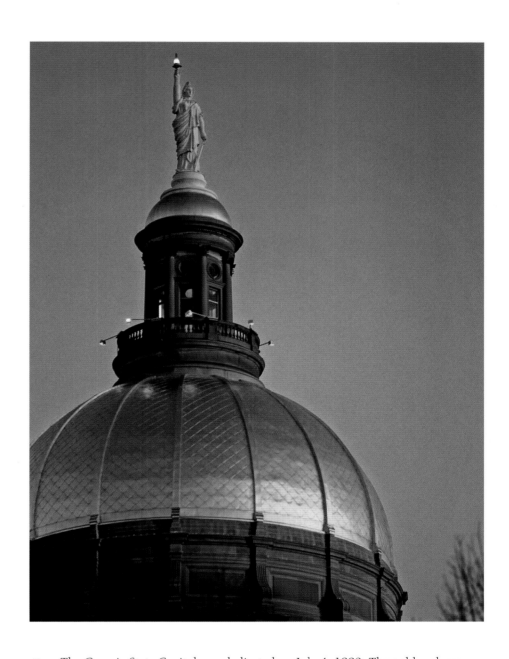

Above: The Georgia State Capitol was dedicated on July 4, 1889. The golden dome has had two separate applications of 23 karat gold to sustain its gleaming luster. ROBB HELFRICK

Left: An early November sky highlights the subtle orange hues of cypress trees at Banks Lake, a national wildlife refuge in southern Georgia. ROBB HELFRICK

Above: Augusta comes alive with color every April—seen here in the Olde Town Historic District— and also nearby at The Masters, one of golf's premier major events. ROBB HELFRICK

Facing page: The classically inspired home of textile magnate Fuller E. Callaway, Sr., was completed in 1916 and sits on the crest of a gently sloping hill in LaGrange. The house and garden are now open as a museum. JAMES RANDKLEV

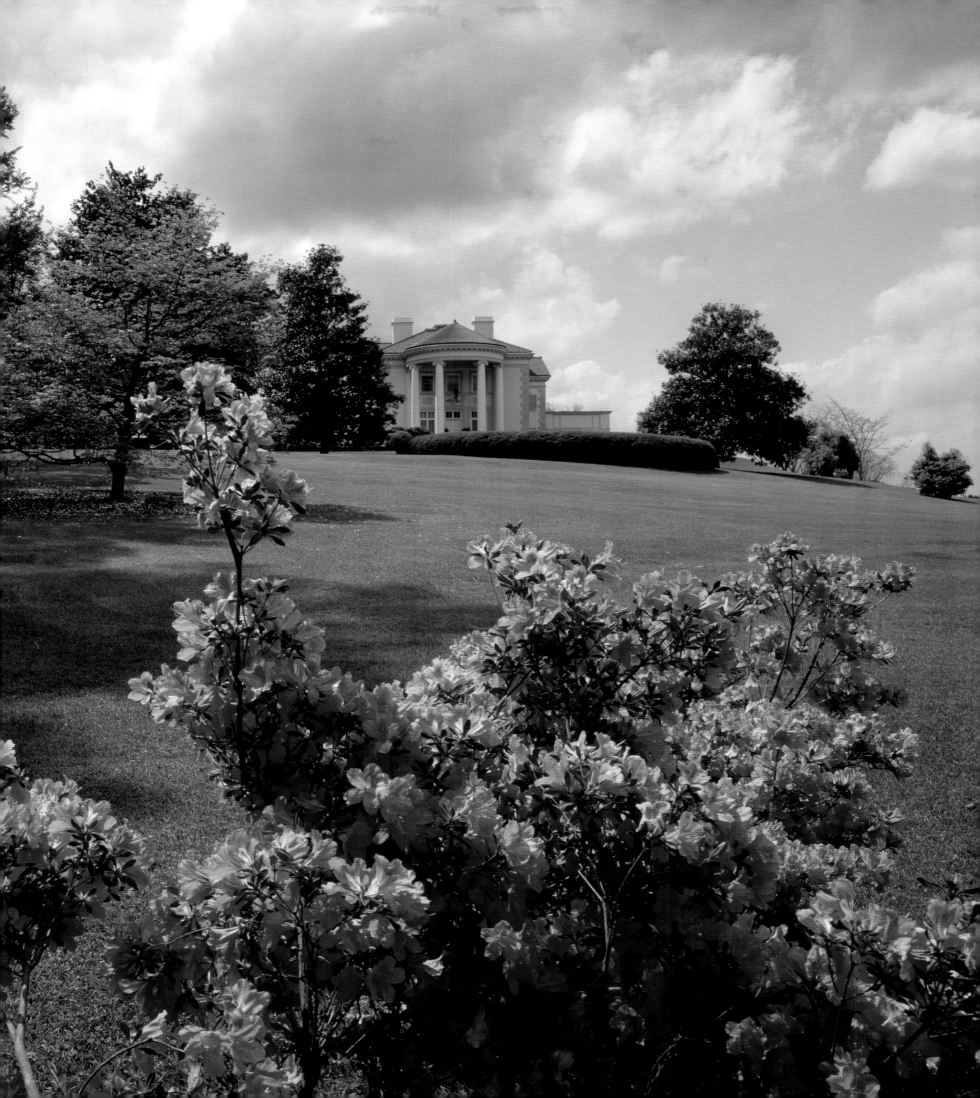

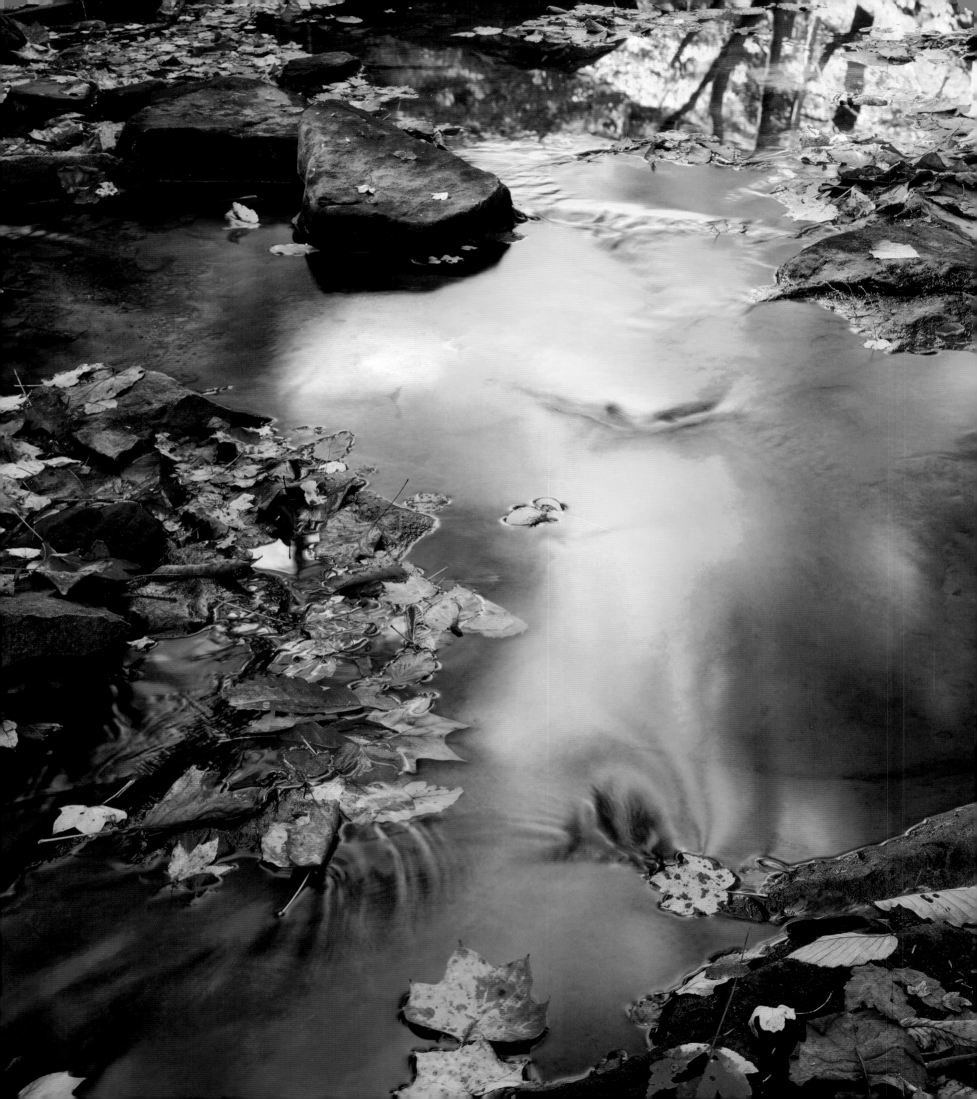

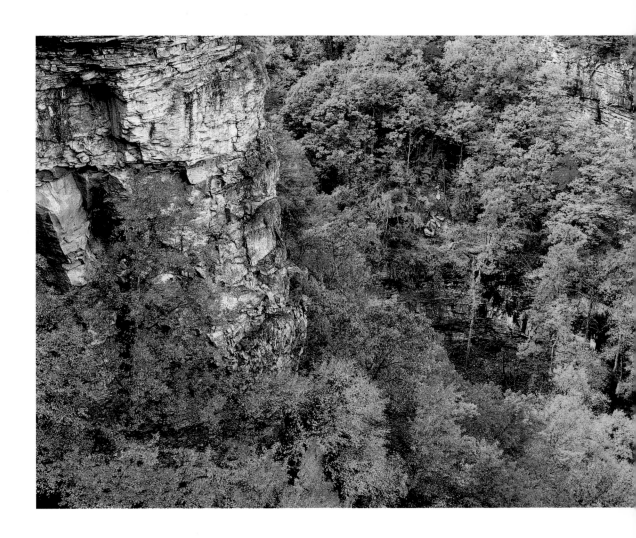

Above: A view from the Cloudland Canyon rim in late October is a multicolored feast for the eyes. ROBB HELFRICK

Left: At Cloudland Canyon State Park, cool and warm colors collide to produce a painterly sheen on Daniel Creek. JAMES RANDKLEV

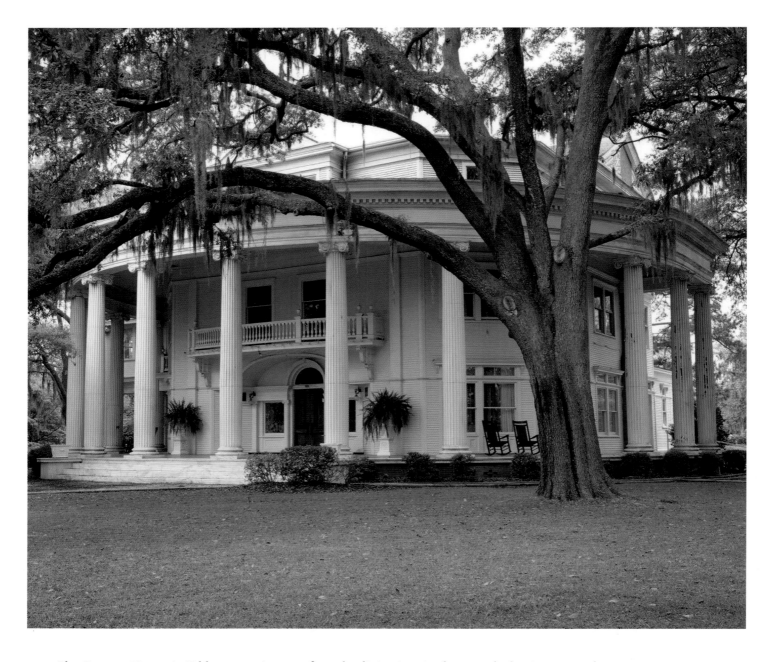

Above: The Crescent House, in Valdosta, gets its name from the distinctive circular veranda that is supported by thirteen massive columns—each a tribute to the thirteen original colonies. JAMES RANDKLEV

Facing page: Toccoa Falls plunges 186 feet and is one of the tallest free-falling waterfalls in the eastern United States. *Toccoah* is the Cherokee word for beautiful. JAMES RANDKLEV

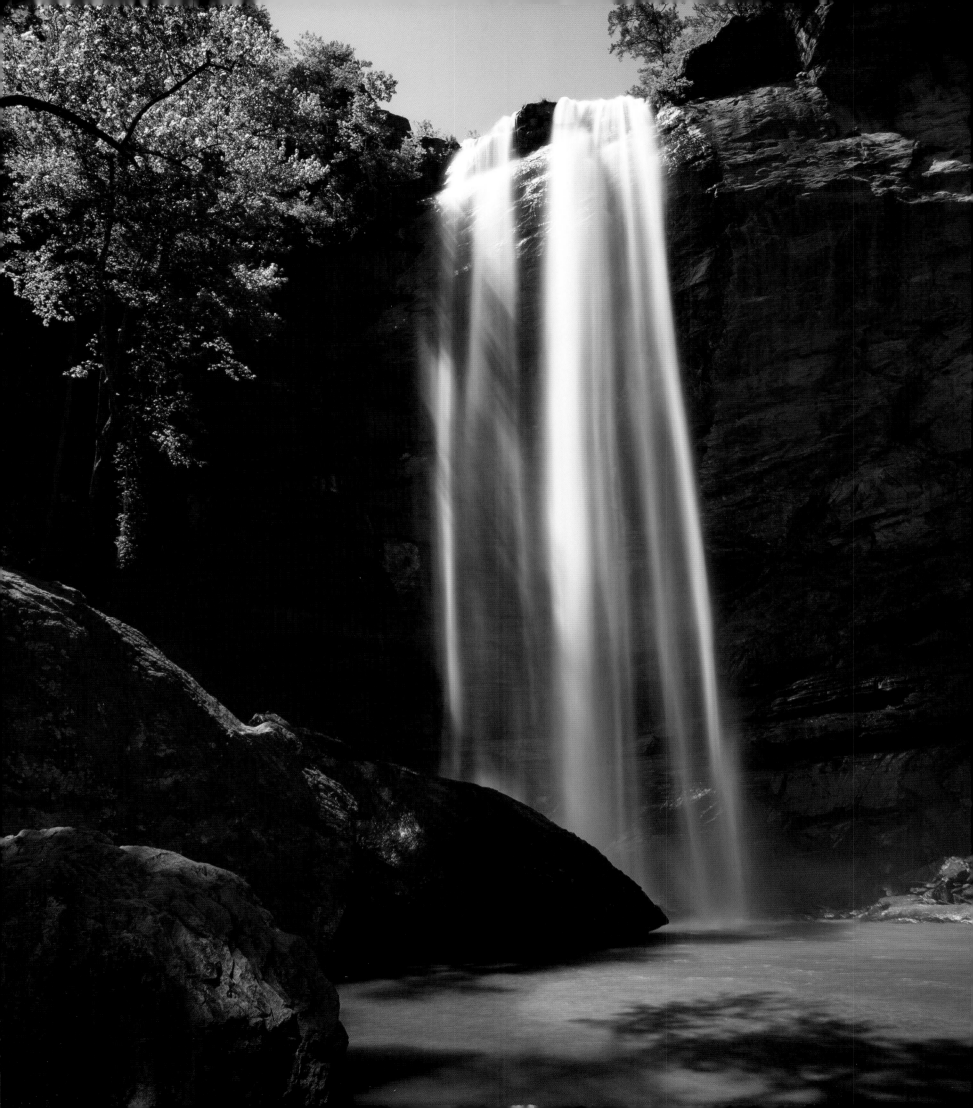

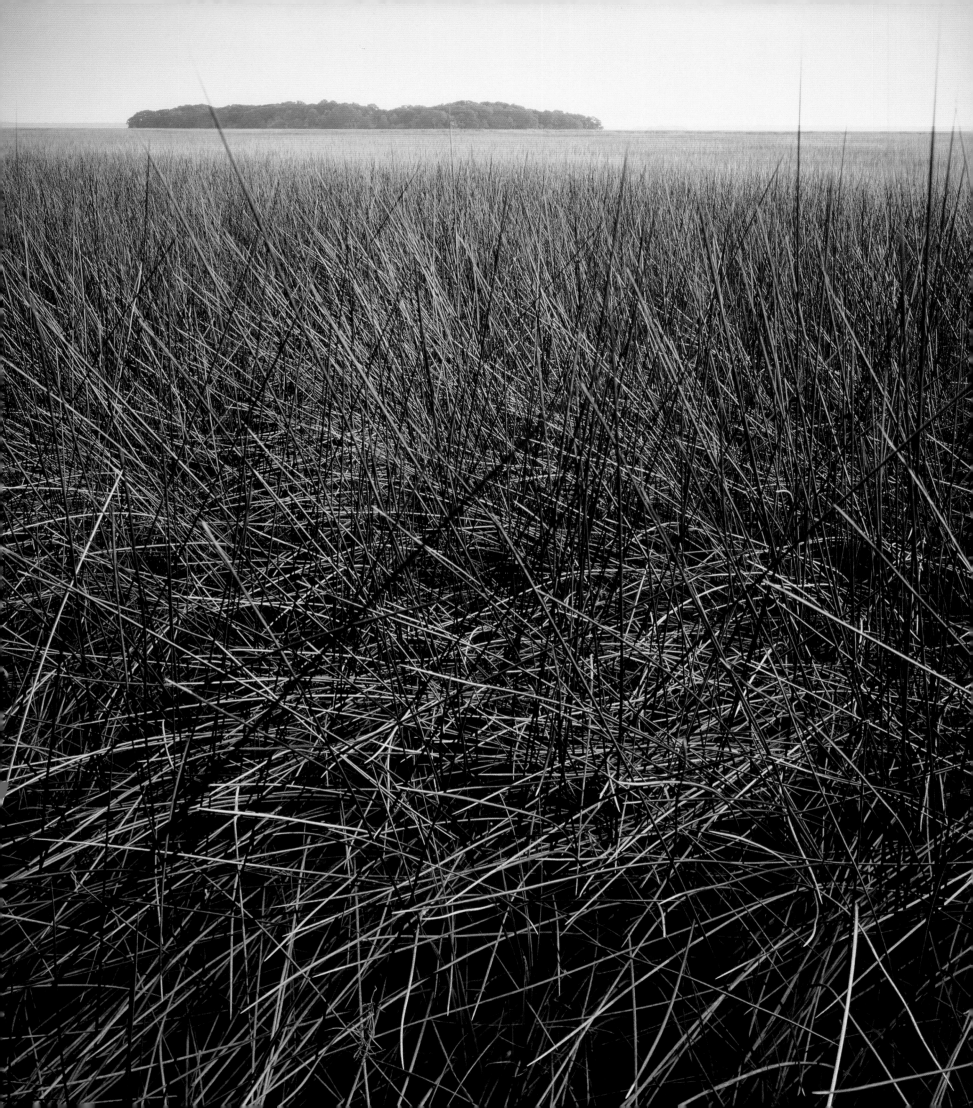

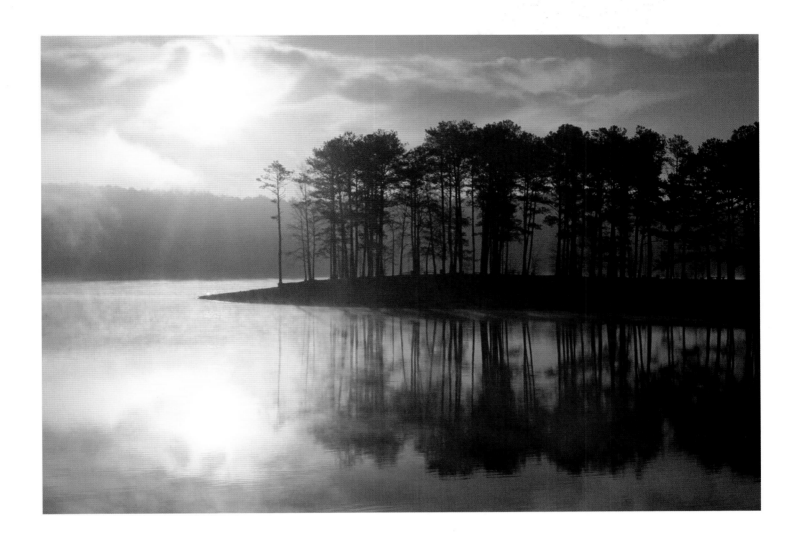

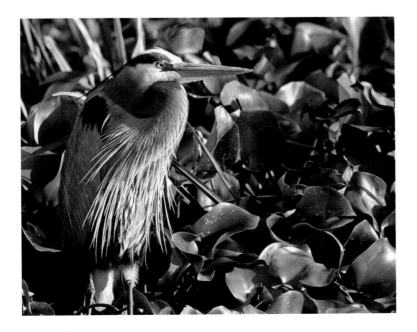

Above: Early-morning clouds diffuse light on the tranquil surface of Allatoona Lake, a popular boating and fishing playground near Canton. ROBB HELFRICK

Left: Great blue herons can grow up to fifty-four inches in height. This one stands tall at the Savannah National Wildlife Refuge. ROBB HELFRICK

Facing page: The tidal marshes and estuaries found along the coast are some of the most fertile and valuable environments in Georgia. They also serve as the nursery for many generations of shellfish and other marine species. JAMES RANDKLEV

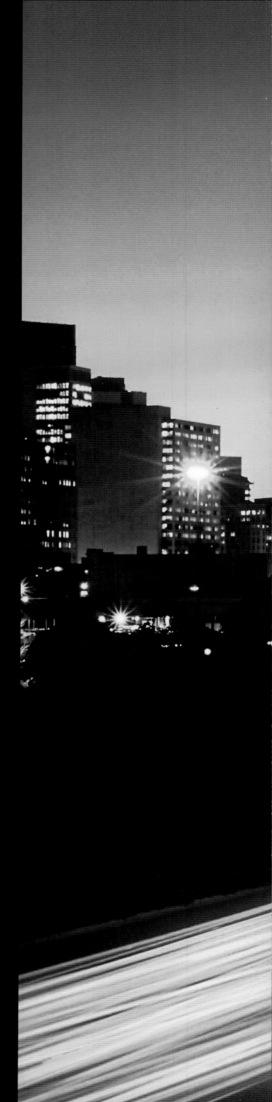

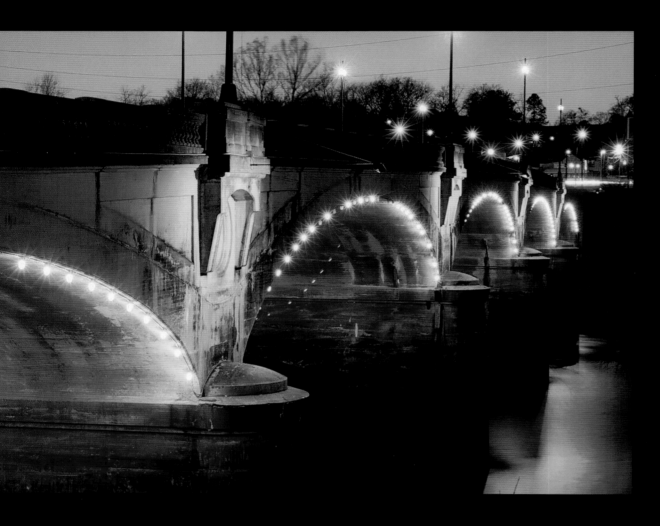

Above: The Chattahoochee River, Georgia's longest river at 436 miles, forms the state's western boundary at Columbus, where water-powered industry was once king. ROBB HELFRICK

Right: Looking west on Freedom Parkway, the Atlanta skyline blazes bright with evening colors, bright lights, and a blur of vehicular activity. ROBB HELFRICK

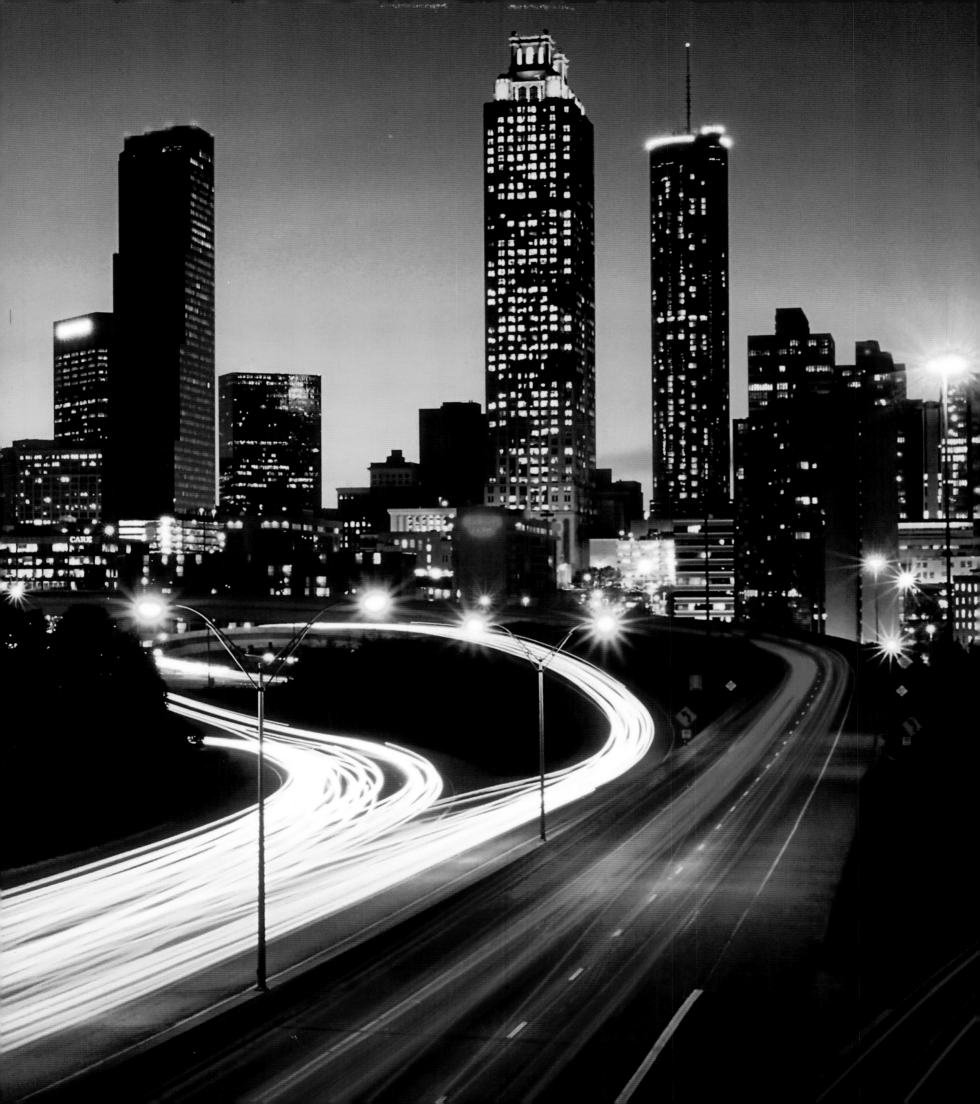

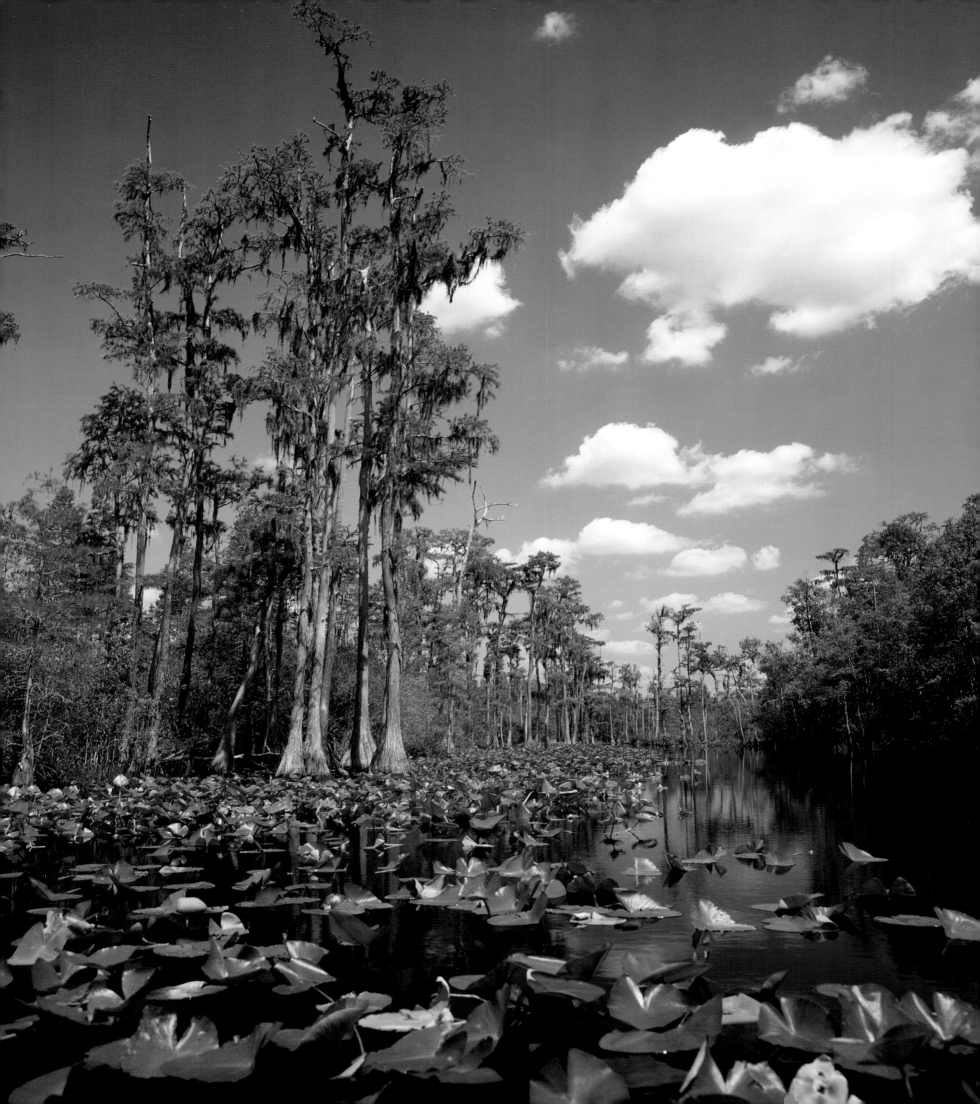

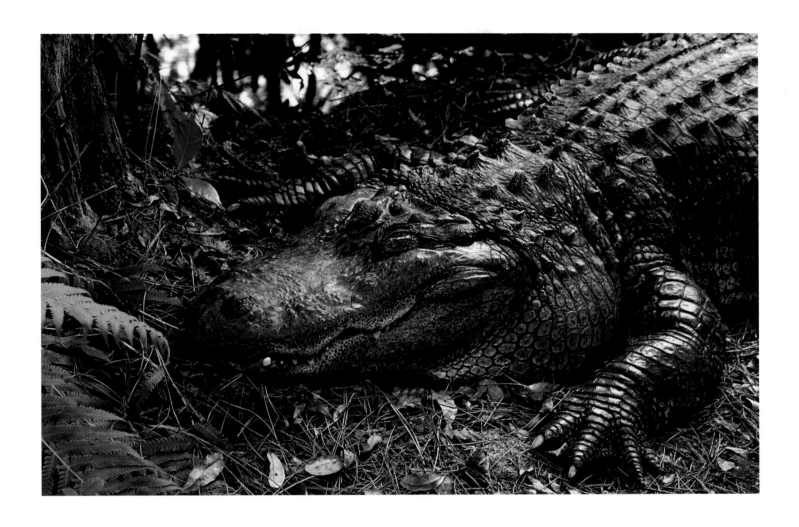

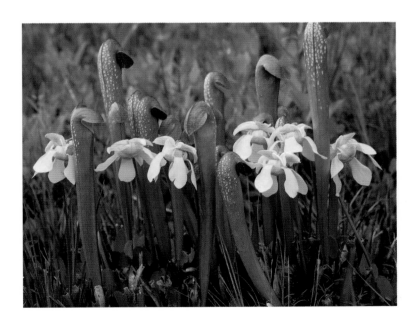

Above: This resident alligator of the Okefenokee Swamp seems to enjoy the lushness of his natural habitat. ROBB HELFRICK

Left: Pitcher plants are both lovely in form and sinister in intent, for they are carnivorous plants that trap and consume insects. JAMES RANDKLEV

Facing page: Long ago, the Okefenokee Swamp was a lagoon in an ancient sea. When the seas retreated, the large shallow depression filled with fresh water, and the Okefenokee was born. JAMES RANDKLEV

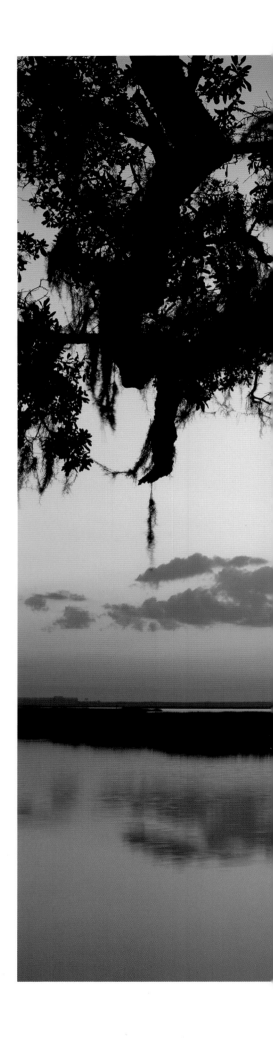

Right: A sunset over the Brickhill River brings a warm day to a colorful conclusion on Cumberland Island. JAMES RANDKLEV

Below: The fragrant and showy water lily floats on top of blackish swamp water in the Okefenokee Swamp, shown here at Barnsley Gardens. ROBB HELFRICK

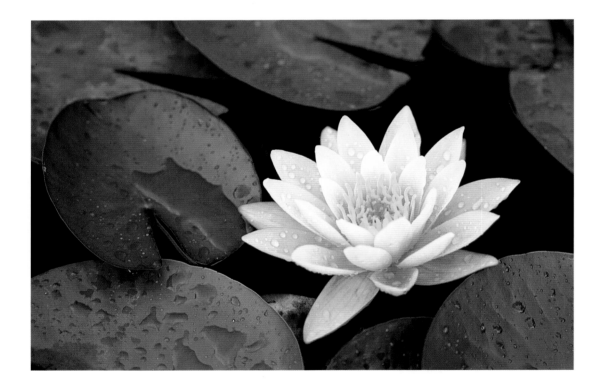

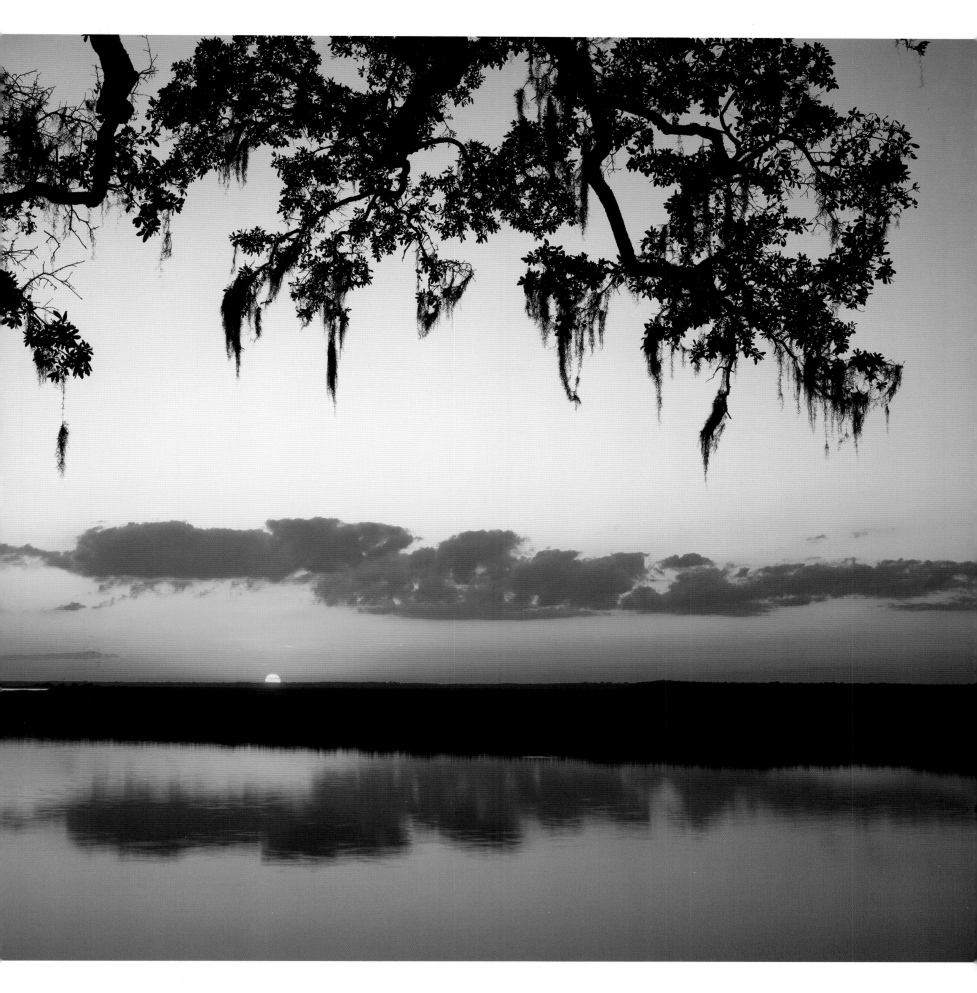

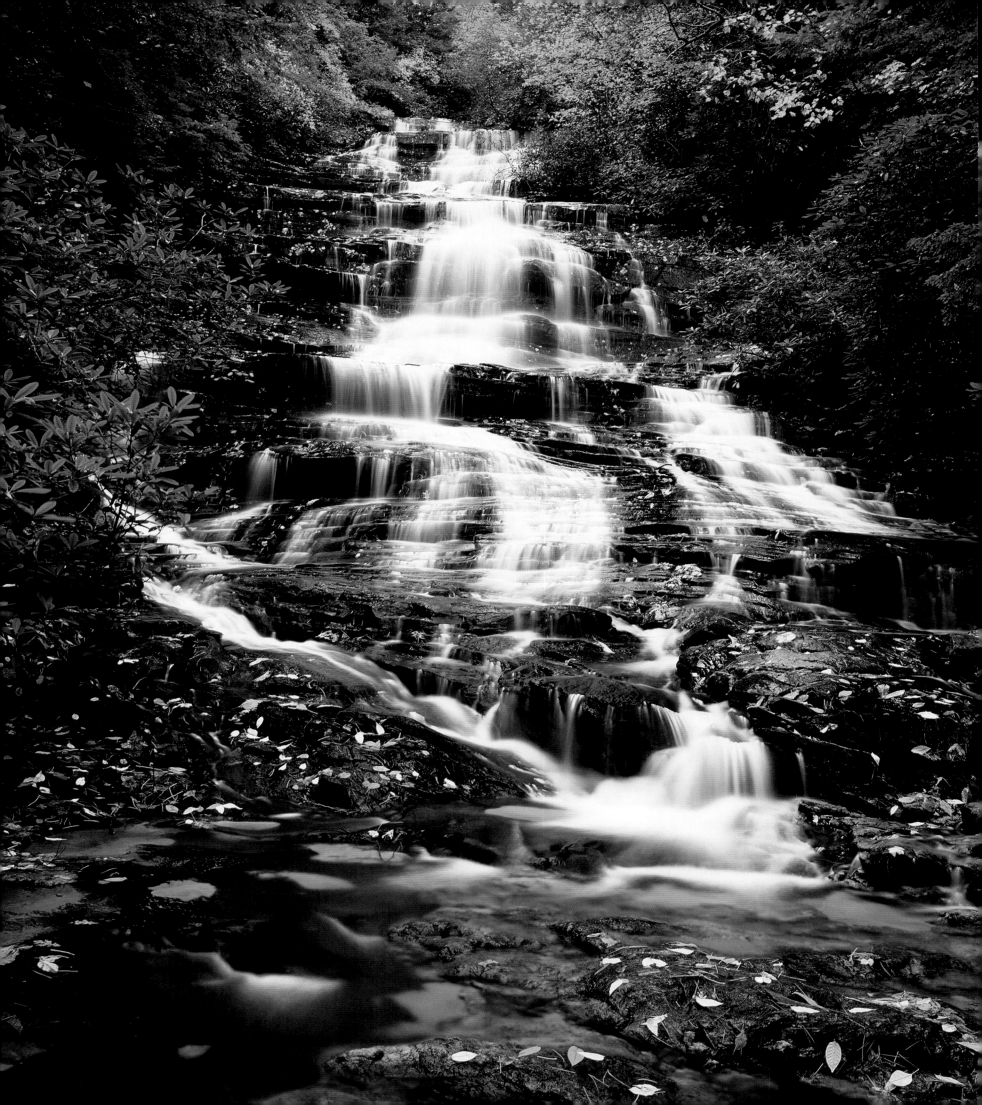

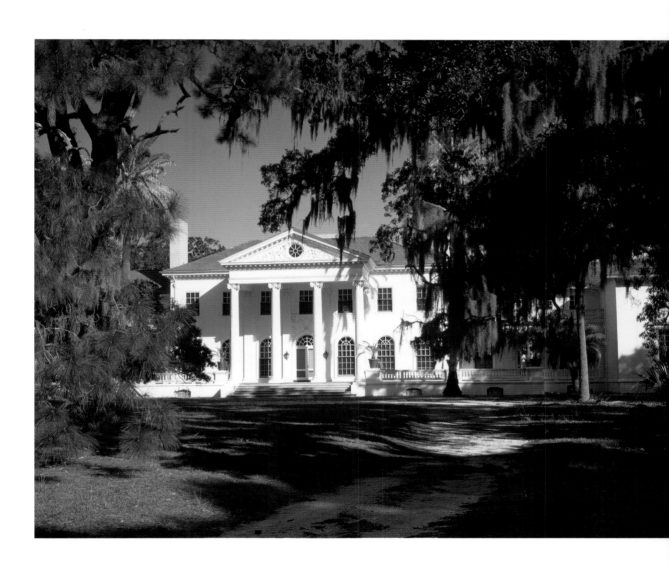

Above: Peach Orchard Mansion was originally designed and built for George Carnegie; today the estate is part of Cumberland Island National Seashore and is listed on the National Register of Historic Places. JAMES RANDKLEV

Left: A short hike leads to Minnehaha Falls, perhaps the most picturesque waterfall found in the Georgia mountains. JAMES RANDKLEV

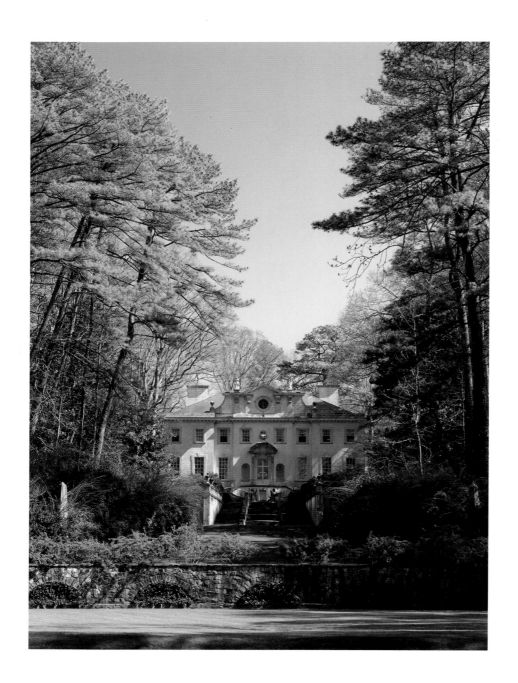

Above: A stately mansion on the grounds of the Atlanta History Center, Swan House was built in 1928 and has been beautifully restored to its original elegance.
JAMES RANDKLEV

Right: Early light finds a leopard crab resting among sand-filled clam shells at low tide.
JAMES RANDKLEV

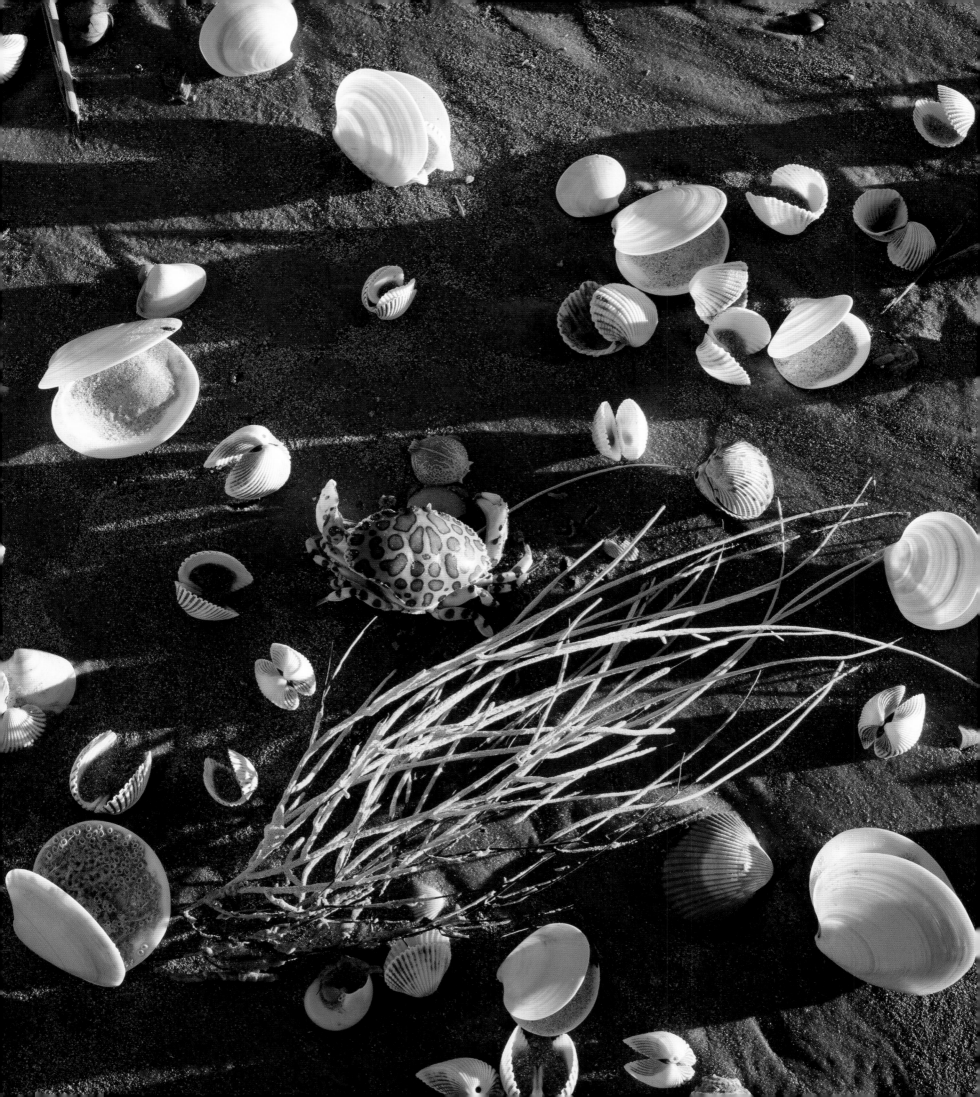

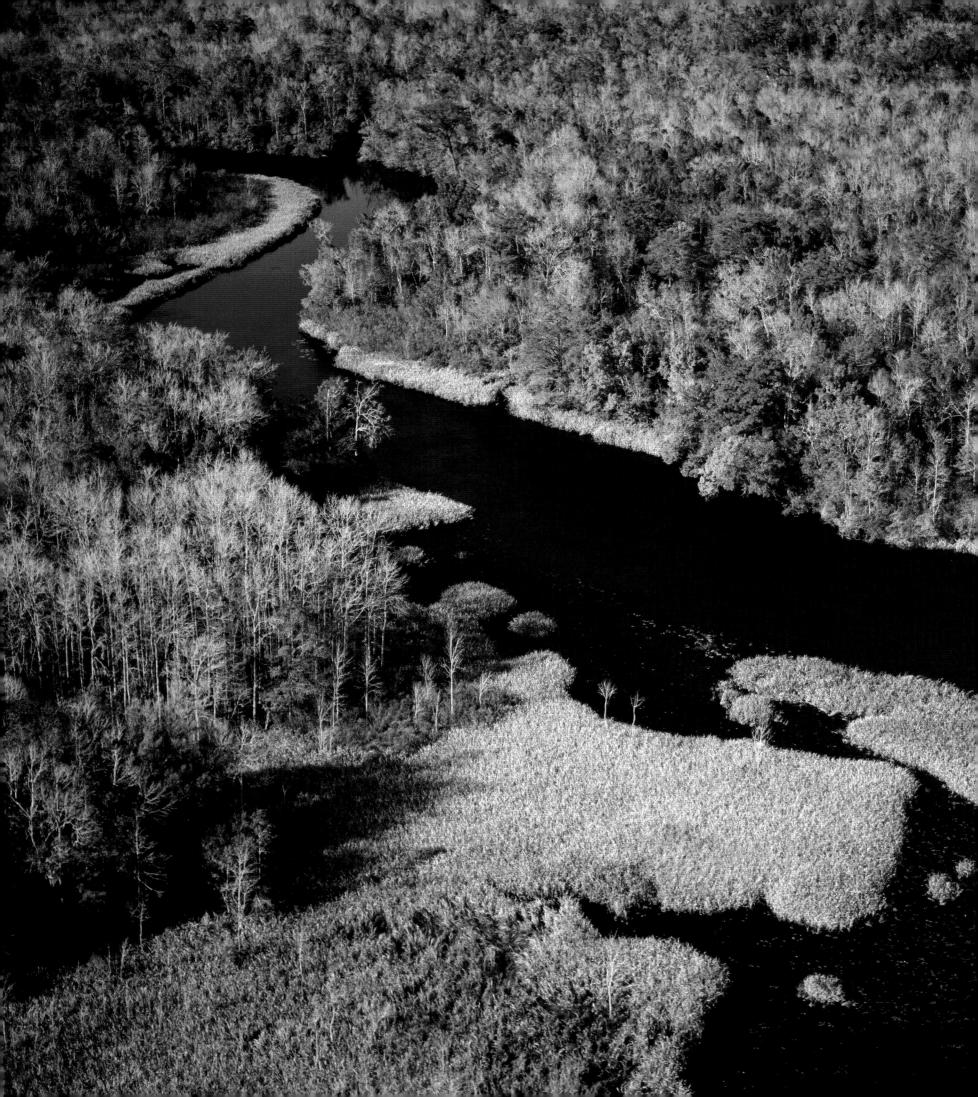

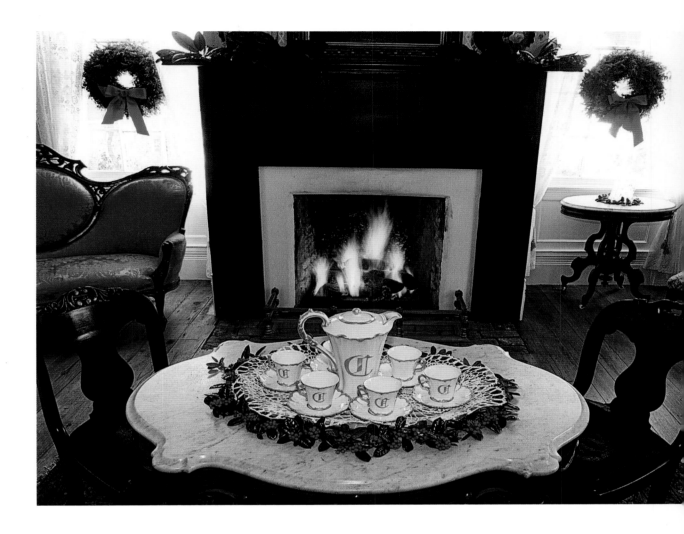

Above: A holiday scene at the Robert Toombs House, a designated state historic site in Washington, is complete with a warm fire and a service of tea. ROBB HELFRICK

Left: The Altamaha is one of Georgia's great wild rivers, and is the longest free-flowing waterway in the East. JAMES RANDKLEV

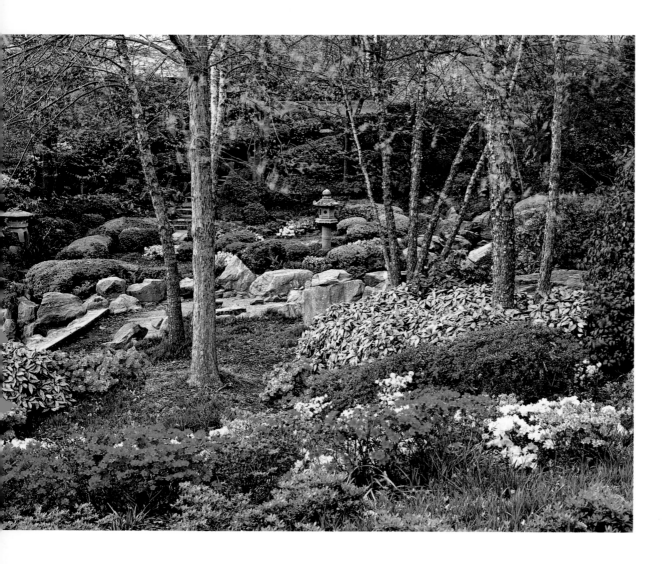

Above: At the Carter Center in Atlanta, spring bursts into full
bloom in the seclusion of the Japanese Garden. ROBB HELFRICK

Right: A classic south Georgia scene, a red clay road extends
to the horizon through fertile farmland. ROBB HELFRICK

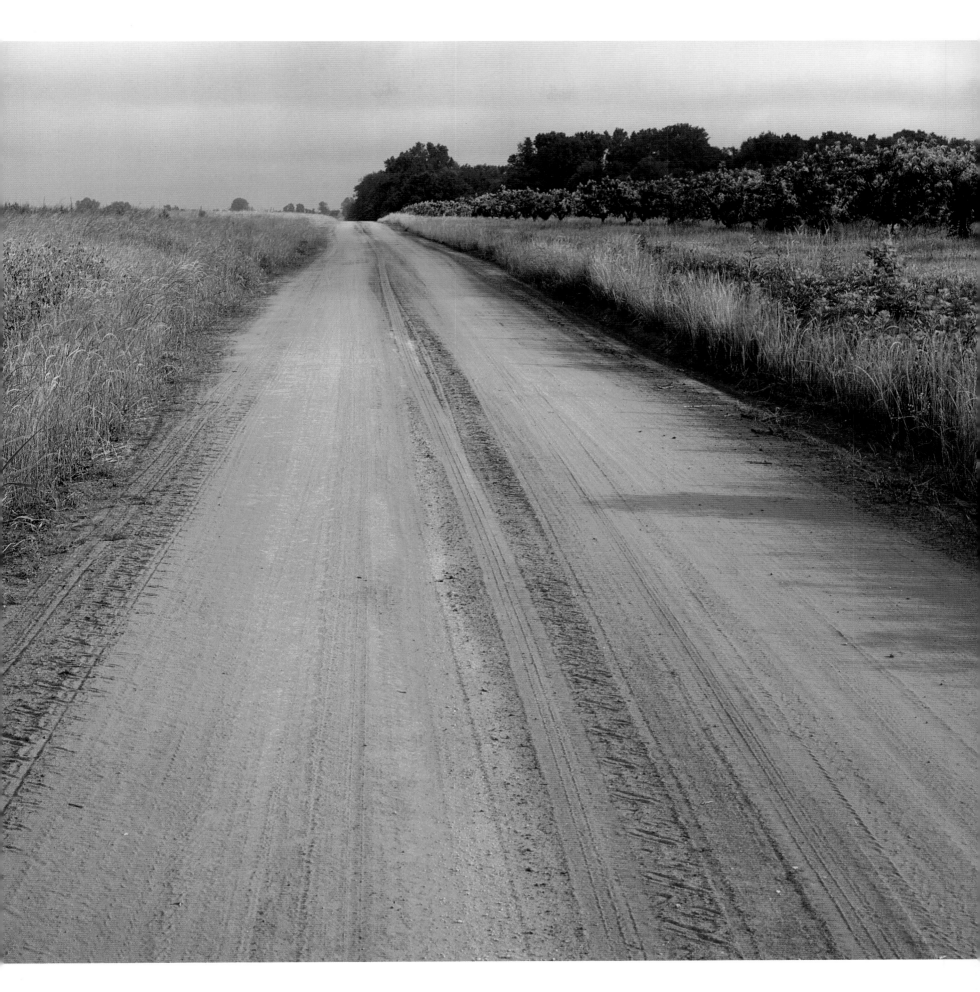

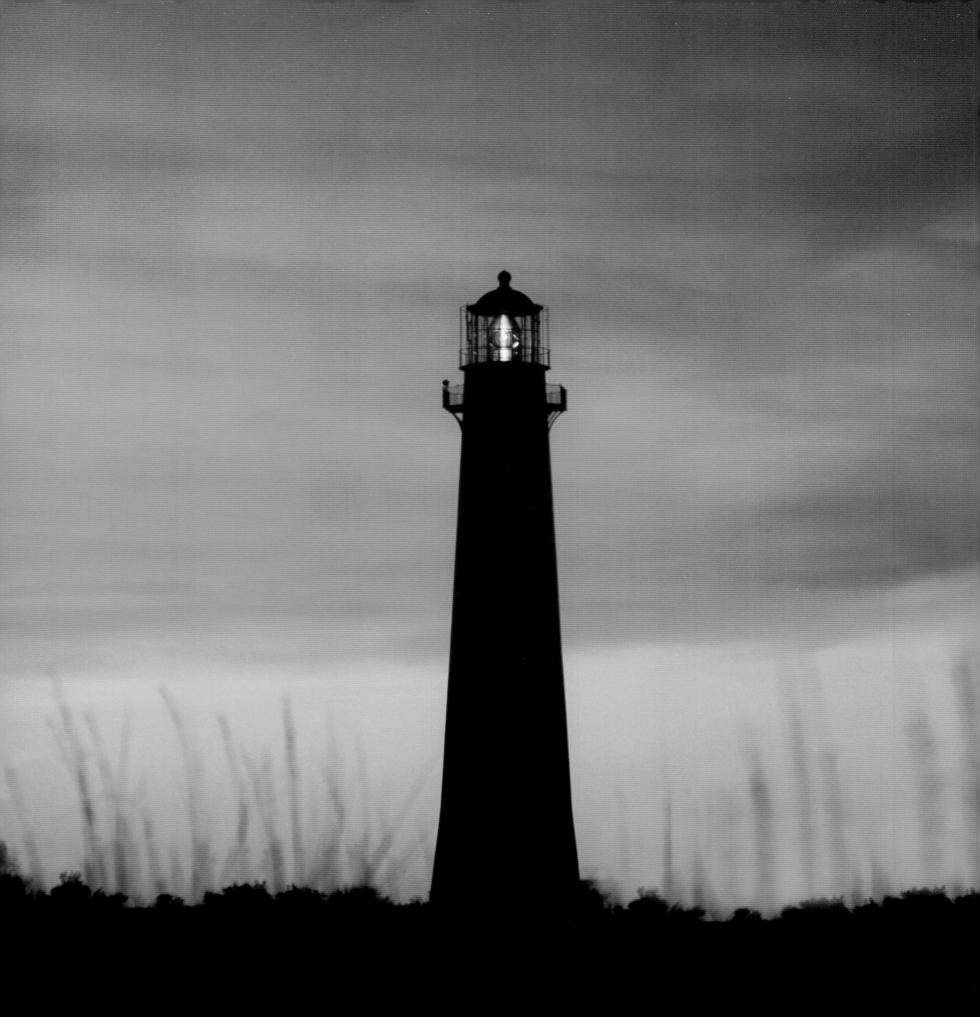

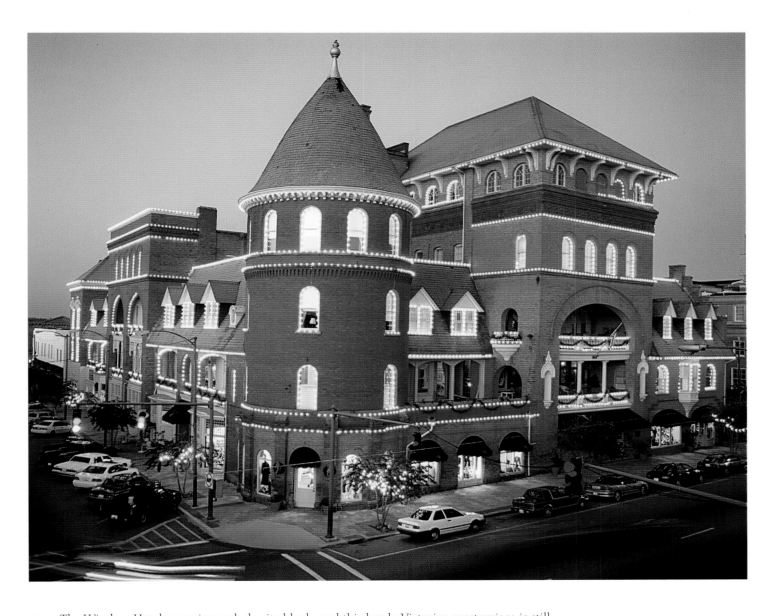

Above: The Windsor Hotel occupies a whole city block, and this lovely Victorian masterpiece is still the heart of hospitality in downtown Americus. ROBB HELFRICK

Facing page: Still shining bright on Georgia's northernmost barrier island, the Tybee Island Lighthouse has given mariners safe entry into the Savannah River for more than 270 years. ROBB HELFRICK

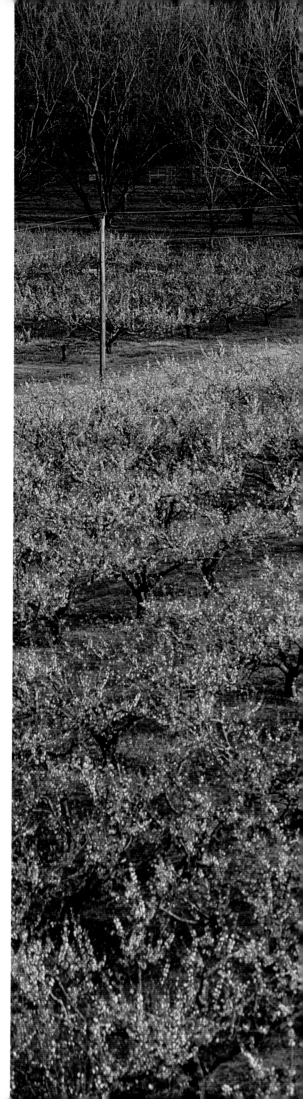

Right: At a Fort Valley farm, a peach orchard explodes with blooms, signaling another bountiful year. ROBB HELFRICK

Below, top: Georgia leads the nation in peach production—would you expect anything less? ROBB HELFRICK

Below, bottom: Delicate peach blossoms appear throughout middle Georgia in early to mid-March. ROBB HELFRICK

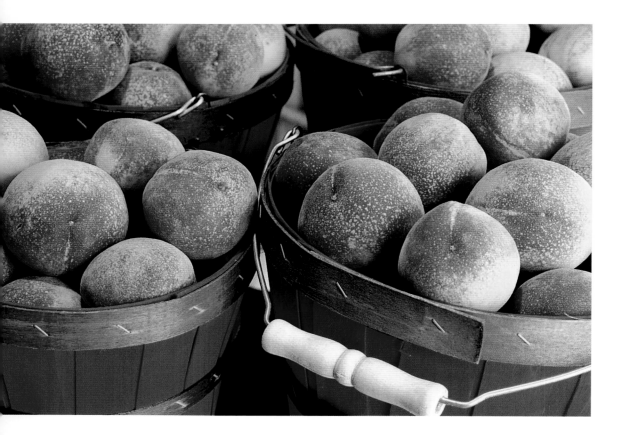

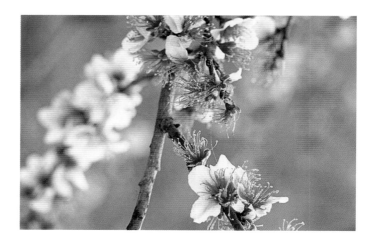

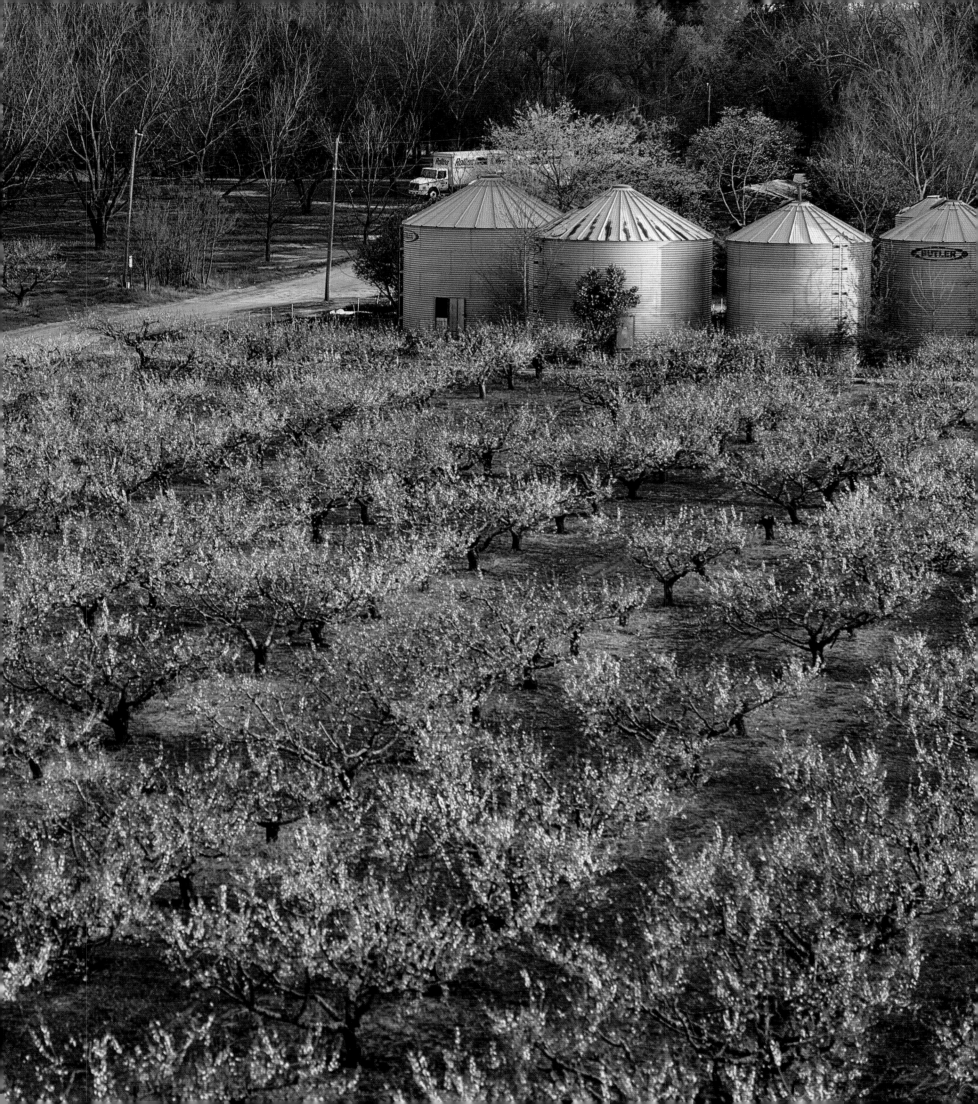

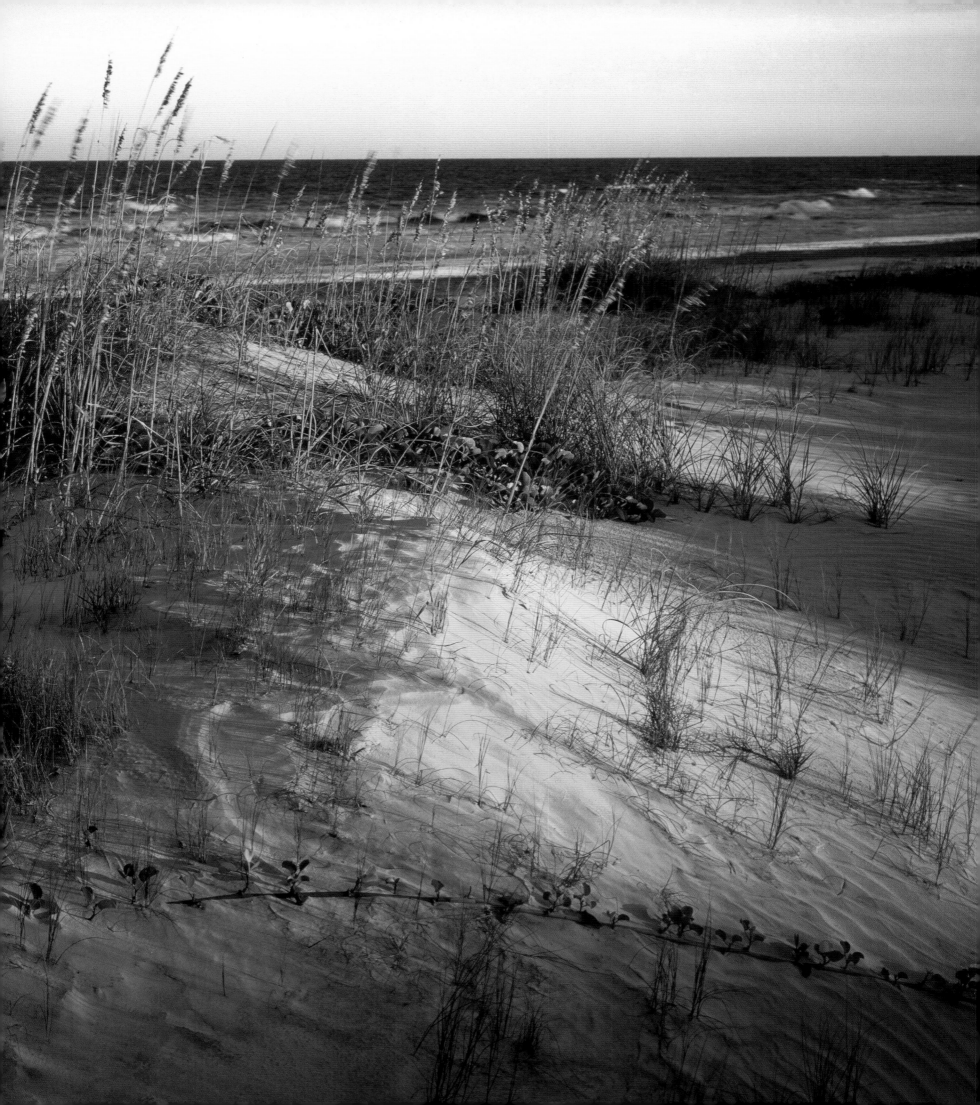

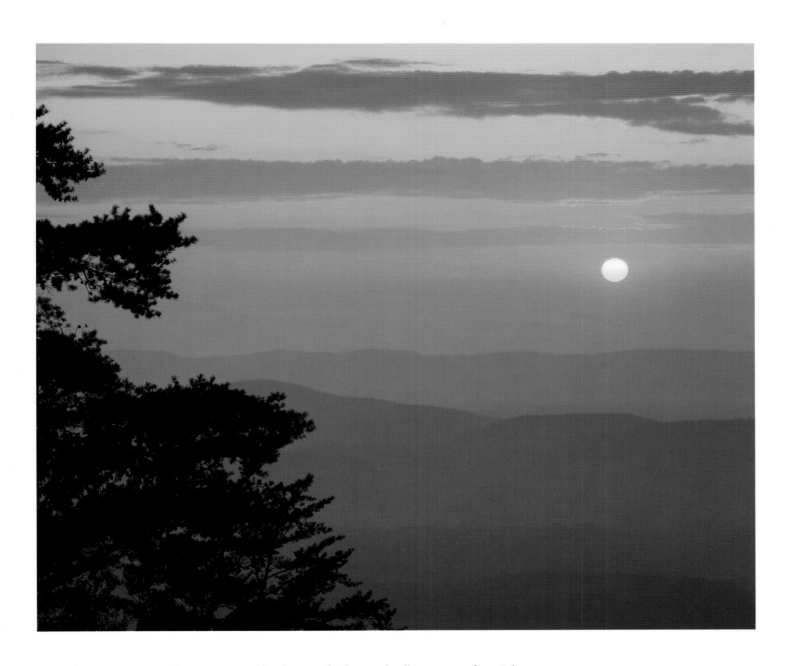

Above: The summer sun sinks into a muted landscape of ridges and valleys as seen from Johns Mountain in northwestern Georgia. JAMES RANDKLEV

Facing page: Sea oats are a beautiful sight swaying in an ocean breeze, but they serve a higher purpose by stabilizing and protecting dunes from storm surges and constant beach erosion. JAMES RANDKLEV

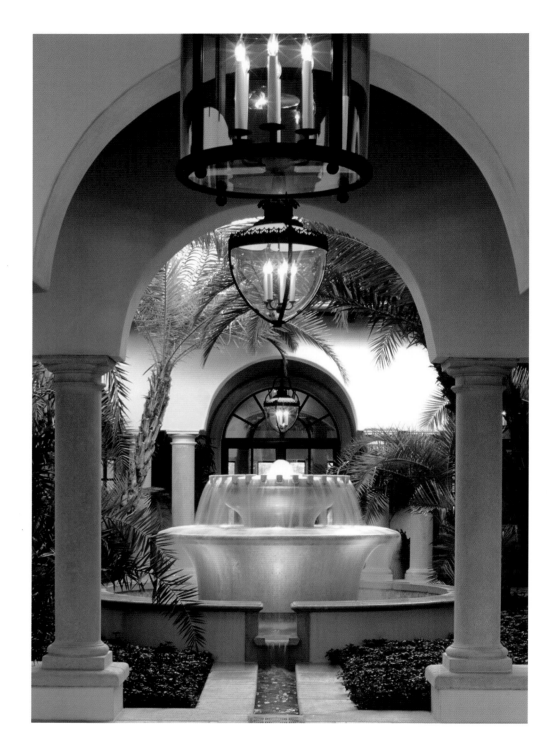

Above: The Cloister is a legendary five-star resort on Sea Island. Its luxurious atmosphere includes this elegant courtyard inside their relaxing spa. ROBB HELFRICK

Right: Morning sunshine penetrates through a lush maritime forest on Skidaway Island near Savannah. Live oaks, palmetto, and Spanish moss are a classic coastal Georgia trio. ROBB HELFRICK

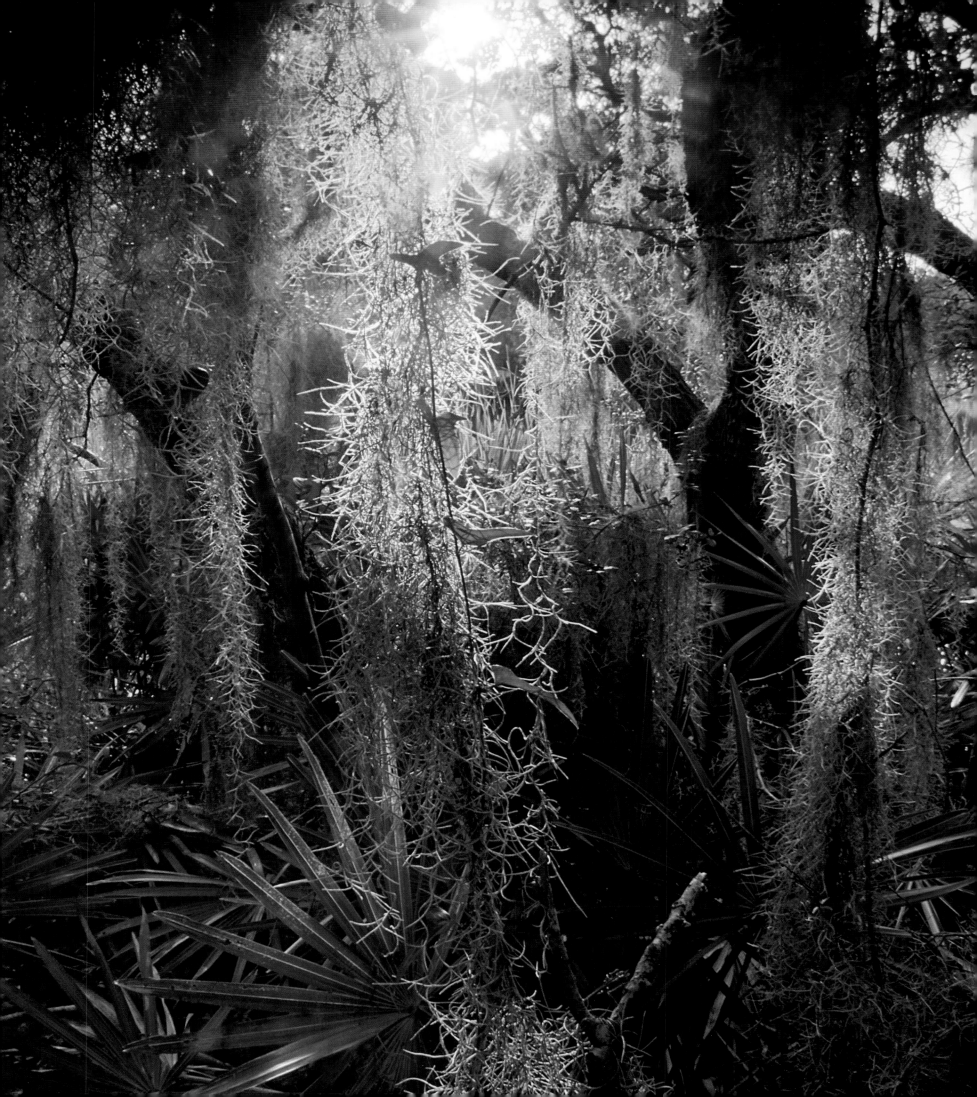

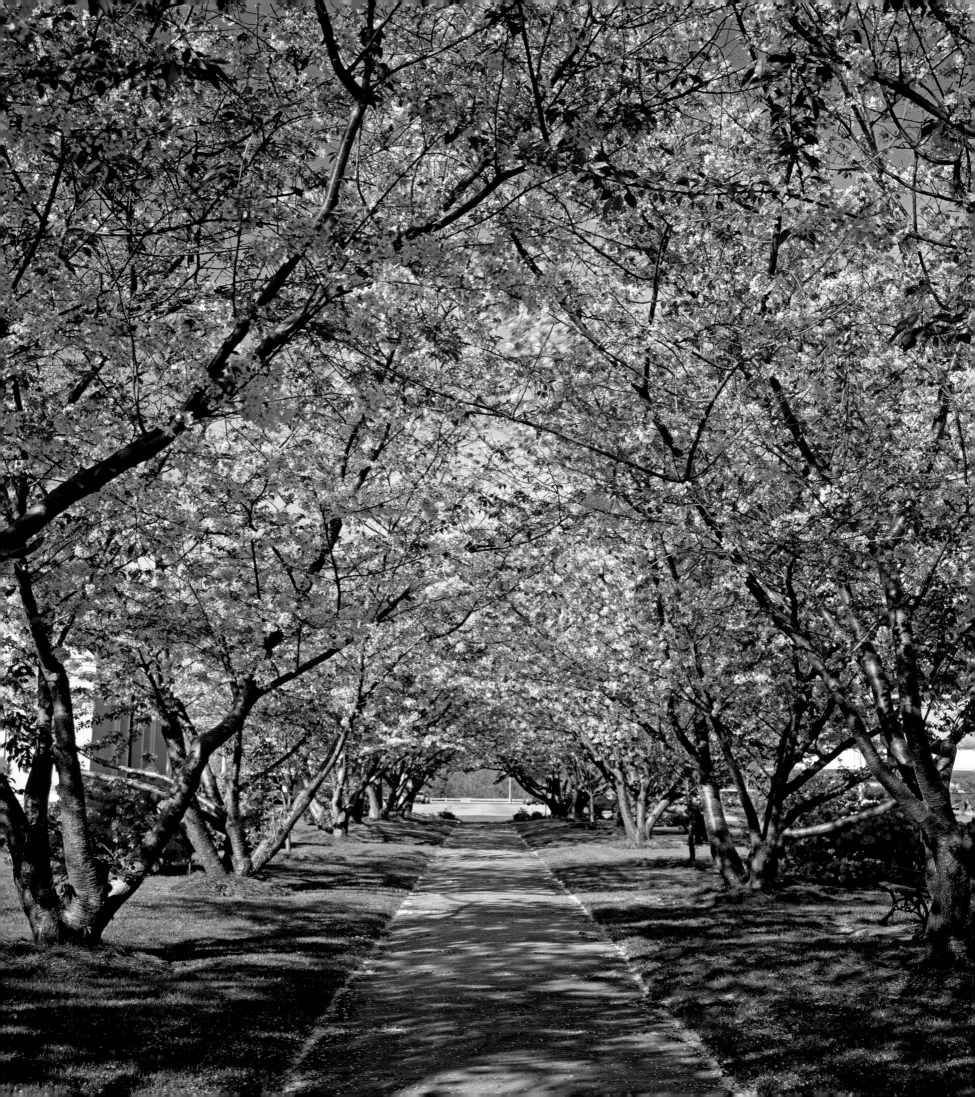

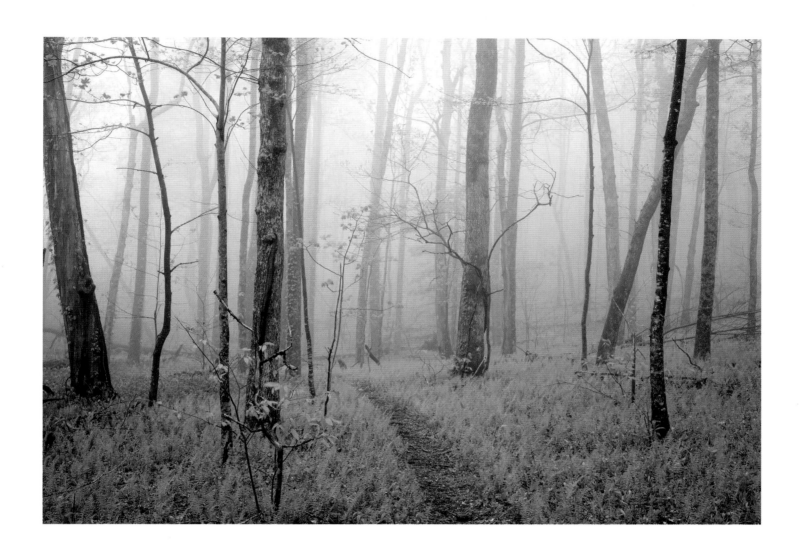

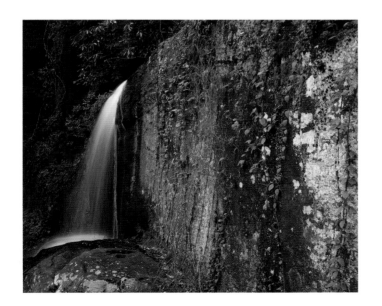

Above: The Appalachian Trail is seen shrouded in fog at Hogpen Gap. This famous footpath begins a few miles farther south at Springer Mountain and meanders northward all the way to Maine. JAMES RANDKLEV

Left: Creeping vines and a delicate veil of water are found at DeSoto Falls in the Chattahoochee National Forest. JAMES RANDKLEV

Facing page: In downtown Macon, March is the month for the annual Cherry Blossom Festival, which showcases the city's 300,000 flowering Yoshino cherry trees. JAMES RANDKLEV

Above: In the wooded landscape of Callaway Gardens, 8 million fantasy lights create a spectacular holiday display. ROBB HELFRICK

Right: The dynamic nature of Georgia's barrier islands is evident at Boneyard Beach on Wassaw Island, where the ocean eventually reclaims what was once a forest. JAMES RANDKLEV

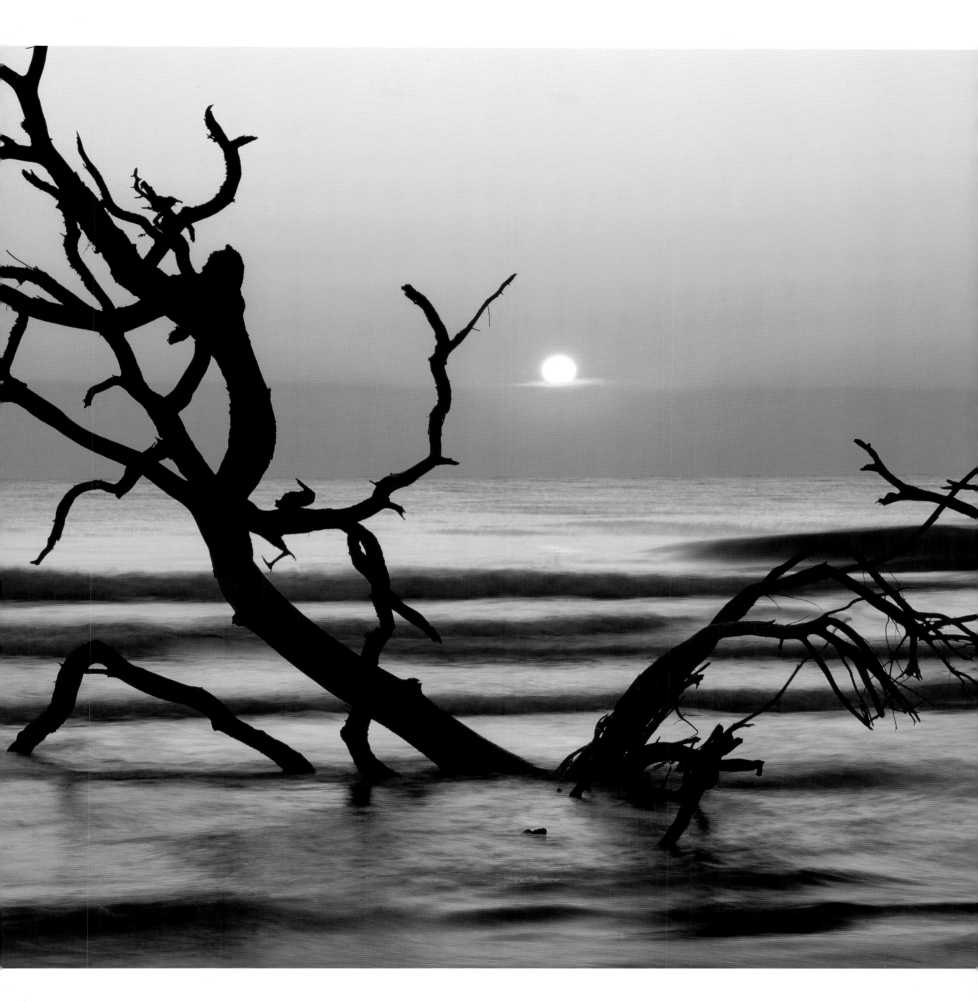

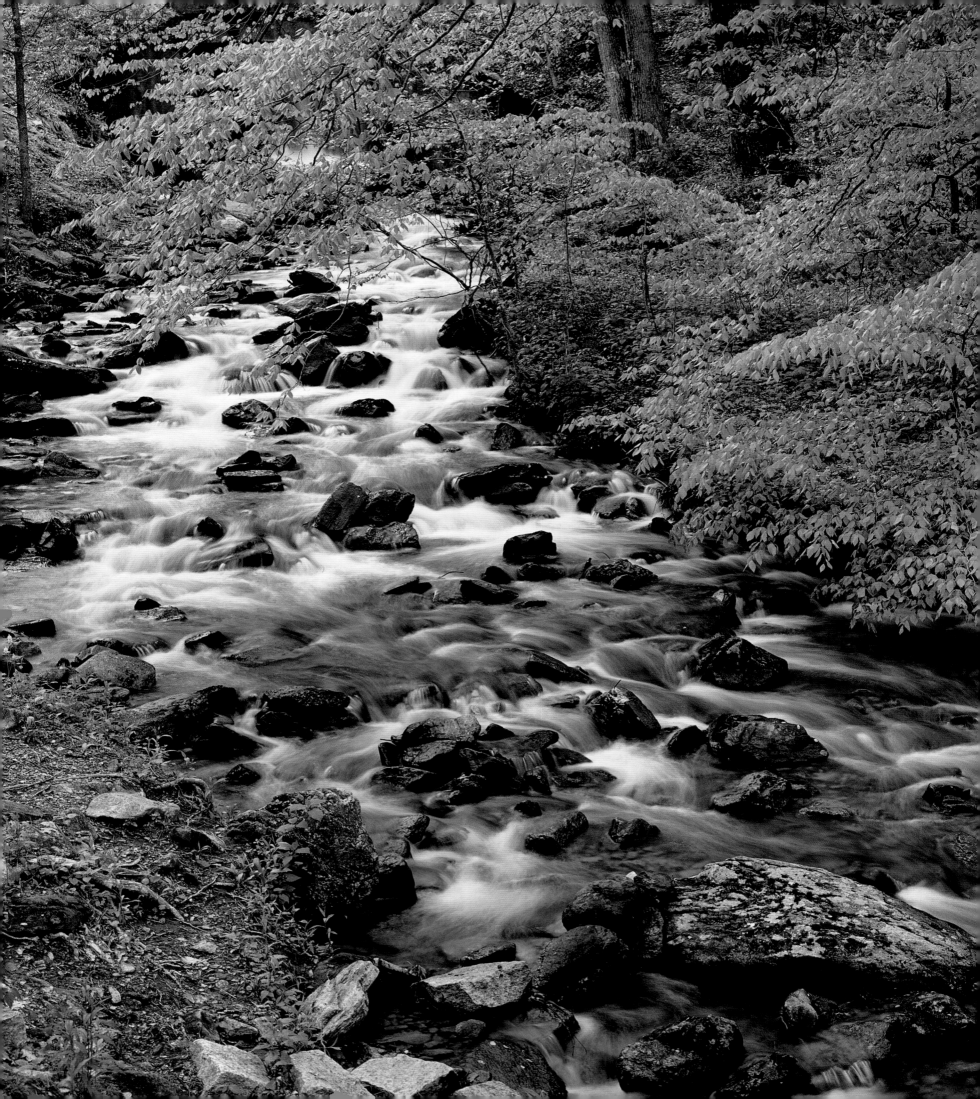

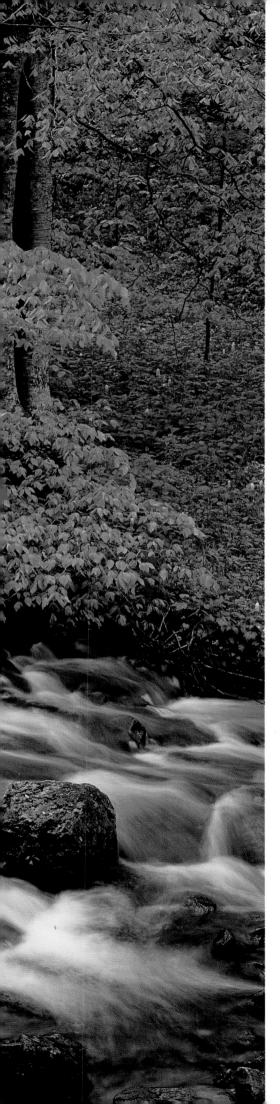

Above: Found at the extreme southwestern corner of the state, Lake Seminole is an excellent place for wildlife viewing, with frequent sightings of osprey and bald eagles. JAMES RANDKLEV

Left: Below the famous falls, Amicalola Creek rushes over a rocky streambed on an early spring morning. ROBB HELFRICK

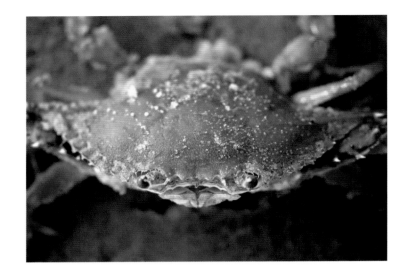

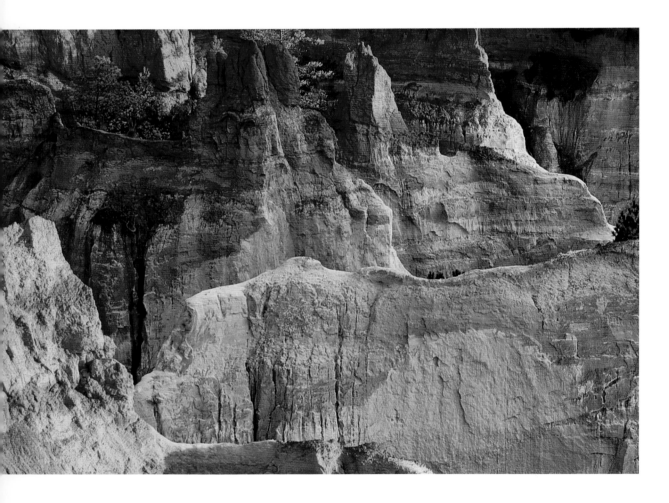

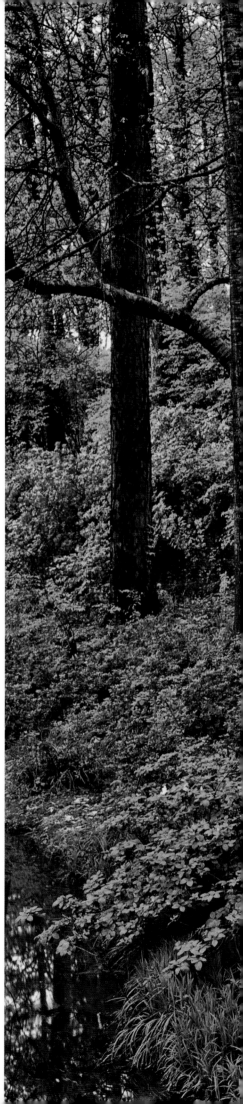

Above, top: A feisty blue crab protects his turf on Jekyll Island.
ROBB HELFRICK

Above, bottom: Looking like a landscape from the American Southwest, Providence Canyon is a place carved not from natural forces, but from erosion due to faulty farming practices. ROBB HELFRICK

Right: Azaleas carpet the hillside at Callaway Gardens, a world-class resort in Pine Mountain that offers the natural beauty of its gardens as well as recreation and relaxation. ROBB HELFRICK

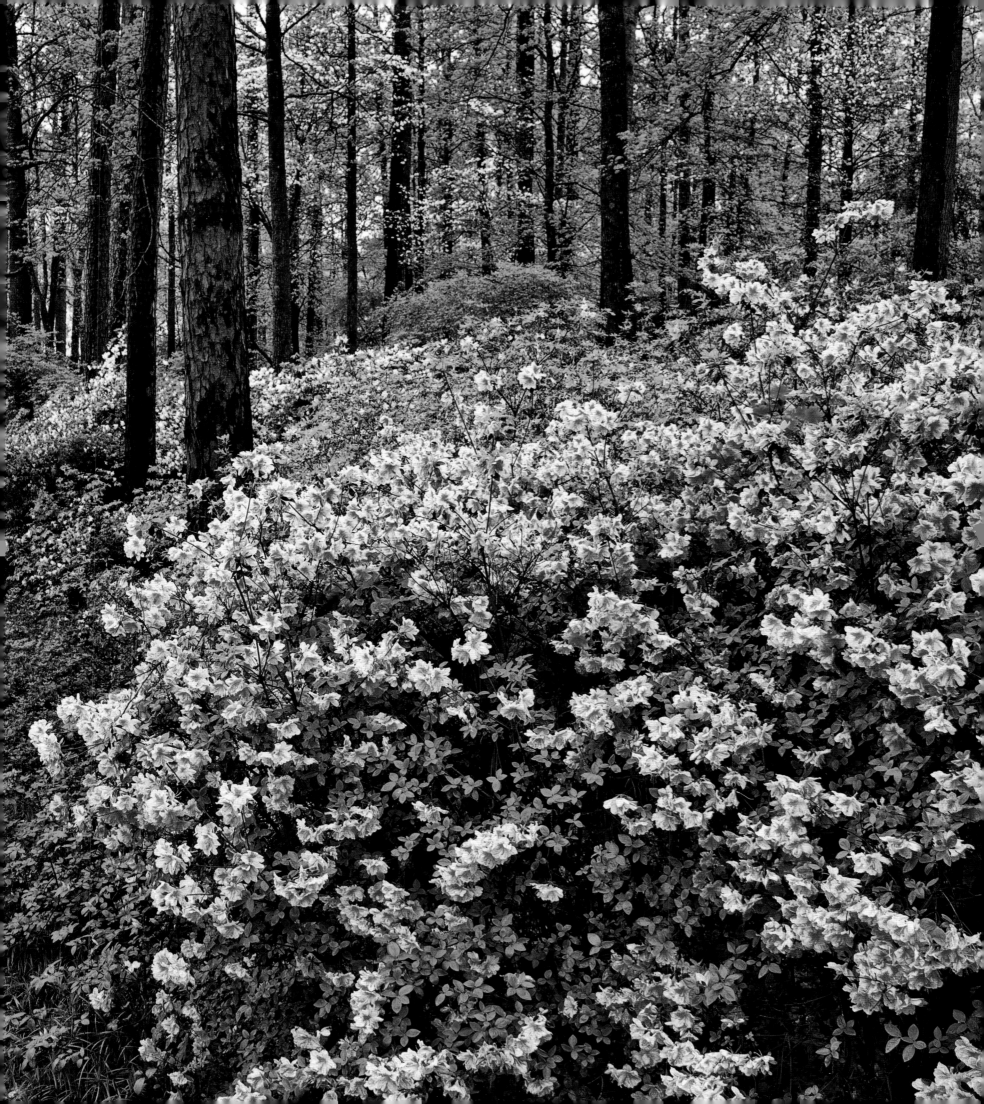

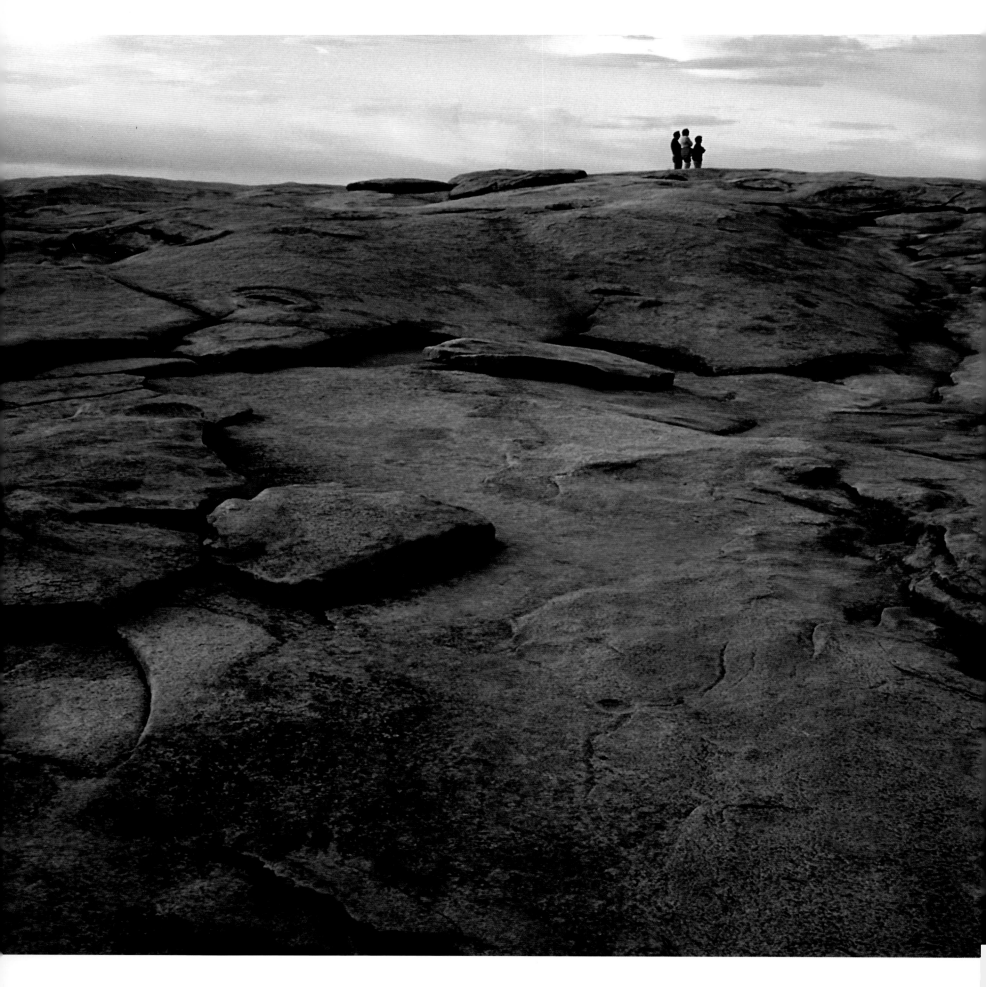

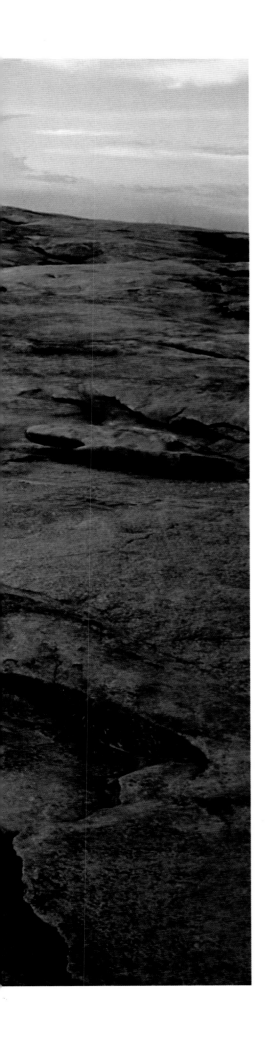

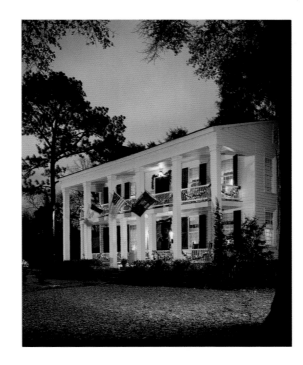

Left: Listed on the National Register of Historic Places, Taylor Hall is a welcoming and graceful historic home in Hawkinsville. ROBB HELFRICK

Far left: Rising 825 feet above the Piedmont and covering 583 acres, Stone Mountain is the largest mass of exposed granite in the world. A hike to the top offers breathtaking views of Atlanta and the surrounding countryside. ROBB HELFRICK

Below: The tomb of Martin Luther King Jr. on Auburn Avenue in Atlanta is a somber remembrance of the life and accomplishments of America's foremost civil rights leader. ROBB HELFRICK

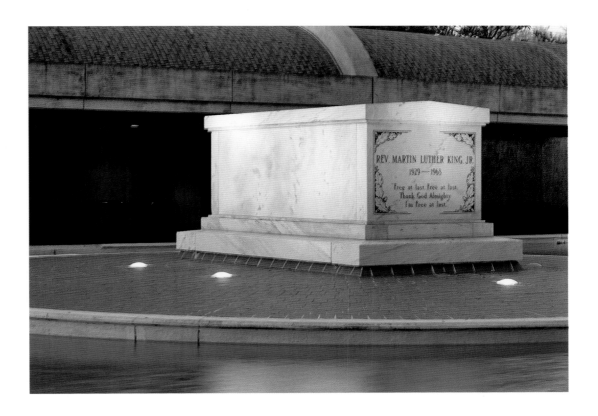

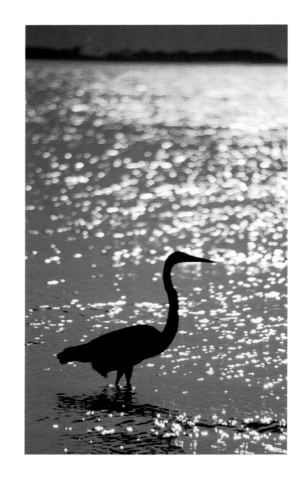

Right: A great egret wades in a shallow sound in search of its next meal. ROBB HELFRICK

Far right: Shrimp boats rest on the shore of the Darien River, awaiting the call for the next trip out to sea. ROBB HELFRICK

Below: A Darien shrimper displays his catch—fresh from a day of fishing. ROBB HELFRICK

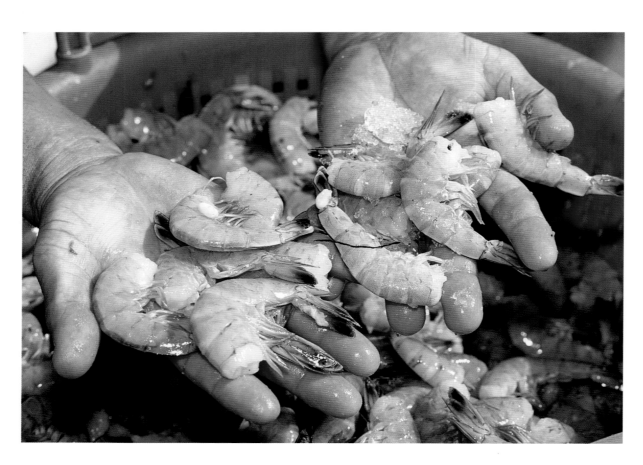

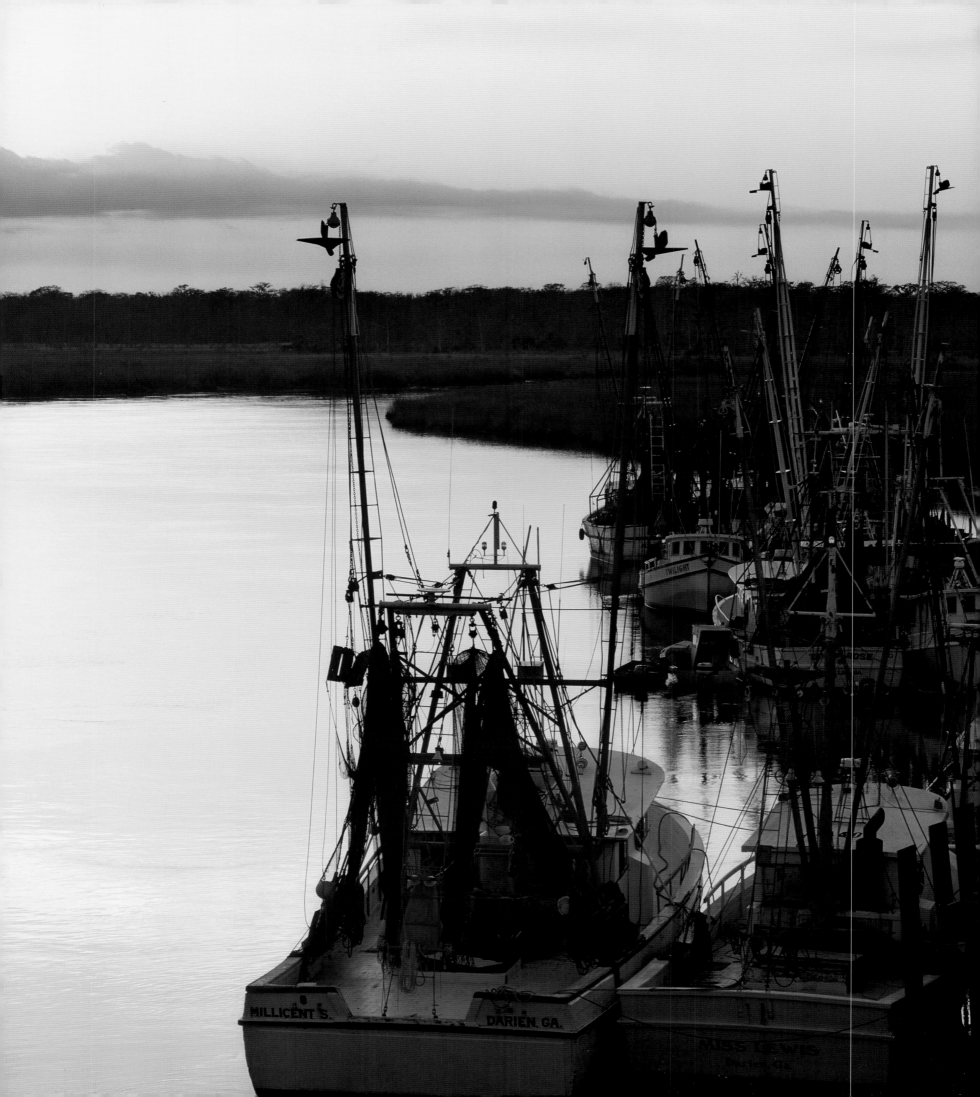

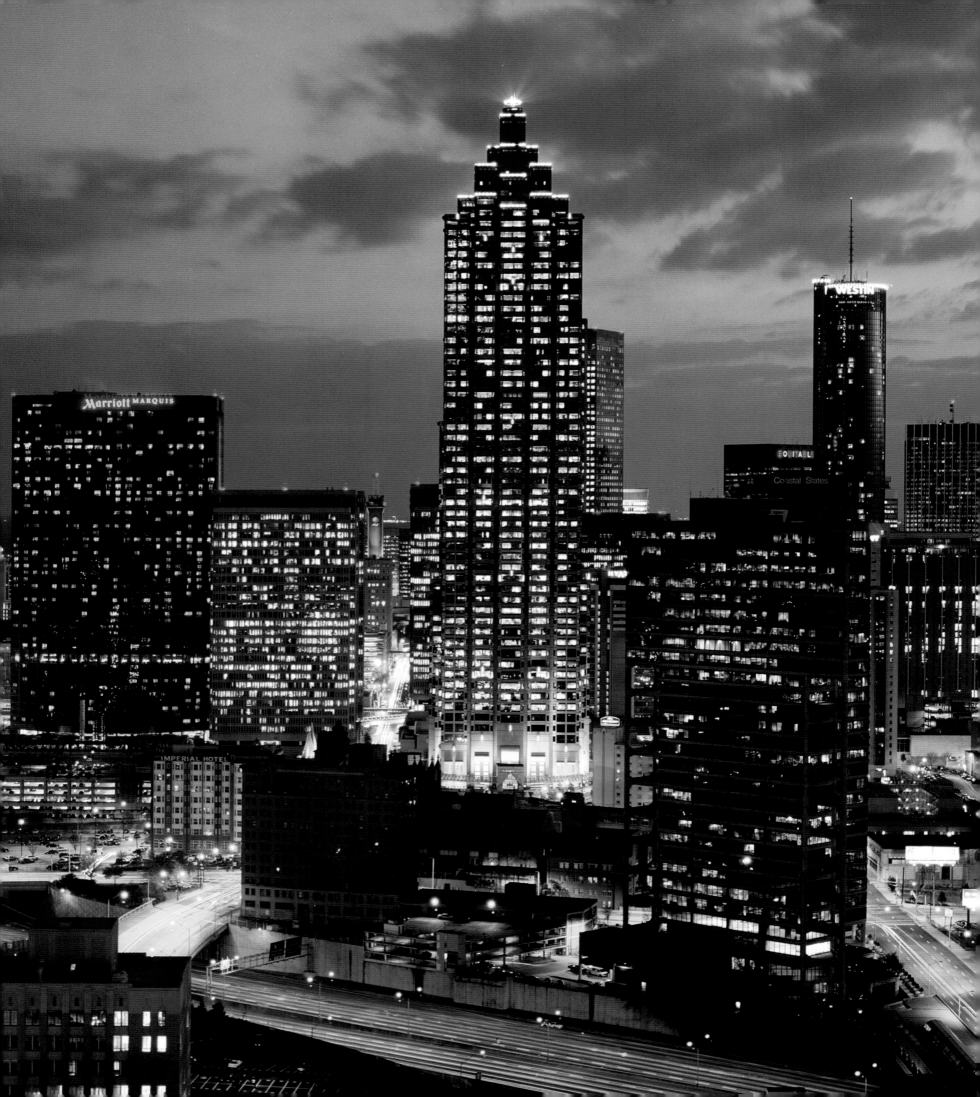

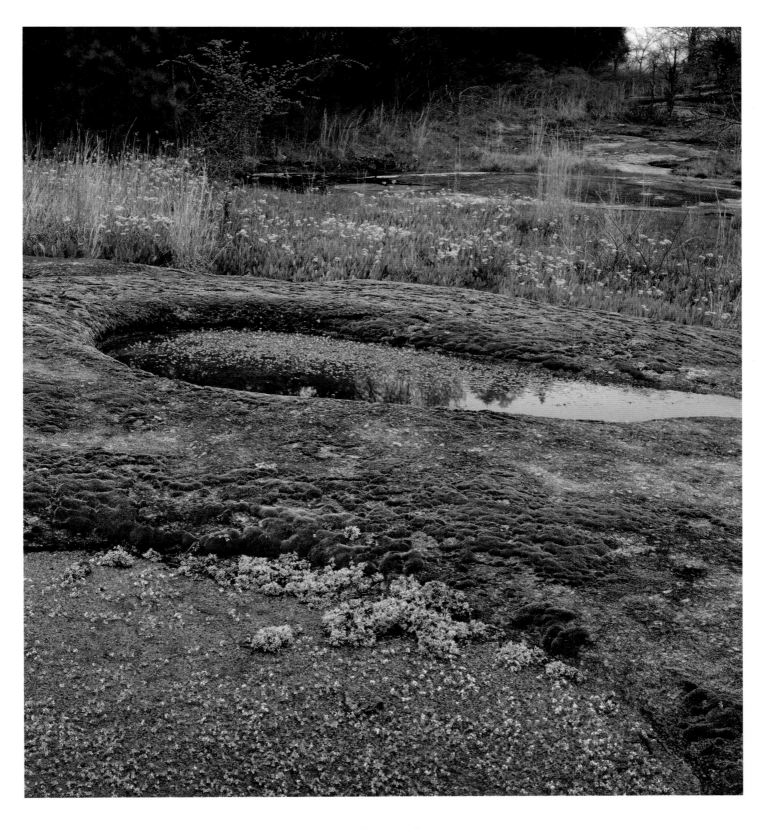

Above: Heggie's Rock Preserve has one of the best examples of a Piedmont flat rock outcrop, with shallow dish gardens that grow rare plants like this red sedum. JAMES RANDKLEV

Facing page: Atlanta is the engine that drives Georgia's business and commerce. Its modern skyline is a steel and glass monument to the city's can-do attitude. ROBB HELFRICK

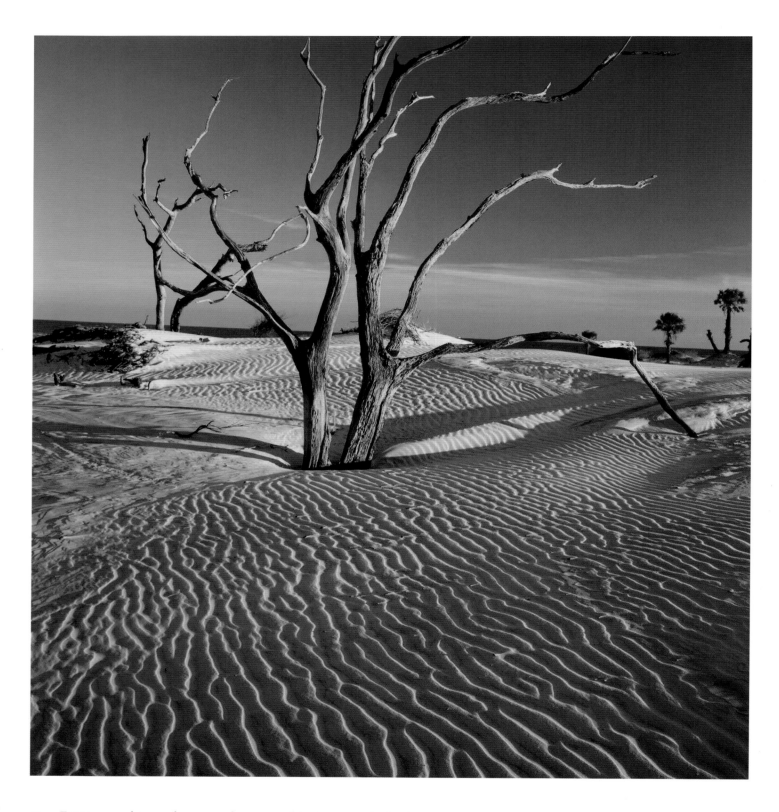

Above: Evening sunshine and an ocean breeze combine to create the intricate patterns seen in the shifting sands of Cumberland Island National Seashore. JAMES RANDKLEV

Facing page: Transparent Godby Springs is a blue geologic wonder in southern Georgia. JAMES RANDKLEV

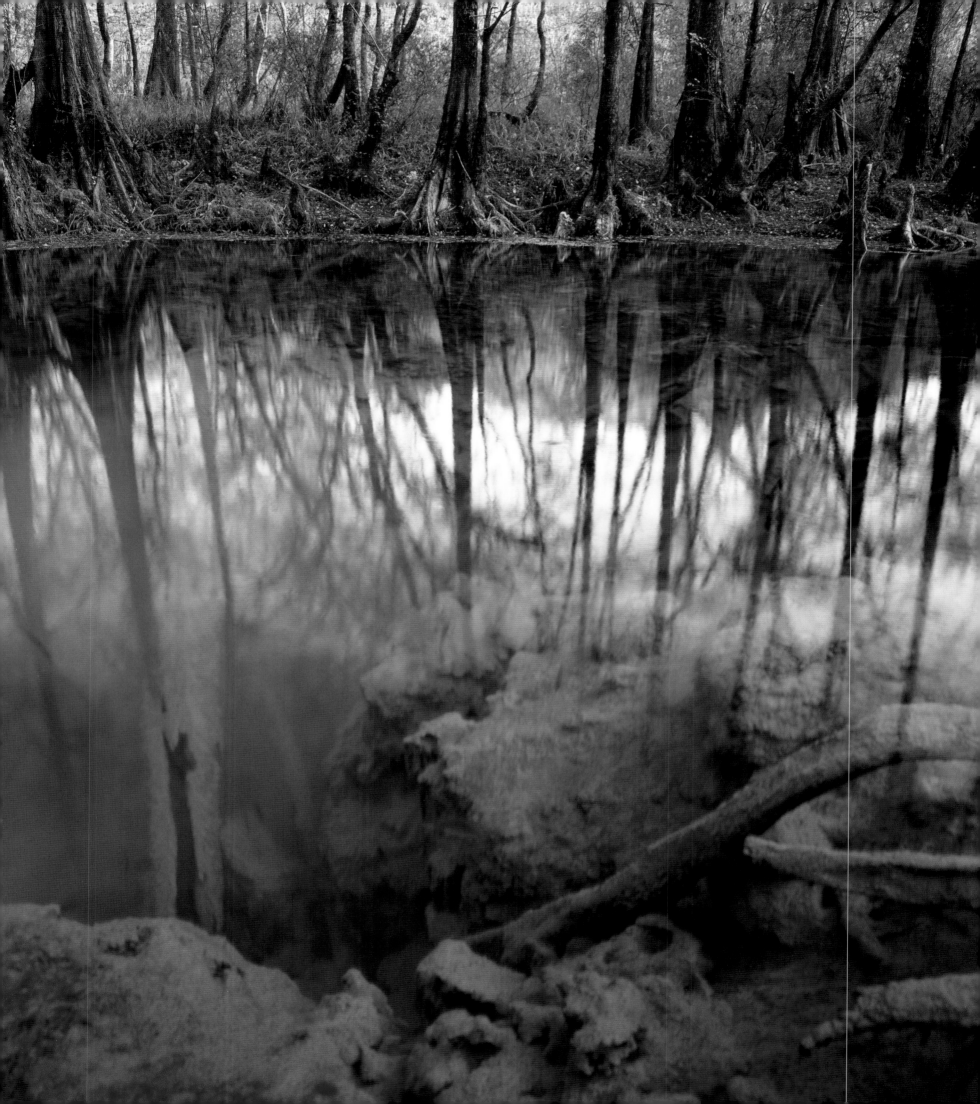

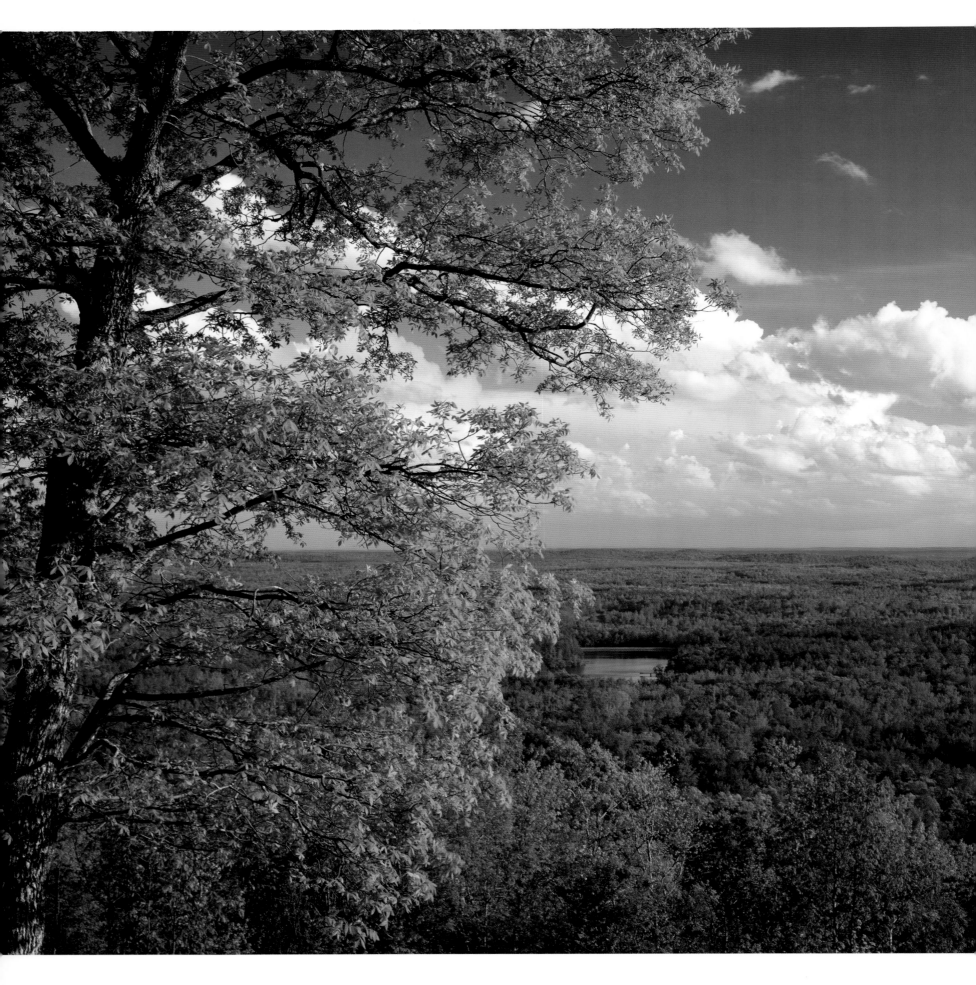

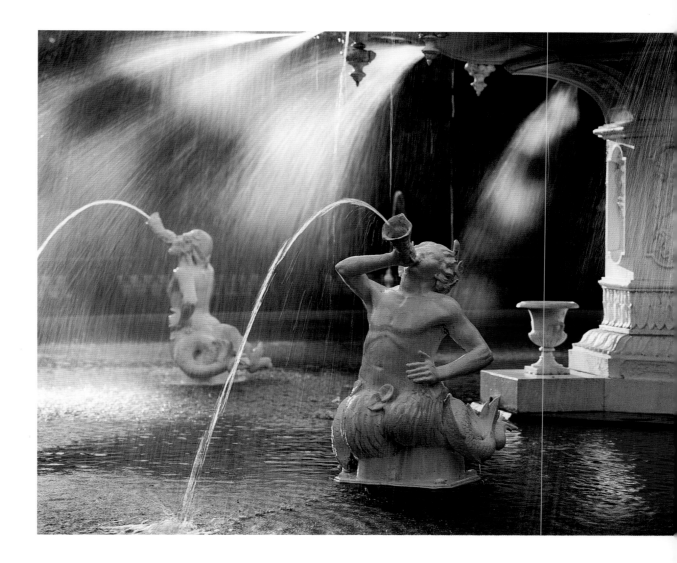

Above: The Forsyth Park Fountain, located in Savannah, was originally built in 1858. In 1998 the fountain was completely restored and it received an award for its outstanding restoration. ROBB HELFRICK

Left: FDR State Park is named in honor of President Franklin Roosevelt, who often enjoyed a relaxing outdoor afternoon here during his frequent visits to Pine Mountain and Warm Springs. JAMES RANDKLEV

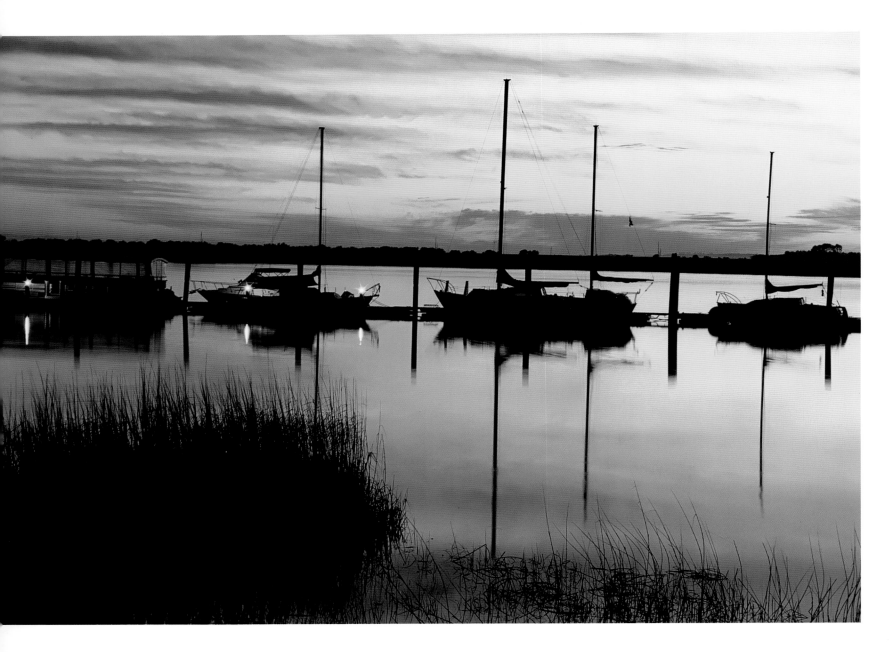

Above: At days end on the Jekyll River, a vibrant sunset silhouettes a group of pleasure boats at a marina on Jekyll Island. ROBB HELFRICK

Facing page: Towering cypress trees and swaying Spanish moss shape the stunning appearance of an ancient landscape at Banks Lake. JAMES RANDKLEV

Following pages: Rugged and rock strewn, the Upper Tallulah River is a mighty mountain stream in an area abundant with scenic splendor. JAMES RANDKLEV

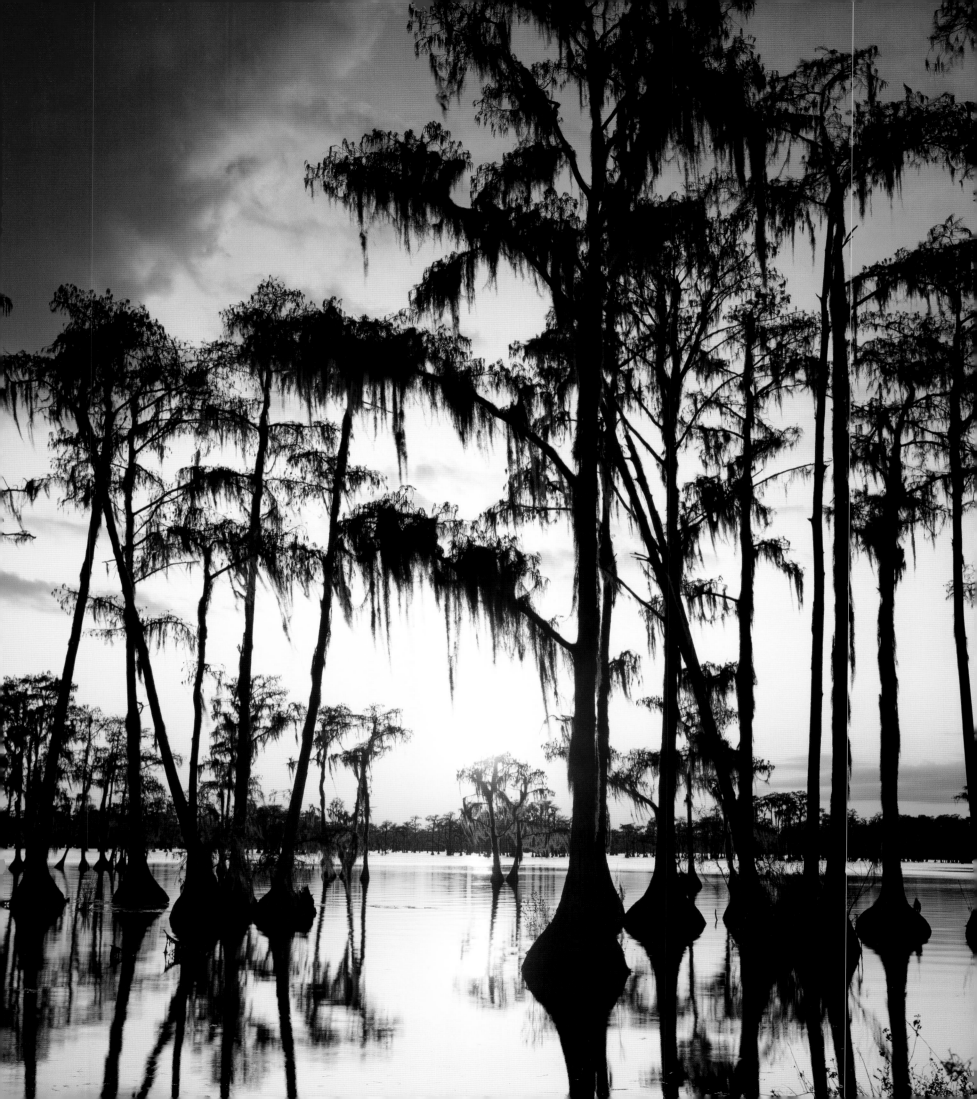

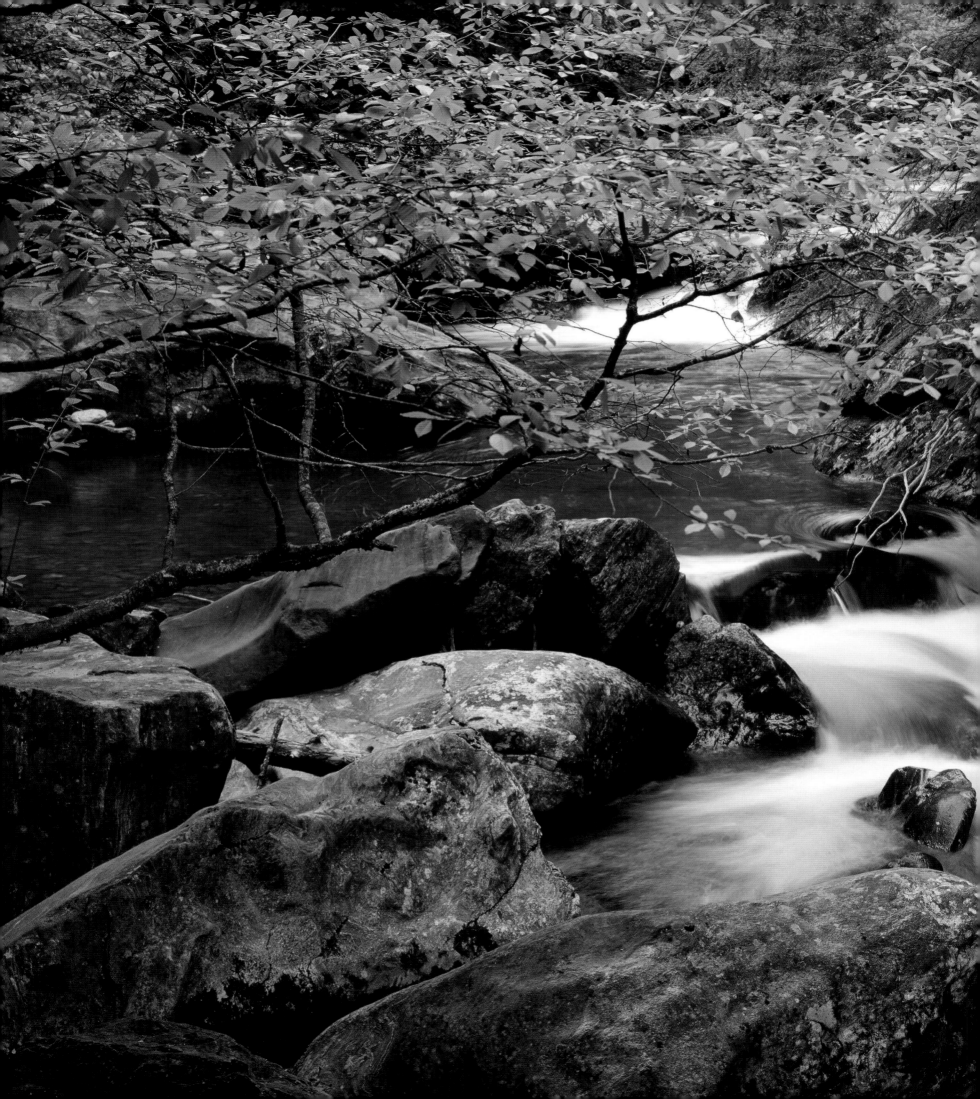

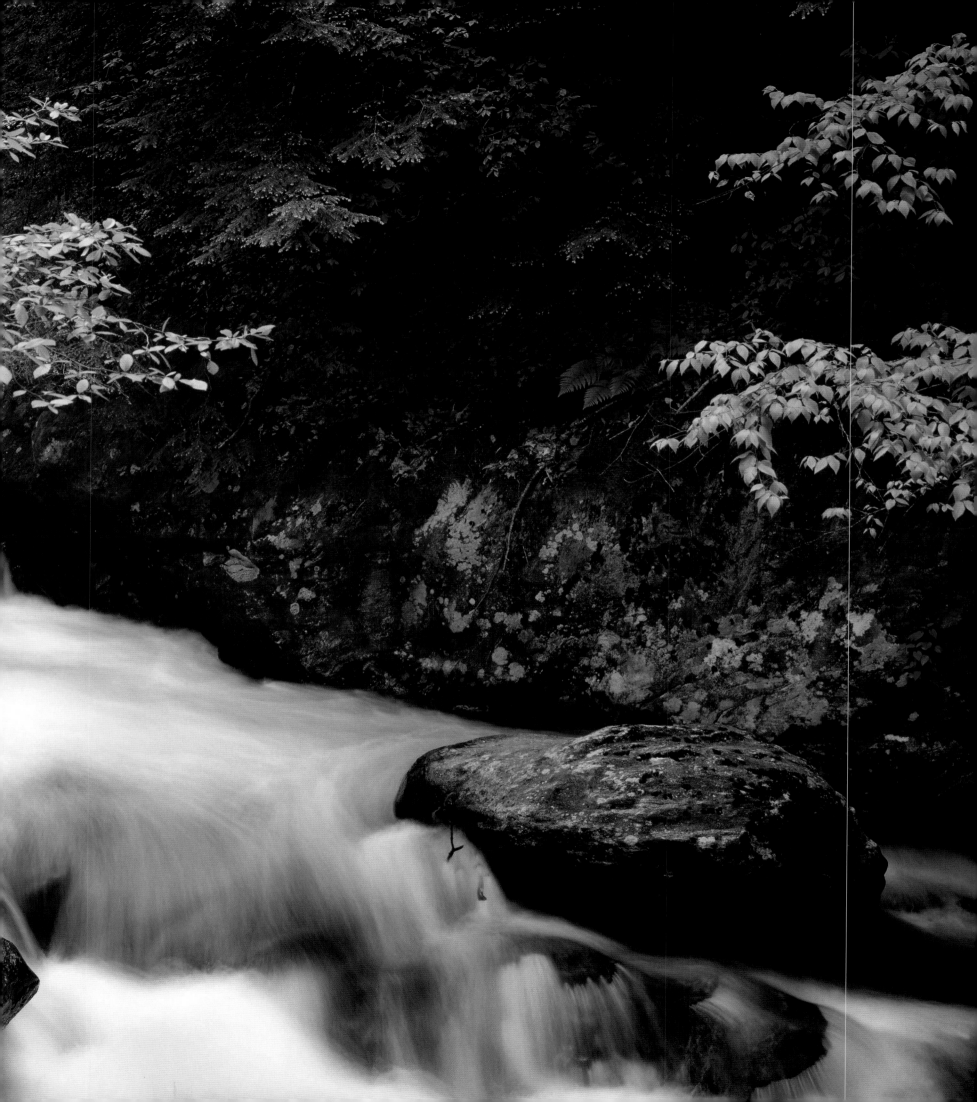

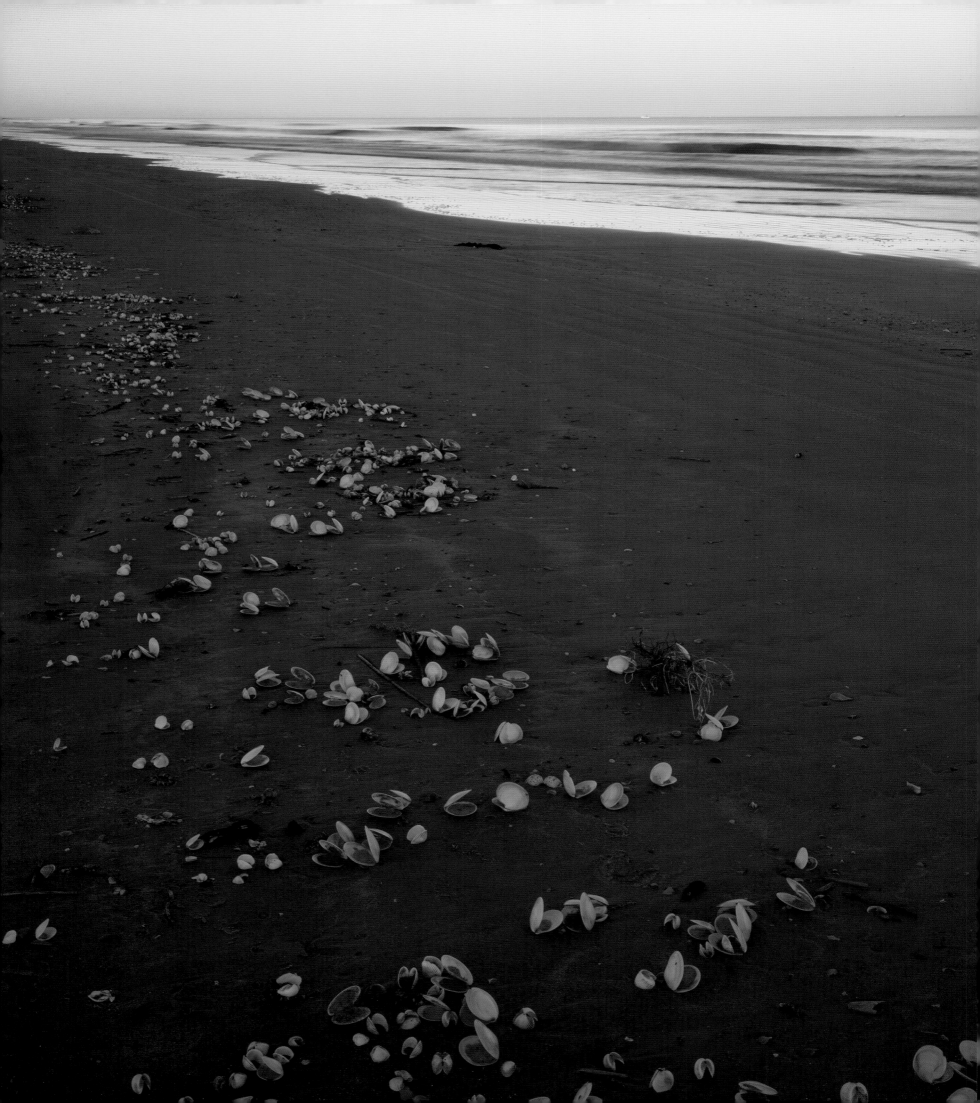

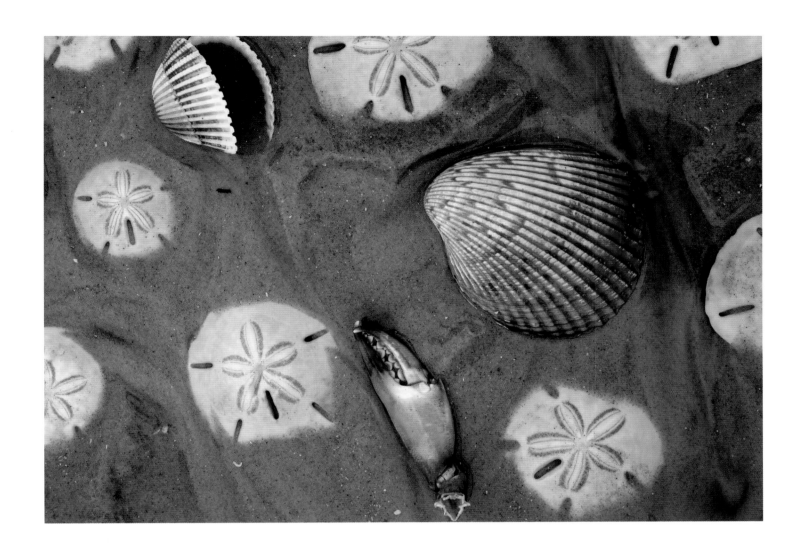

Above: Held captive by wet sand, a group of sand dollars frame this intimate beach scene with cockle shells and the remnants of a blue crab. JAMES RANDKLEV

Left: Fading light on the frozen surface of Lake Mabry announces a cold January night in Roswell.
ROBB HELFRICK

Facing page: Seashells in an array of colors dot the beaches of Cumberland Island National Seashore.
JAMES RANDKLEV

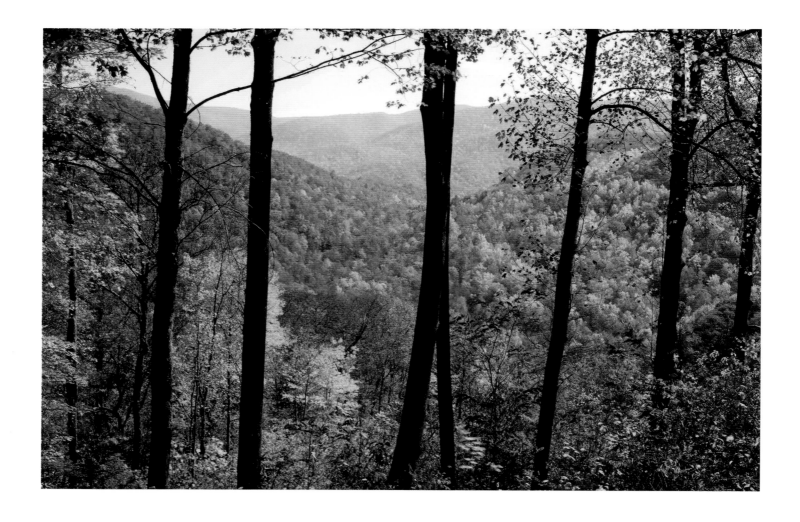

Above: Near the summit of Brasstown Bald, Georgia's highest peak, autumn is evident in all directions. JAMES RANDKLEV

Right: The Hay House is a grand home in Macon, built in the Italian Renaissance Revival style. ROBB HELFRICK

Facing page: Vogel is one of Georgia's oldest and most beloved state parks. Within this mountainous retreat, one can hike, swim, camp, or simply enjoy an autumn view of Trahlyta Falls. ROBB HELFRICK

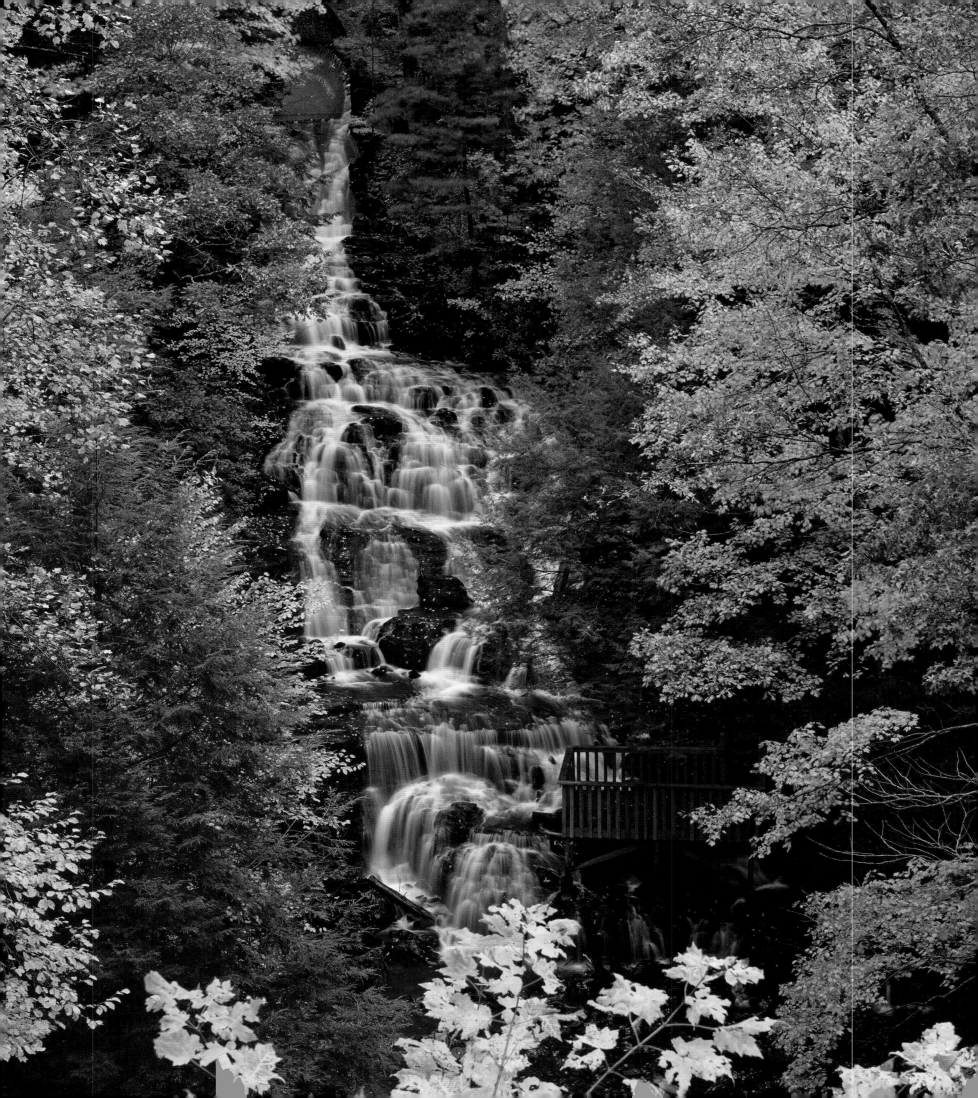

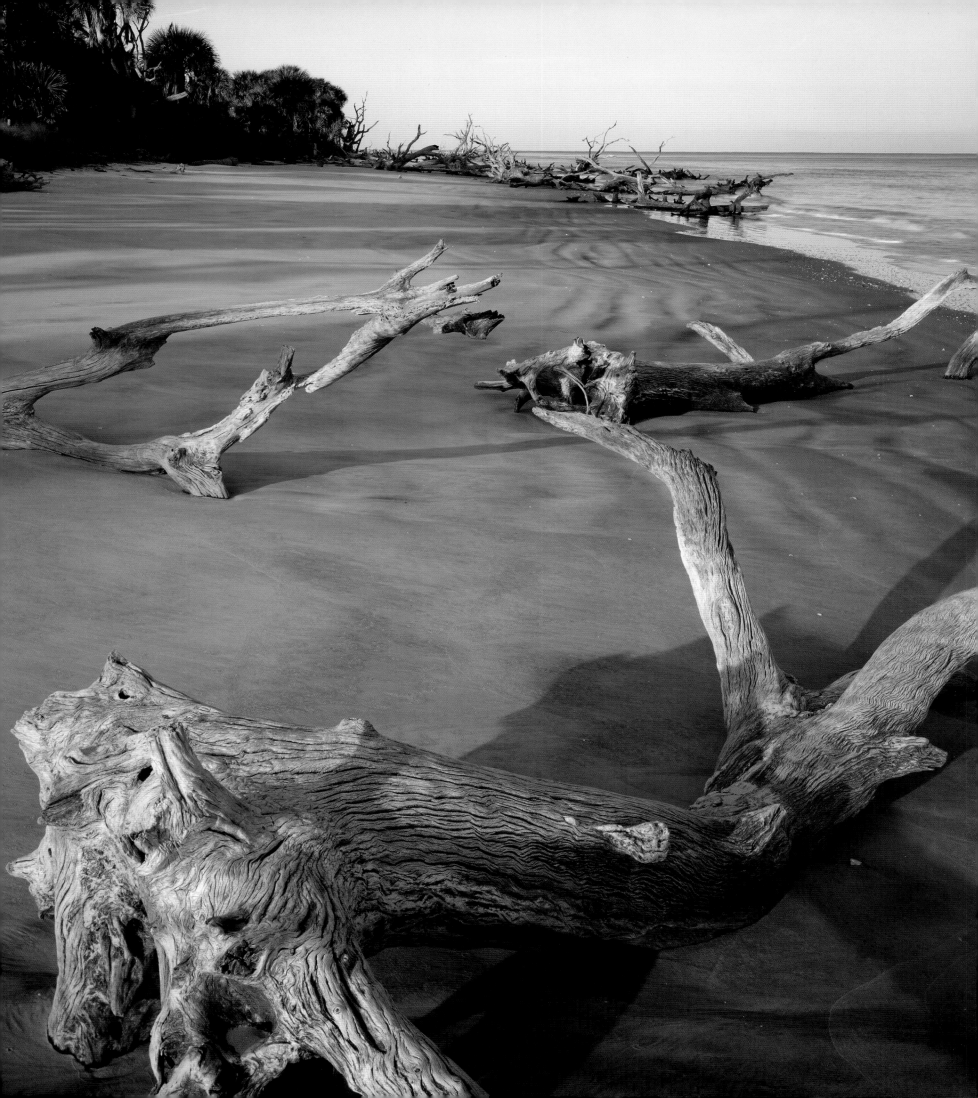

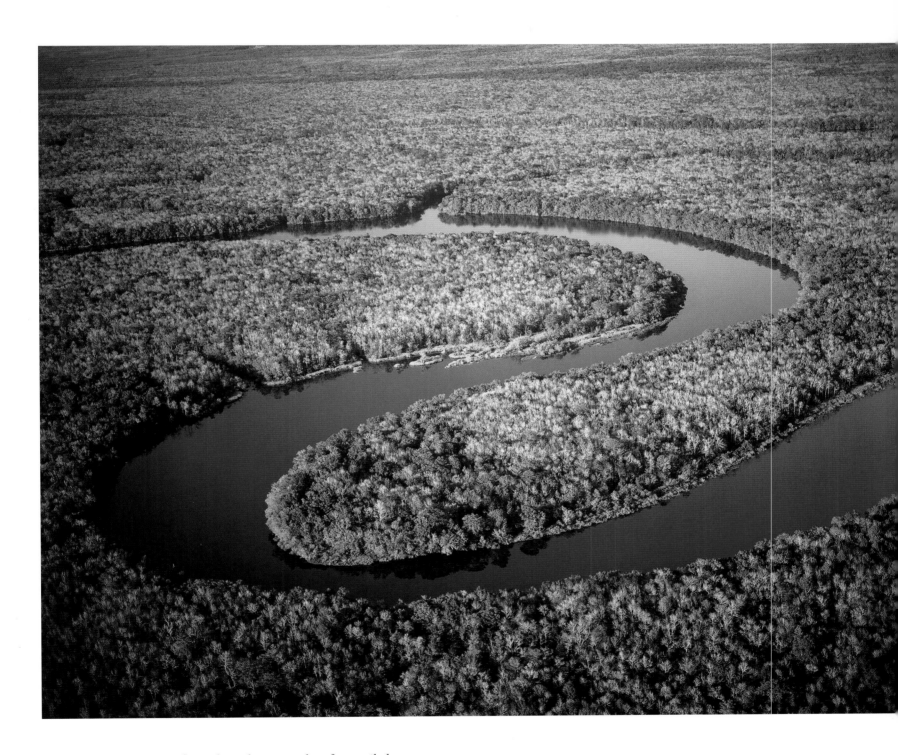

Above: The Altamaha River flows through many miles of unspoiled cypress swamps on its journey to the Atlantic. JAMES RANDKLEV

Facing page: Due to erosion from prevailing currents and winds, St. Catherines Island is moving southward at a slow but steady pace. These trees are the weathered victims of that constant movement. JAMES RANDKLEV

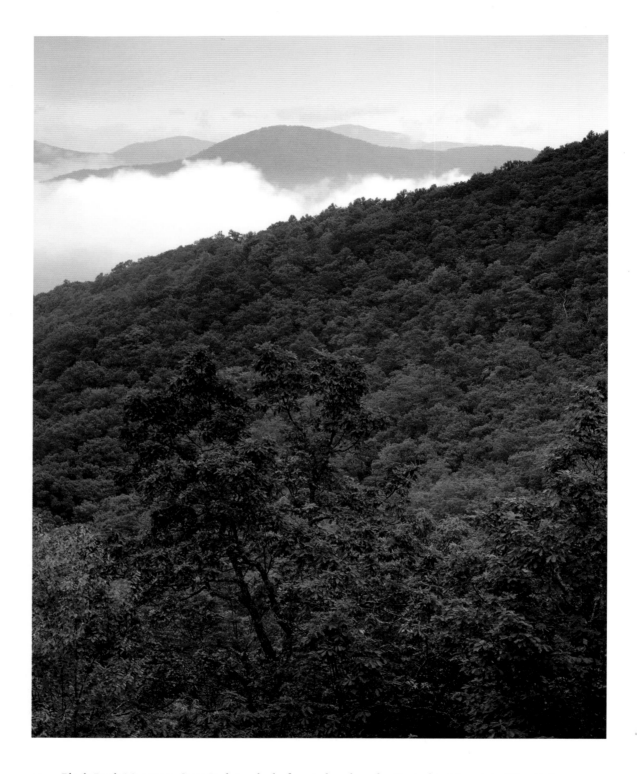

Above: Black Rock Mountain State Park is a lush, forested park aptly situated in Mountain City. At the summit of the 3,640-foot-tall namesake mountain—the highest point in any Georgia state park—visitors can experience stunning eighty-mile vistas. JAMES RANDKLEV

Right: This gristmill was moved to Stone Mountain Park in 1965 from its original site in Ellijay, Georgia. JAMES RANDKLEV

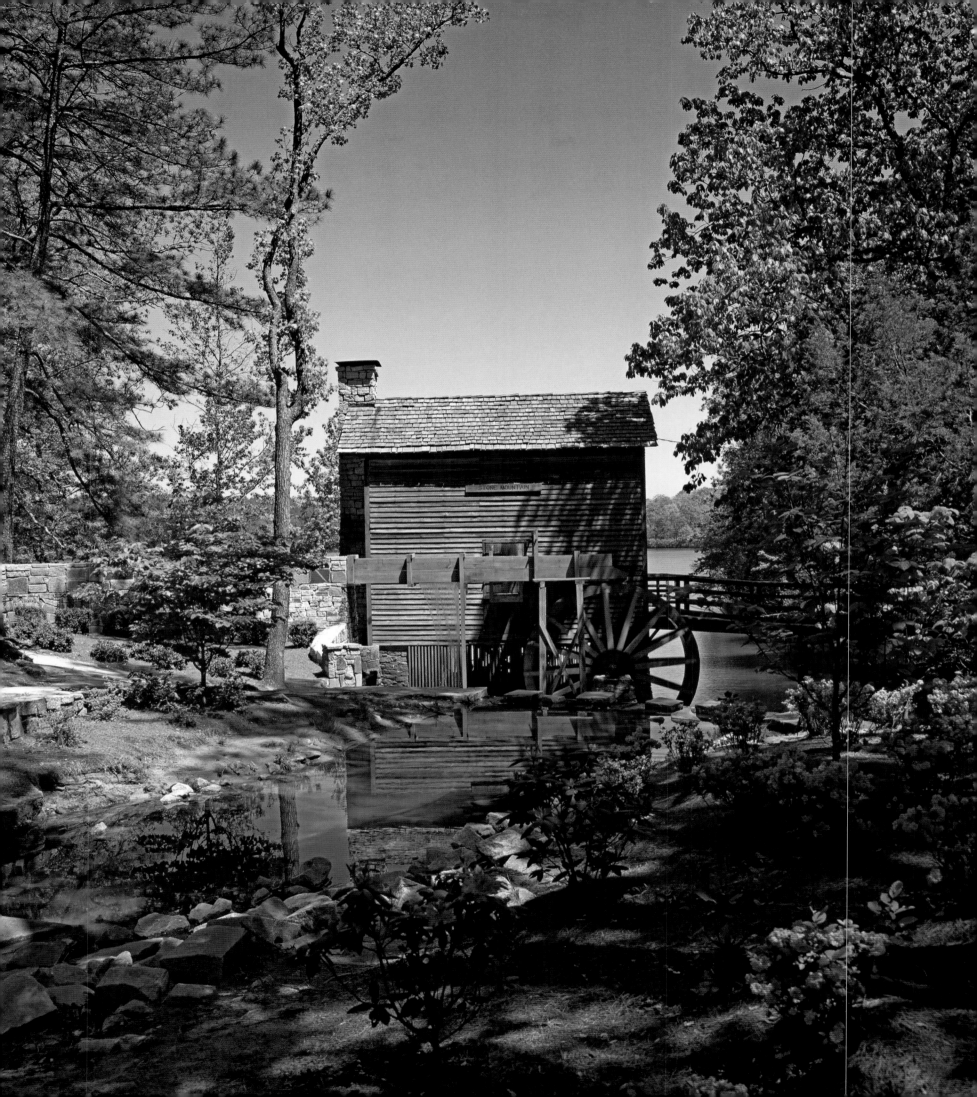

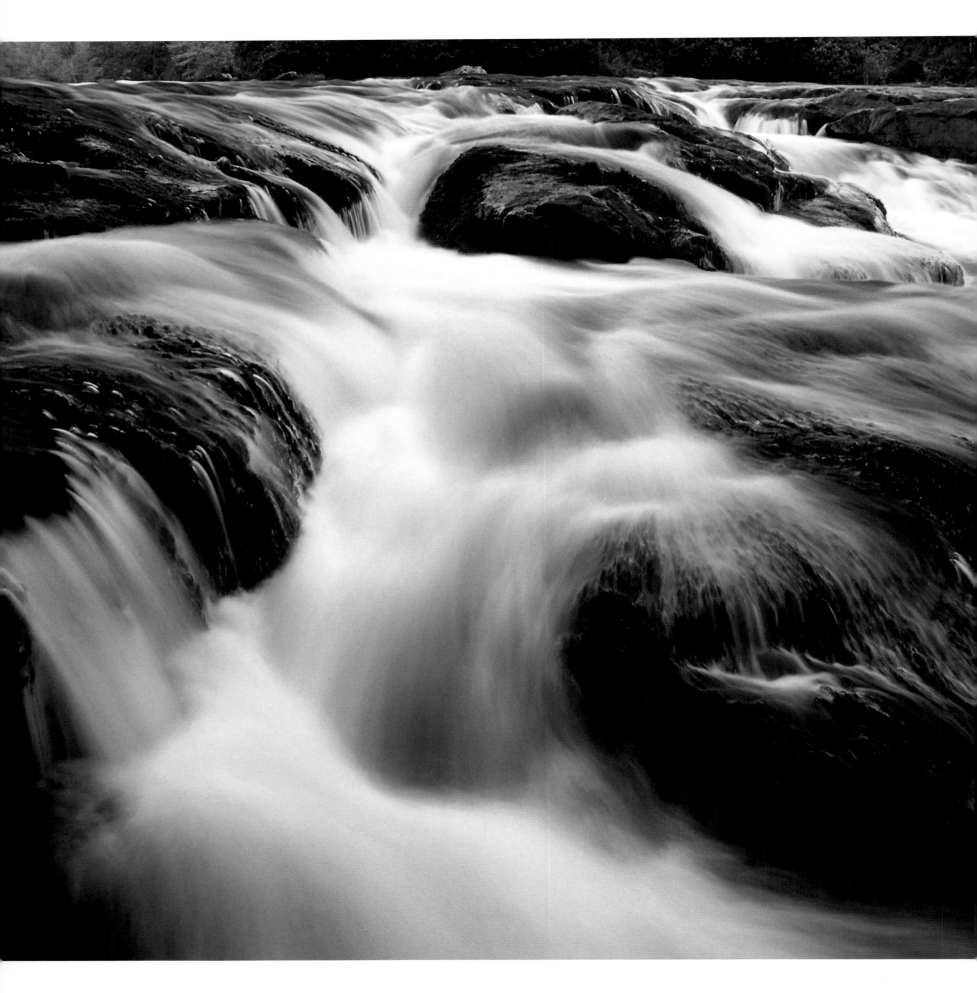

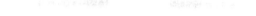

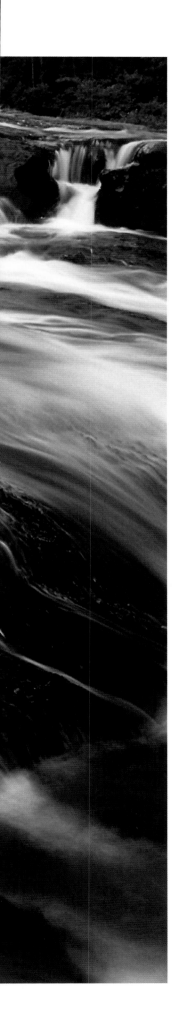

Left: Mix freezing temperatures and the watery mist from a cold mountain creek, and often the result is a naturally created winter work of art. JAMES RANDKLEV

Far left: For most of its length, the Alcovy River flows in a passive and peaceful manner. At this shoal near Covington, however, the river roars with a more spirited personality. ROBB HELFRICK

Below: This Greek Revival home in Athens is known as the President's House, since it housed University of Georgia presidents. Benjamin Harvey Hill, a former U.S. senator, built the house in 1856. ROBB HELFRICK

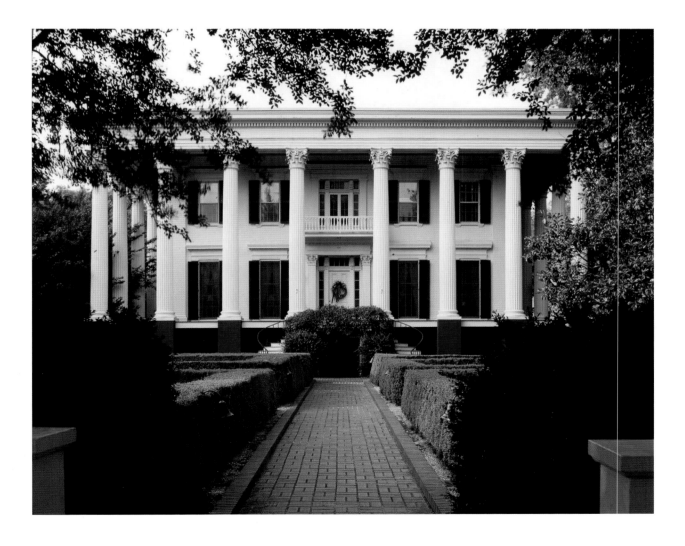

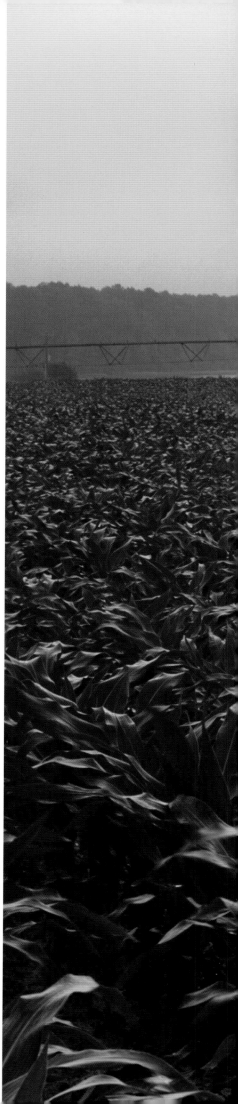

Above: The stone figure atop a Confederate monument in Gainesville remains ready for battle. ROBB HELFRICK

Right: The three Ps (peaches, pecans, and peanuts) aren't the only major crops grown in the state. This cornfield near Montezuma is a testament to the variety of crops produced by hardworking central and southern Georgia farmers. ROBB HELFRICK

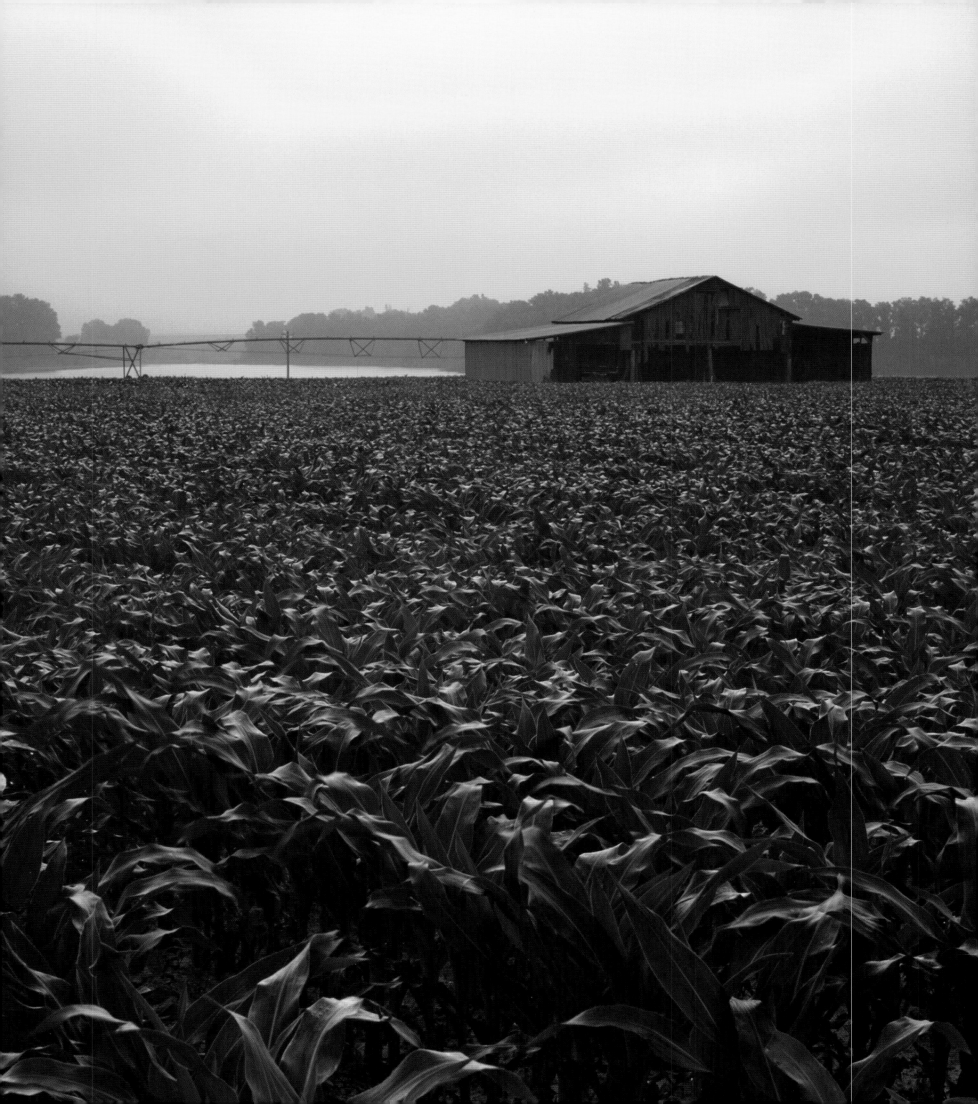

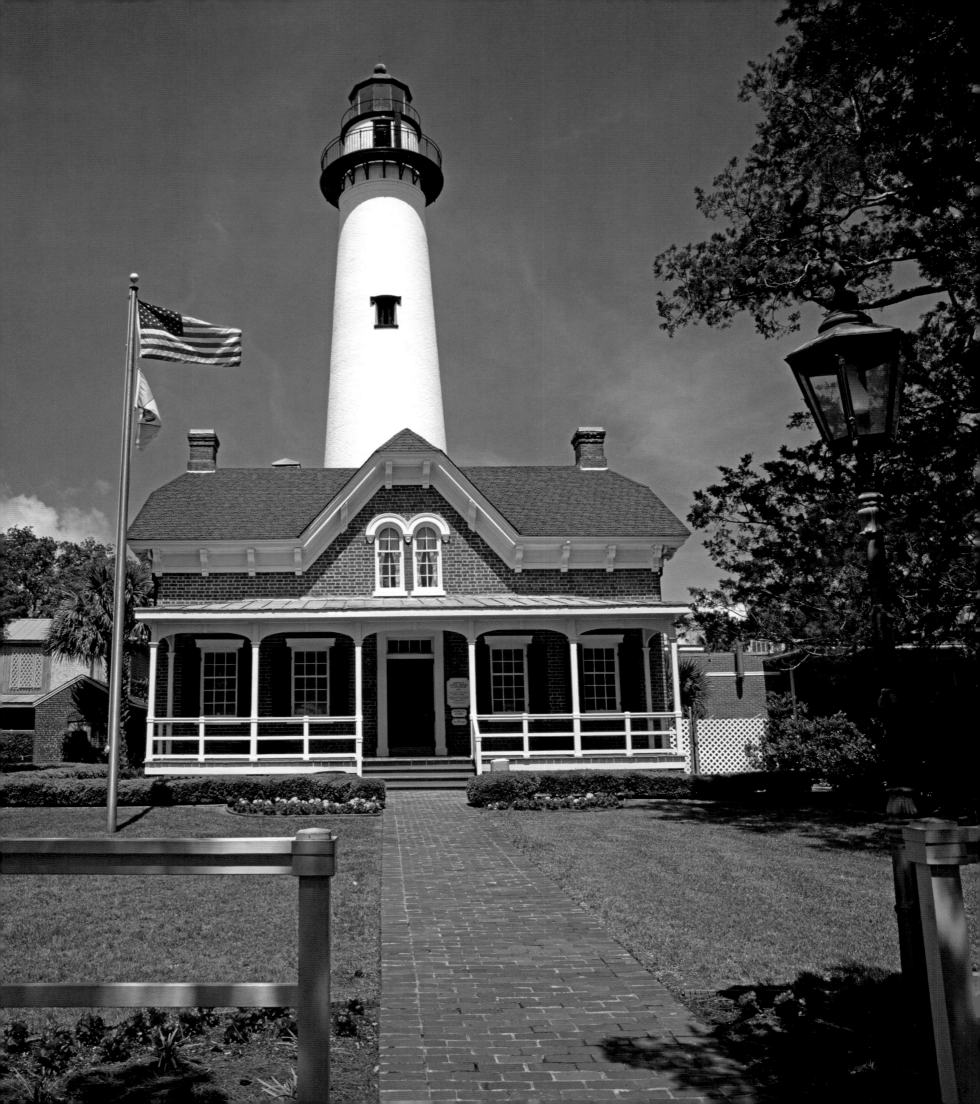

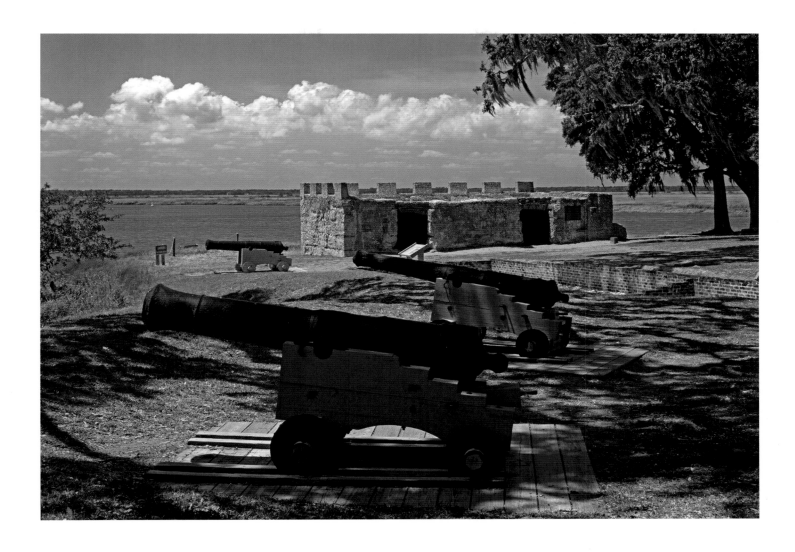

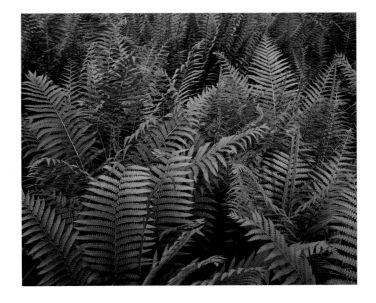

Above: Fort Frederica National Monument interprets the 1742 battle between British and Spanish forces. The British victory ensured that Georgia would be their colony.
JAMES RANDKLEV

Left: The rusty color of the fertile spore-bearing fronds on the cinnamon fern give the species its name. JAMES RANDKLEV

Facing page: In the charming seaside village of St. Simons Island, this is the second lighthouse to beam over the southern tip of the isle. The current structure, built west of the original 1810 original site, dates back to 1872.
JAMES RANDKLEV

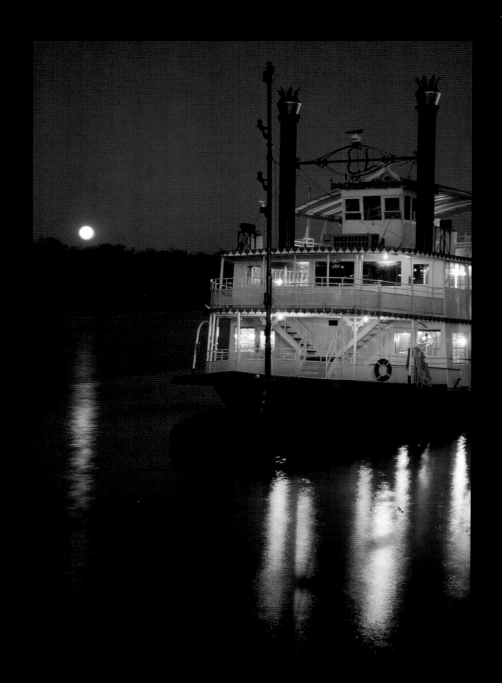

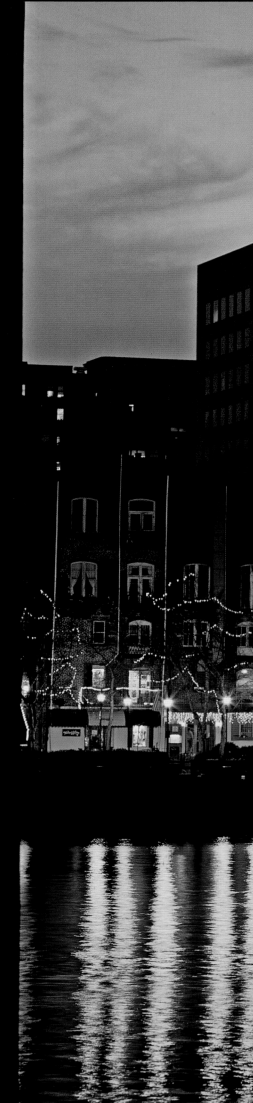

Above: At rest in the moonlight, a Savannah riverboat is a nostalgic sight on an evening stroll along River Street. ROBB HELFRICK

Right: Savannah was built on a bluff above the Savannah River in 1733. Today the waterfront is a thriving destination for entertainment, shopping, and hospitality. ROBB HELFRICK

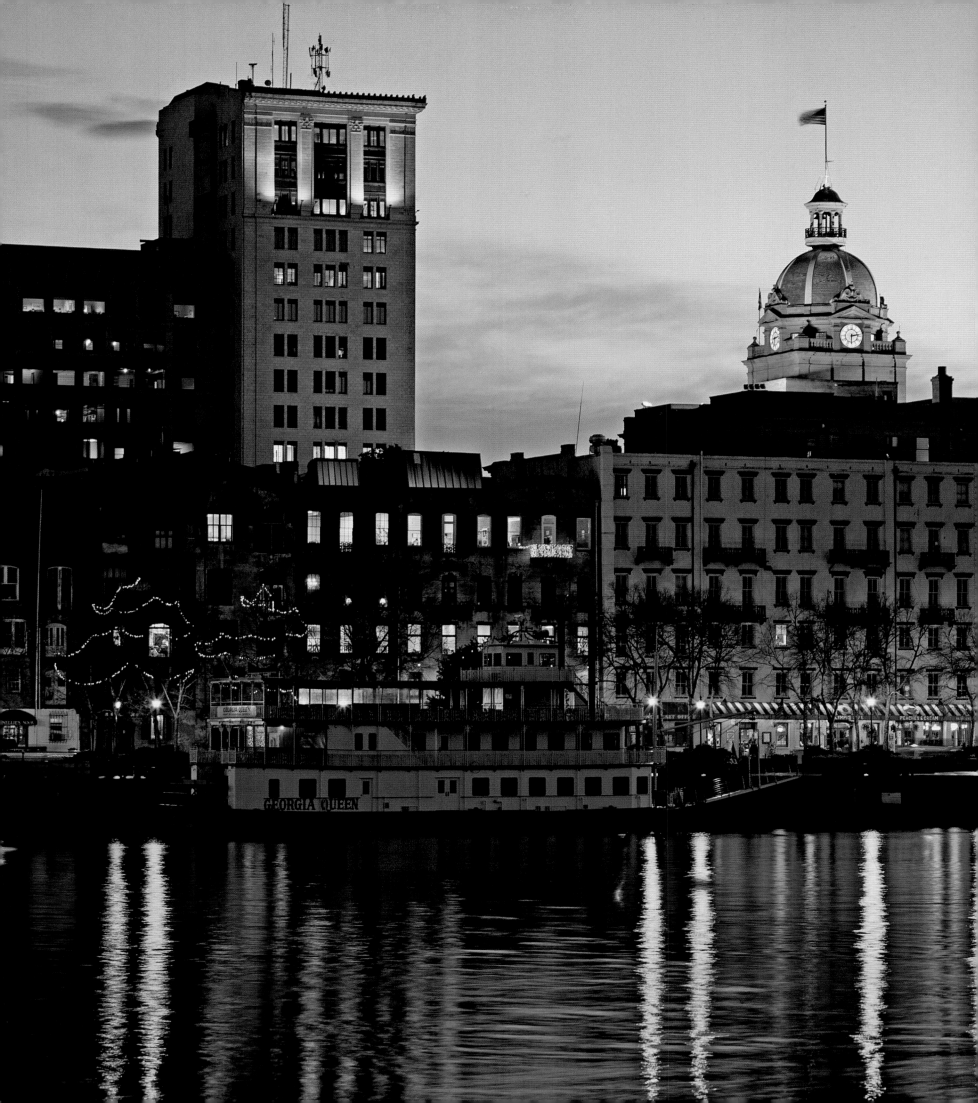

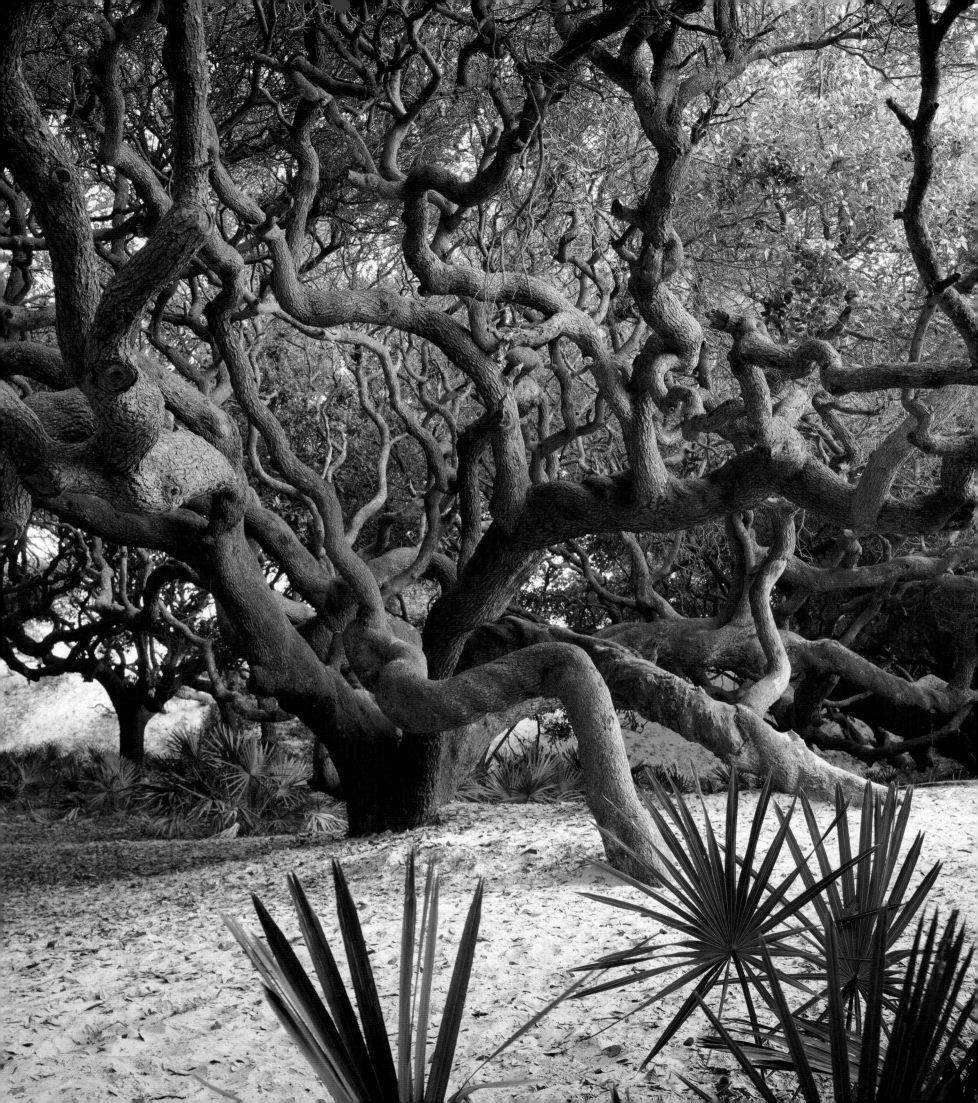

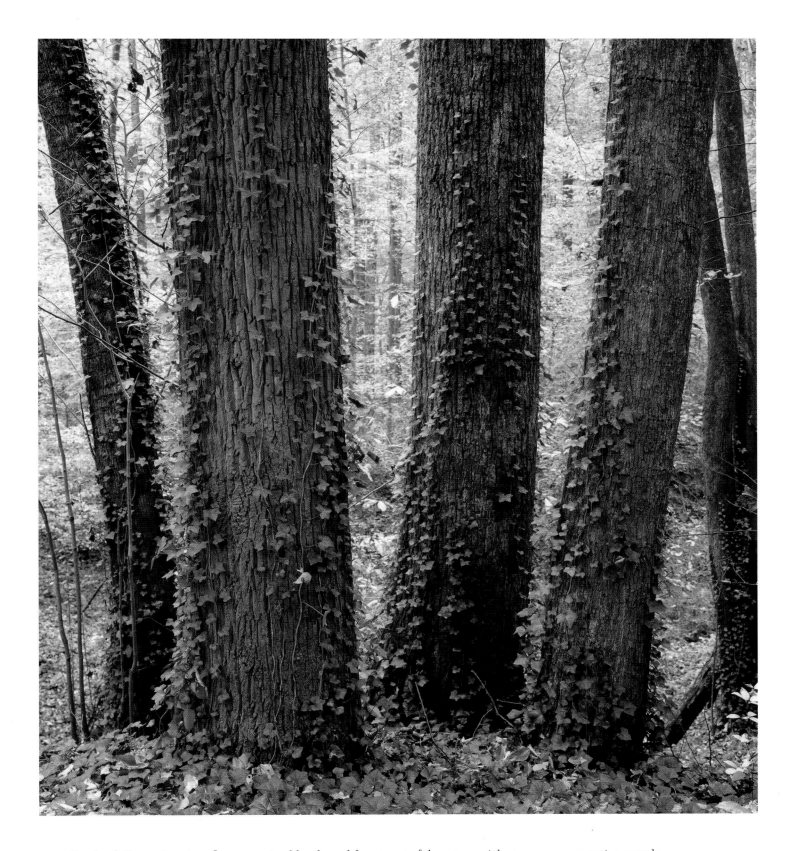

Above: Fernbank Forest is a sixty-five-acre mixed hardwood forest east of downtown Atlanta—a representative sample of what an undisturbed Piedmont forest should look like. JAMES RANDKLEV

Facing page: On Cumberland Island, the twisting and graceful limbs of Georgia's state tree are a reminder of its amazing durability and strength. Live oak trees measure their life spans in centuries, not single years. JAMES RANDKLEV

Right: Sea oats are silhouetted in the early-morning sun on the dunes of Cumberland Island. JAMES RANDKLEV

Below: The Georgia Aquarium in downtown Atlanta is an architectural marvel. Seen from the second-largest viewing window in the world, the Ocean Voyager tank exhibits the world's largest fish, the whale shark, as well as almost 100,000 other fish. ROBB HELFRICK

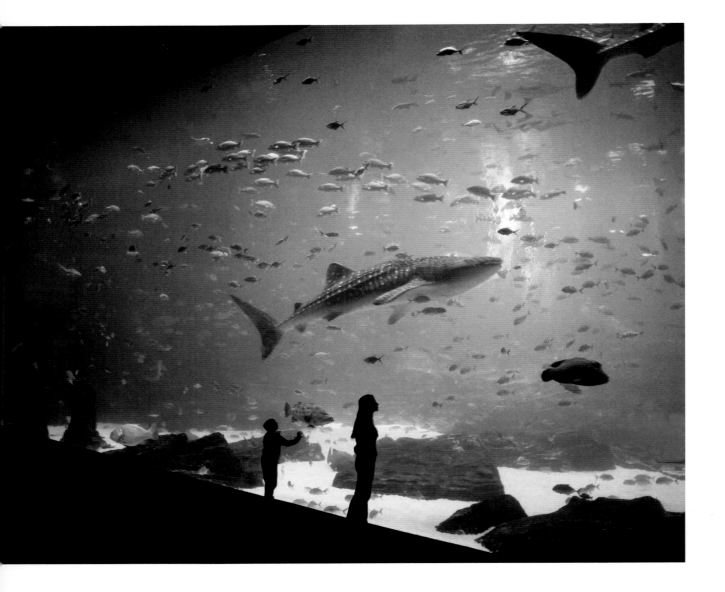

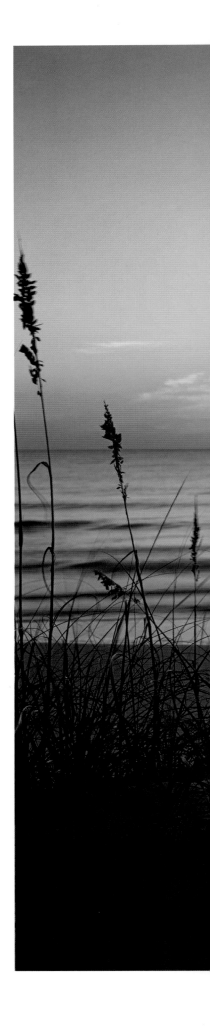

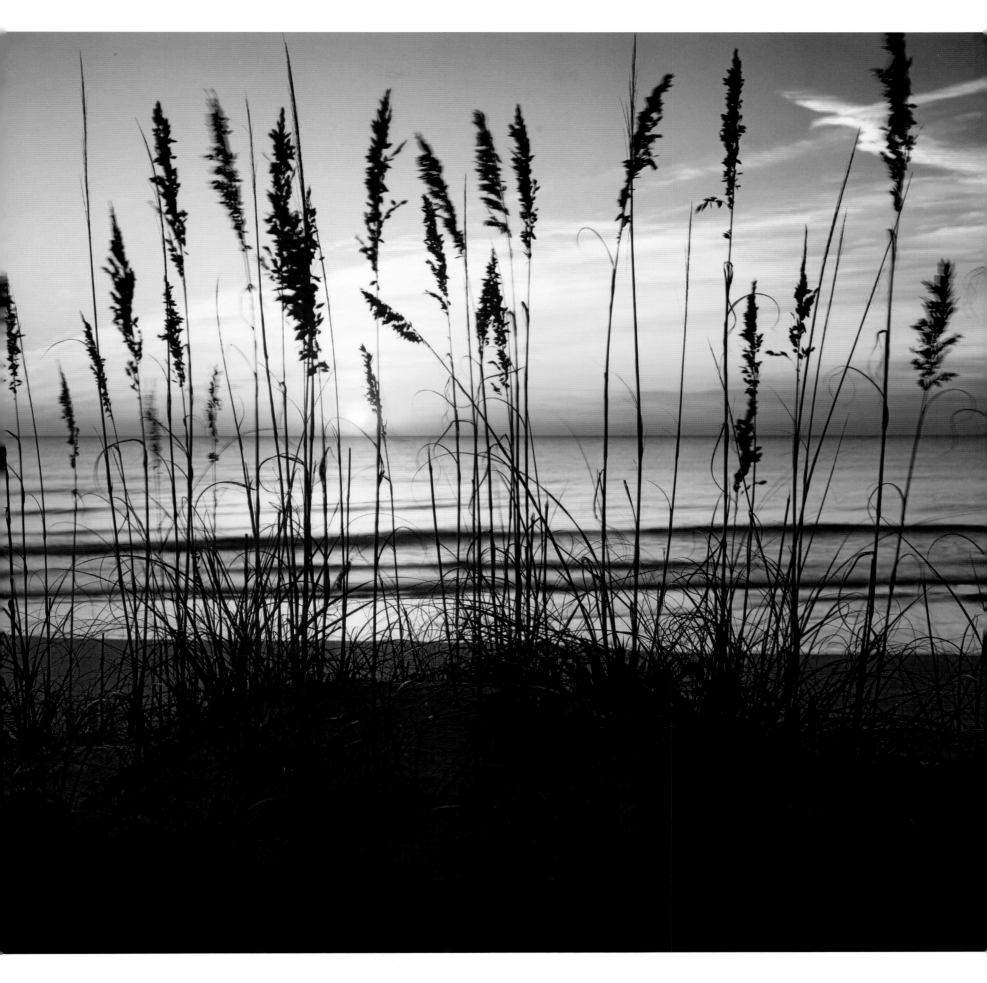

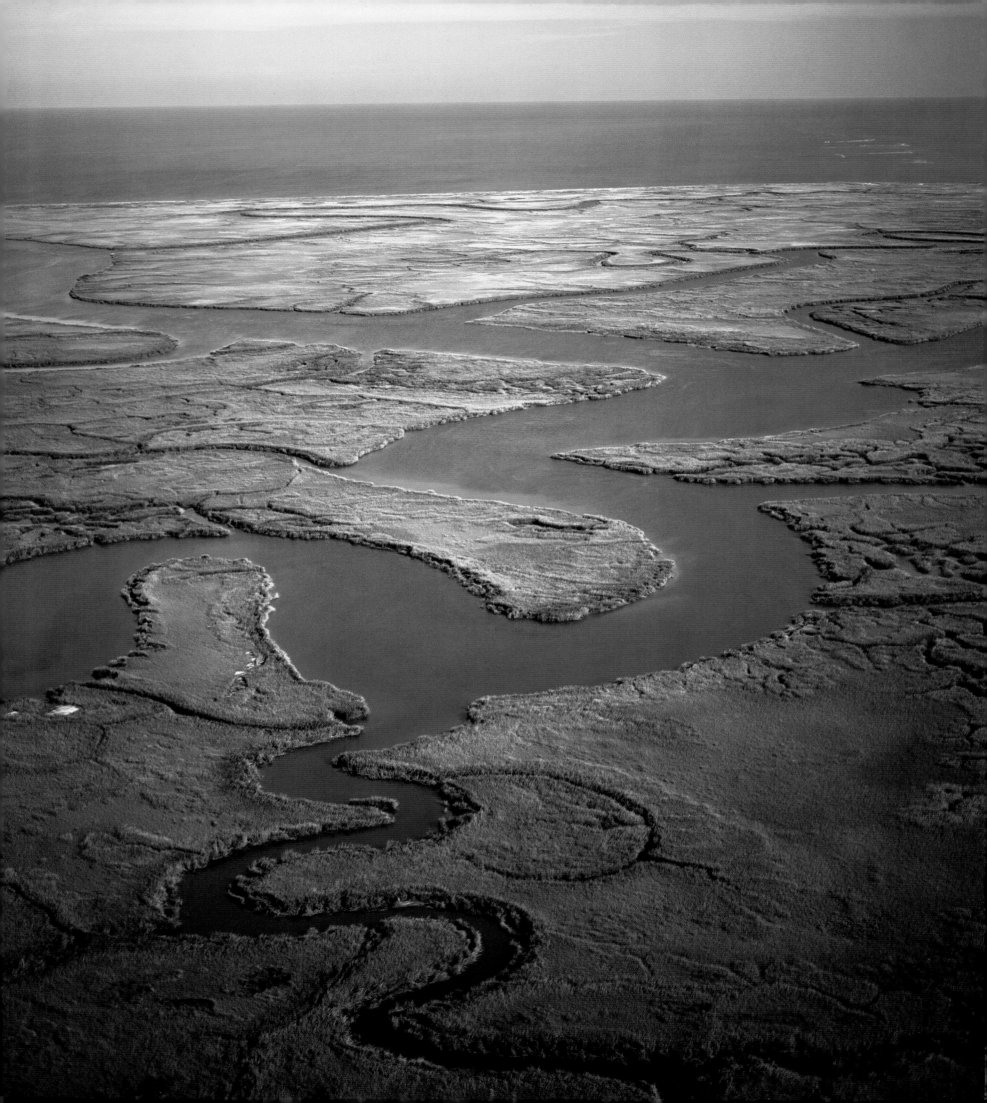

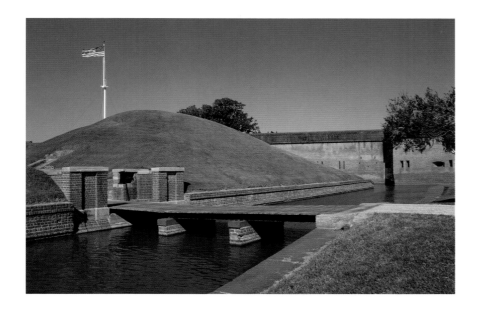

Left: Fort Pulaski marked a turning point in military history when masonry fortifications were rendered practically obsolete by new technological weapons like the rifled cannon. JAMES RANDKLEV

Facing page: Seen from the air, the intricate patterns of Georgia's coastal marshes and tidal creeks are a study in the complexity and beauty of natural environments. JAMES RANDKLEV

Below: Ocmulgee National Monument interprets the relationship between people and natural resources. These mounds remain as a testament to over 17,000 years of constant human habitation and history in Georgia. ROBB HELFRICK

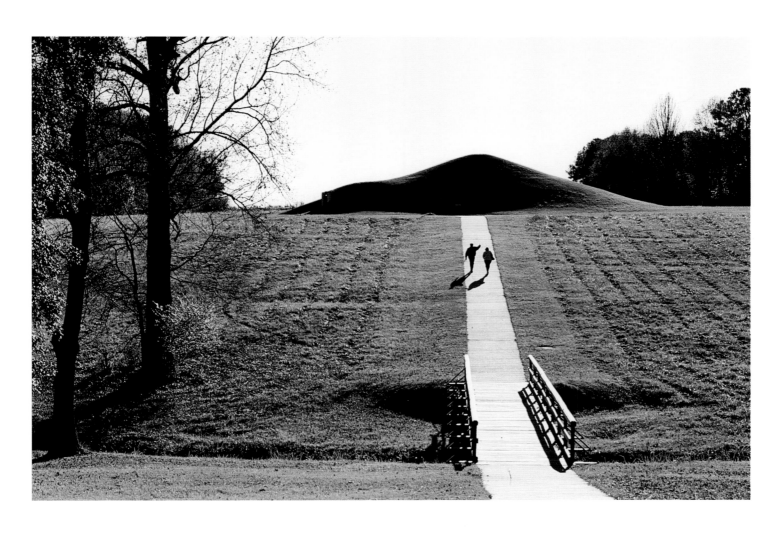

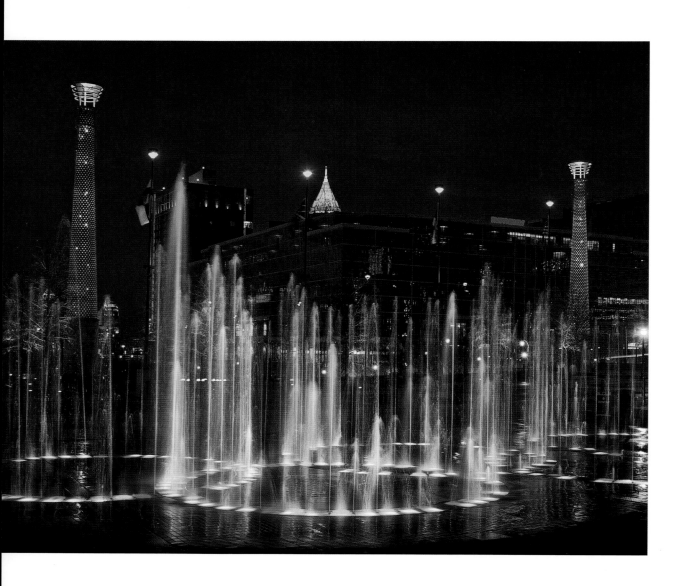

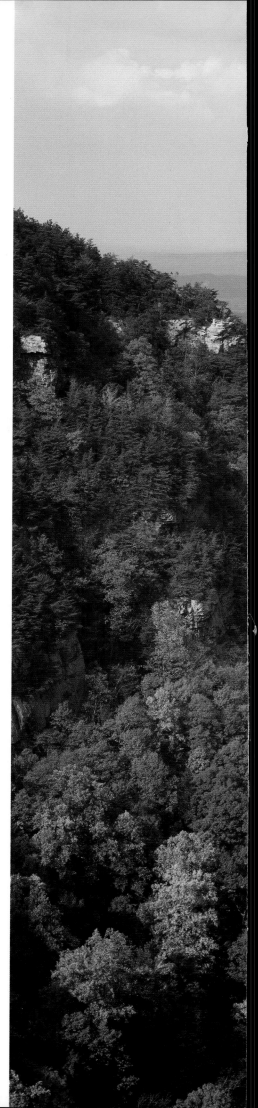

Above: Centennial Olympic Park is home to the Fountain of Rings, which commemorates Atlanta's hosting of the 1996 Summer Olympic Games. ROBB HELFRICK

Right: Cloudland Canyon, located in the northwest corner of Georgia, display's its marvelous fall colors. JAMES RANDKLEV

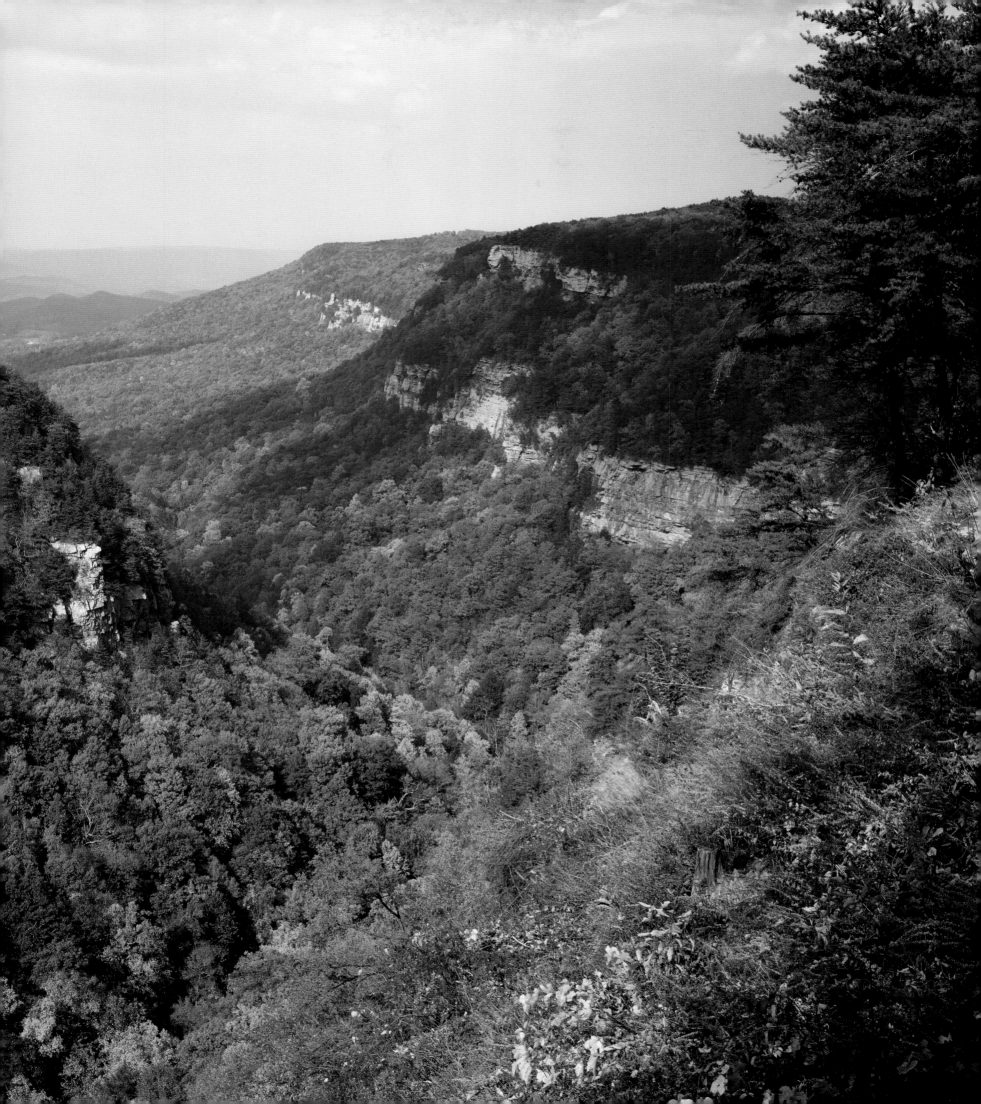

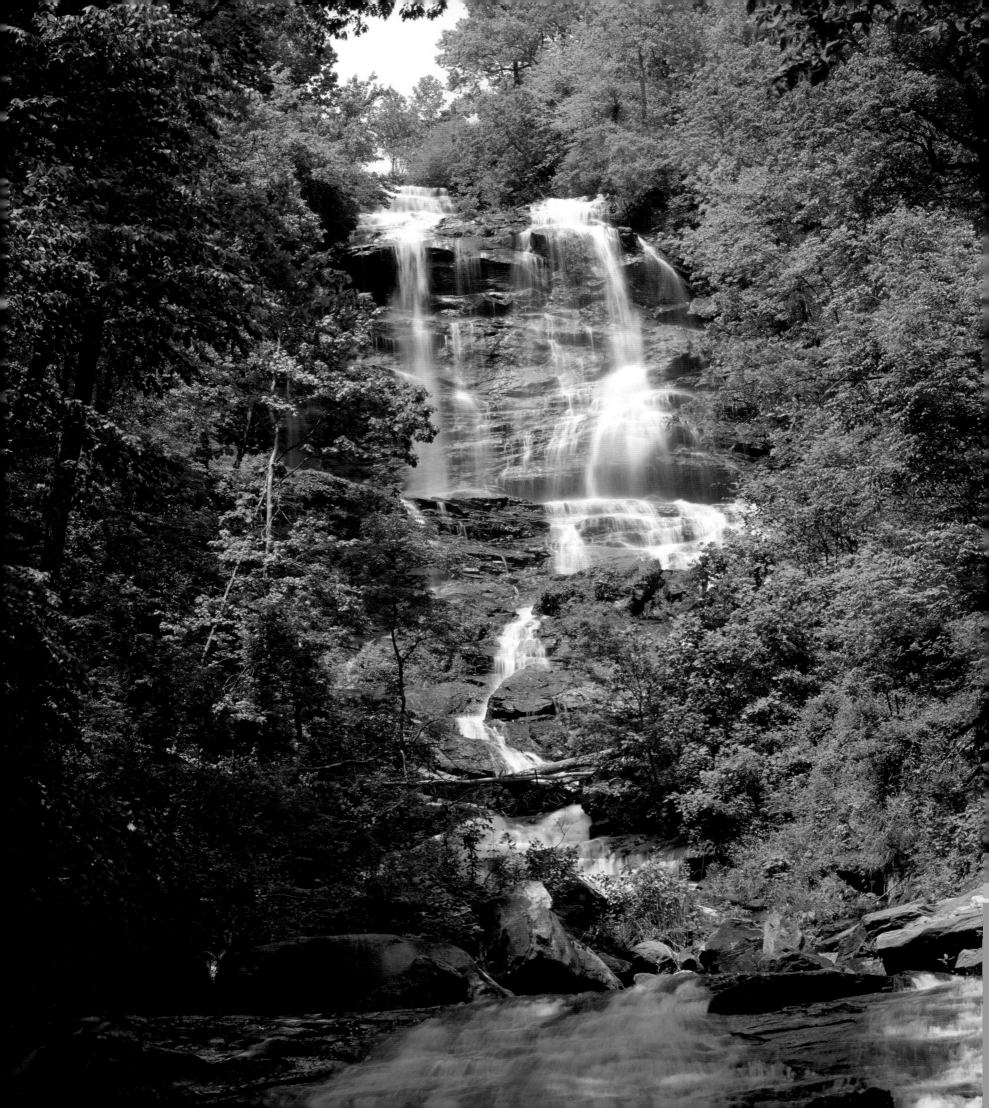

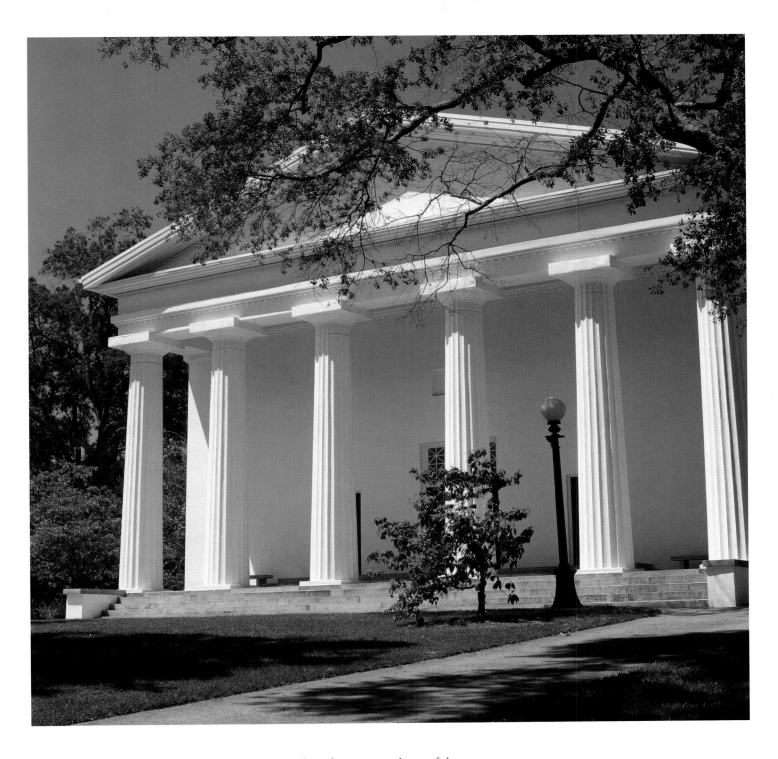

Above: The Chapel at the University of Georgia in Athens has remained one of the most popular landmarks on the campus green since its construction in 1832. JAMES RANDKLEV

Facing page: Georgia's most visited and perhaps most inspiring falls is Amicalola. It impresses with a 729-foot tumbling drop and is the highest waterfall in Georgia. JAMES RANDKLEV

Above: Seen from Monterey Square, a live oak frames a classic Savannah scene. ROBB HELFRICK

Right: This dune swale on Ossabaw Island, now a peaceful meadow stirred by the wind, may once have been home to a plantation field of indigo or cotton. JAMES RANDKLEV

Facing page: Raven Cliffs Wilderness is a premier hiking destination, with numerous trailside cascades along bubbling Dodd Creek. JAMES RANDKLEV

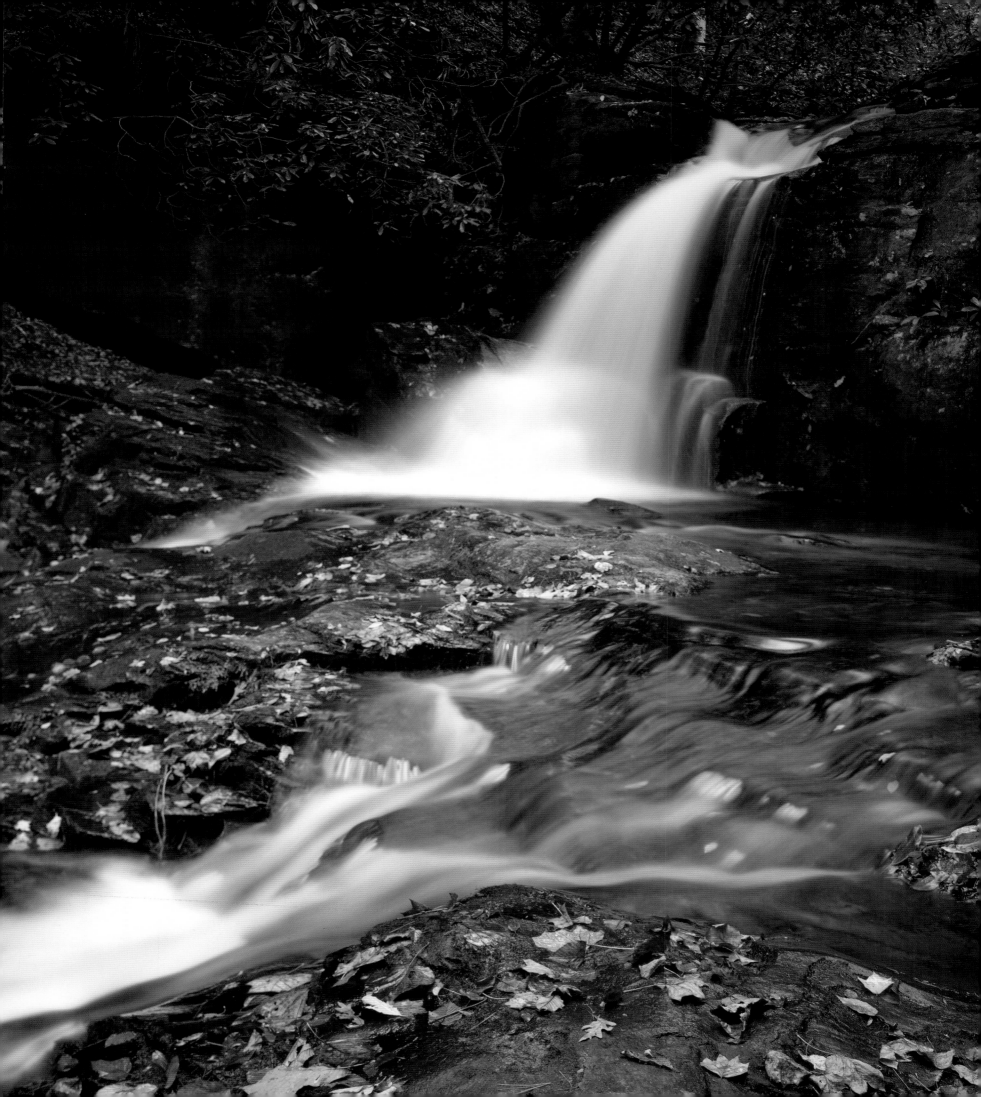

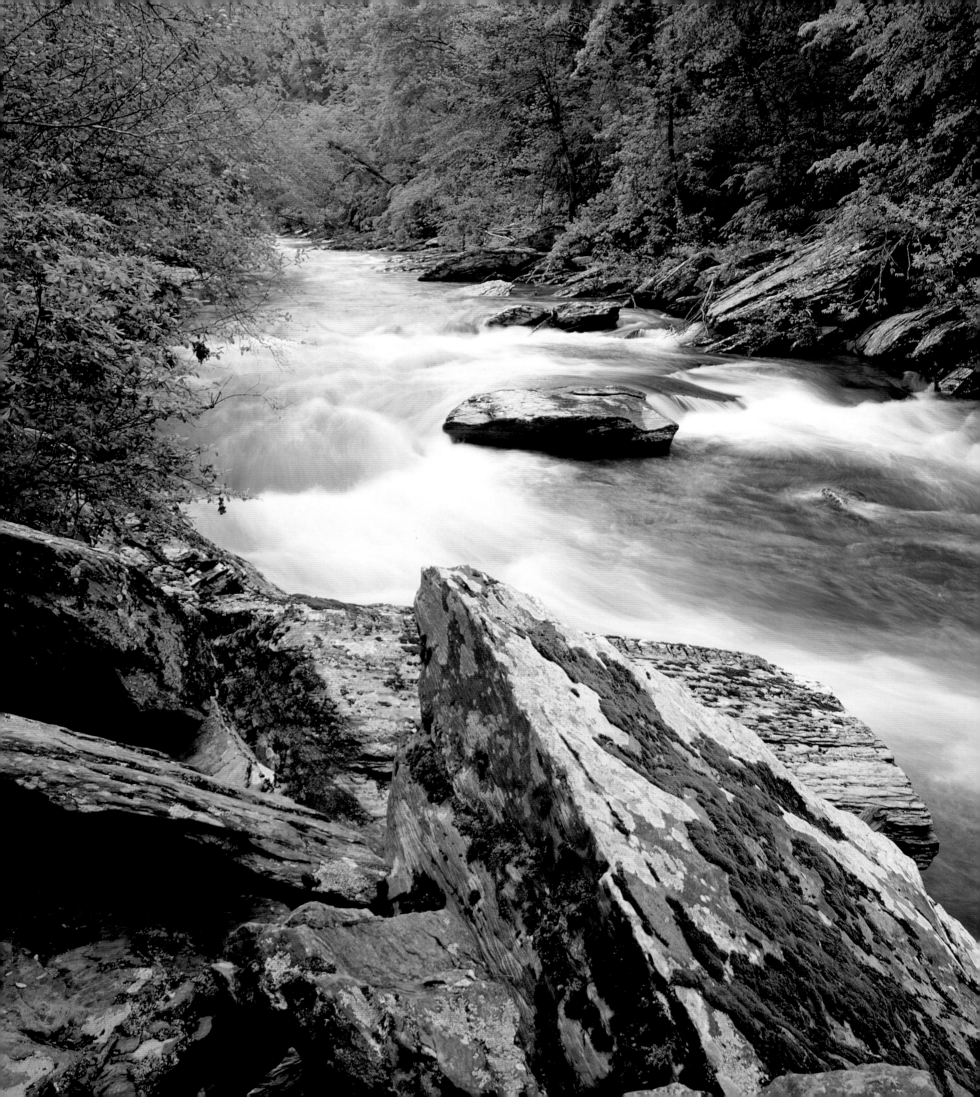

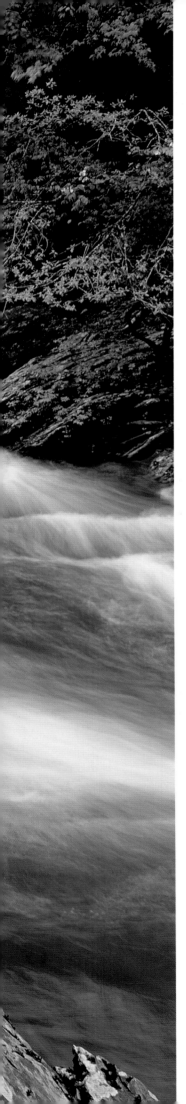

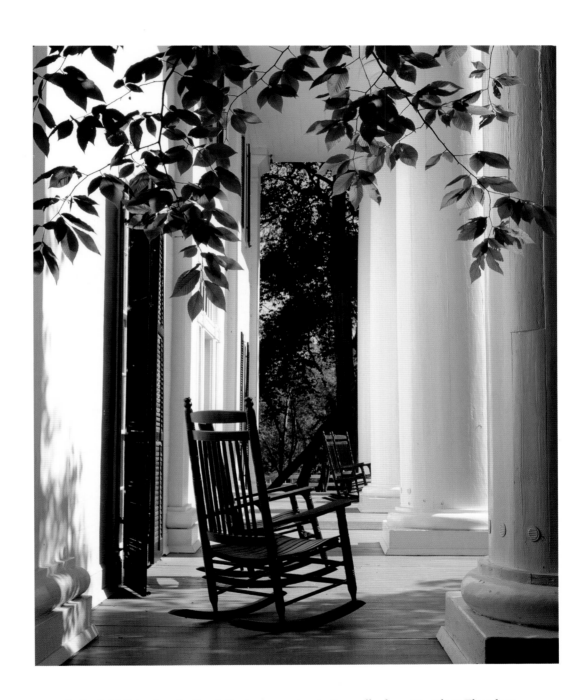

Above: Bulloch Hall is a lovely Greek Revival mansion in Roswell where President Theodore Roosevelt's parents were married in 1853. Those memorable nuptials are still reenacted there every December. JAMES RANDKLEV

Left: The Jacks River is a clear-flowing trout stream in the Cohutta Wilderness that has retained an untamed character along most of its nineteen-mile length. ROBB HELFRICK

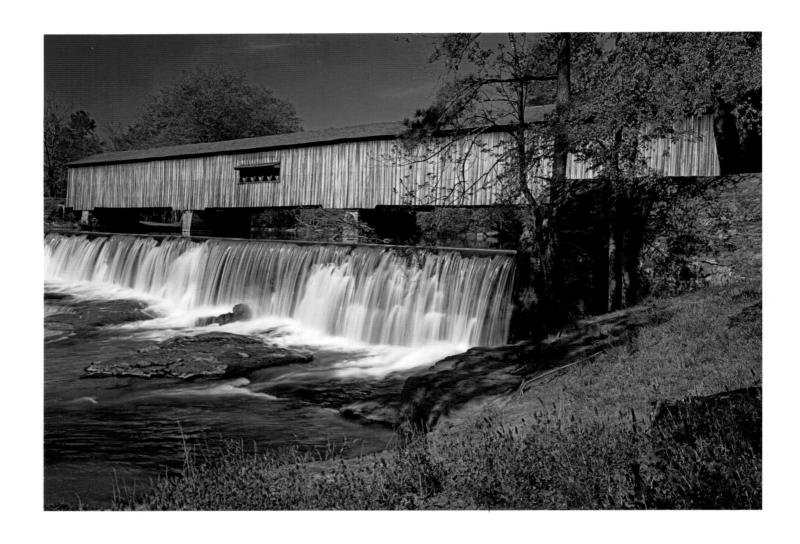

Above: Watson Mill Bridge is the longest covered bridge in the state at 229 feet; the 1885 structure is the centerpiece of a picturesque state park near Comer. JAMES RANDKLEV

Right: White-tailed deer are a familiar sight at Red Top Mountain. ROBB HELFRICK

Facing page: This massive bald cypress seen along Ebenezer Creek may have gained its oversized base due to constant inundation from the coastal waters of this Wild and Scenic River. JAMES RANDKLEV

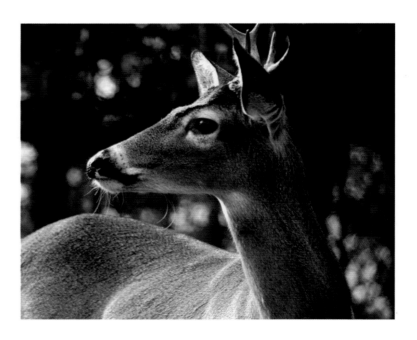

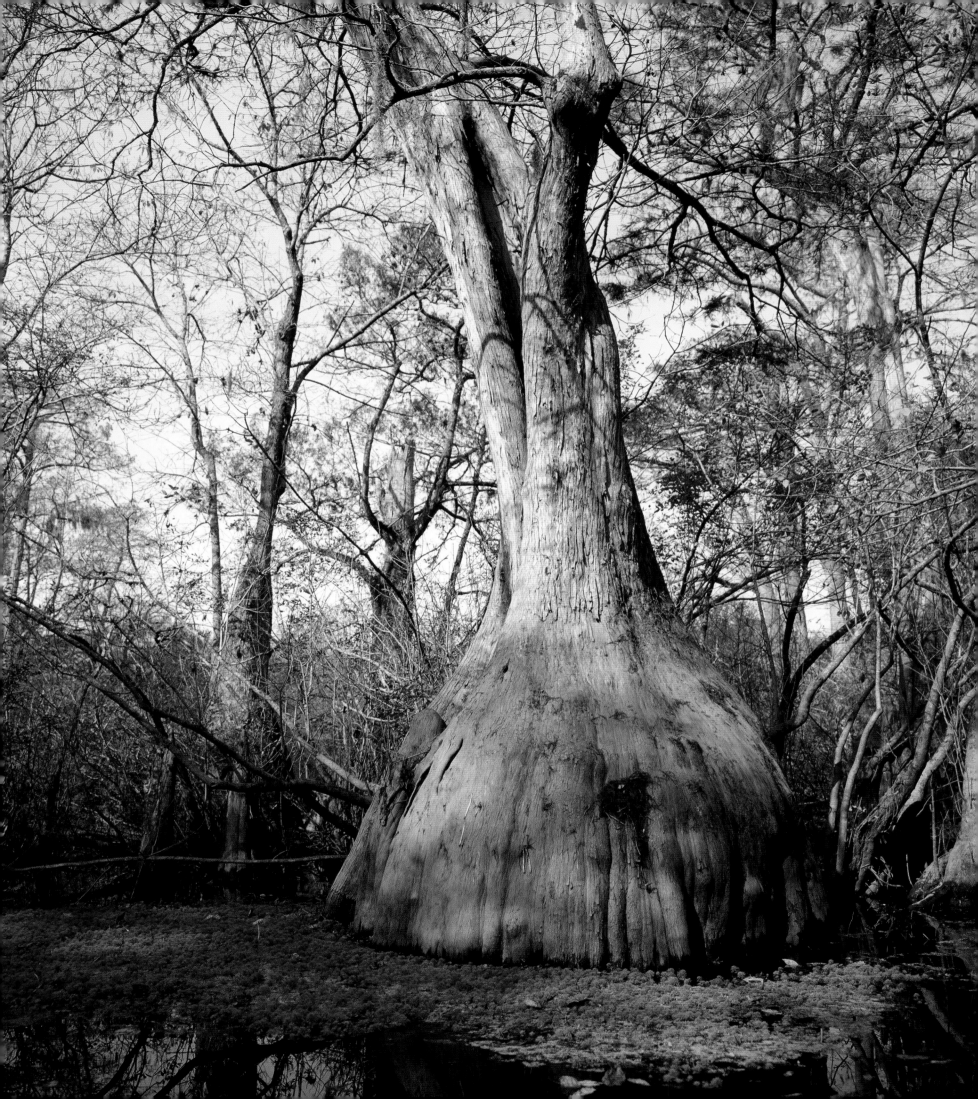

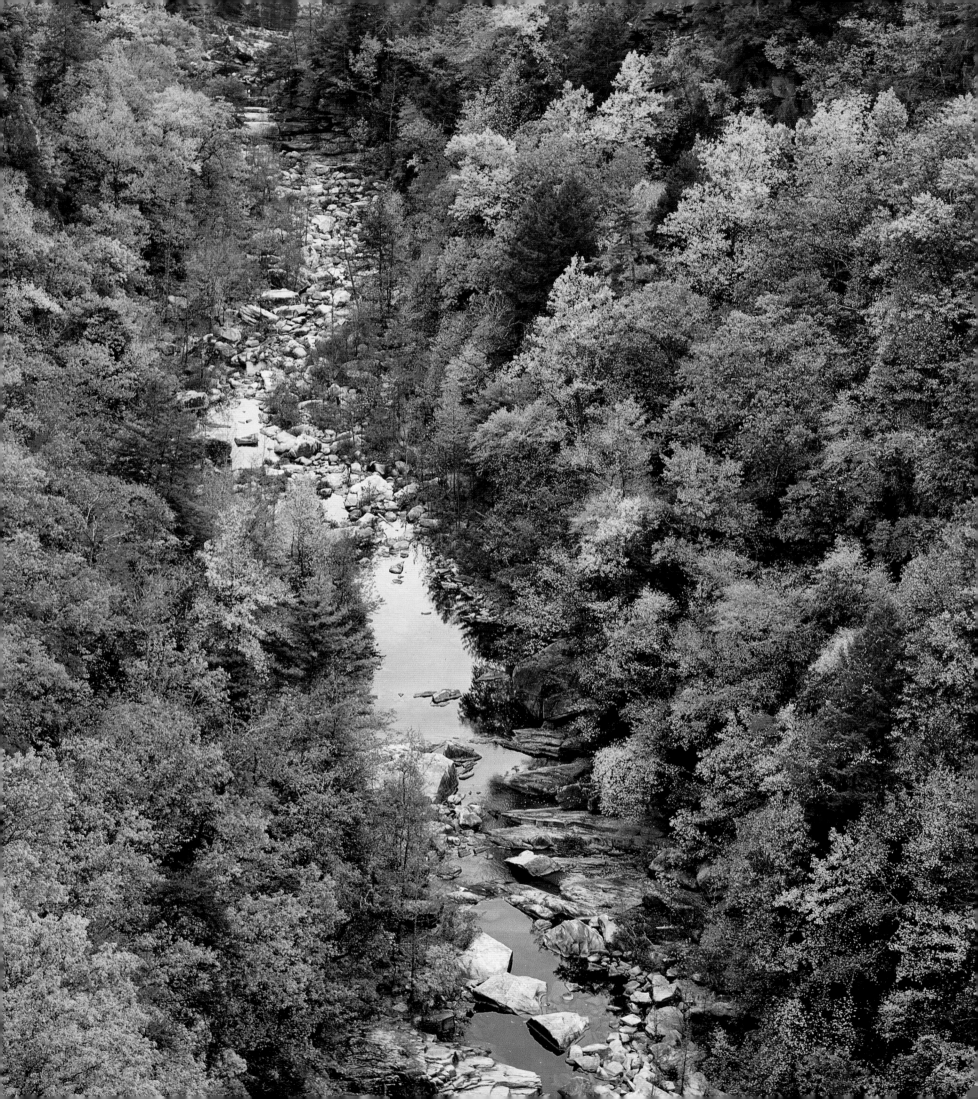

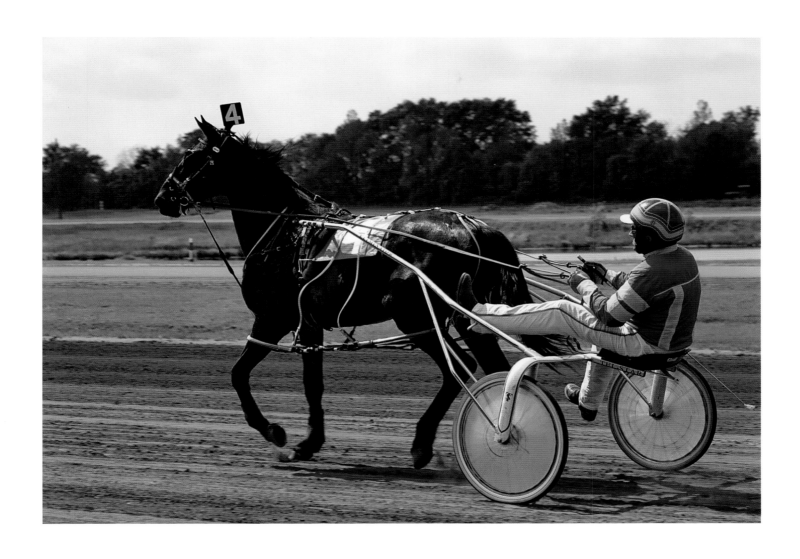

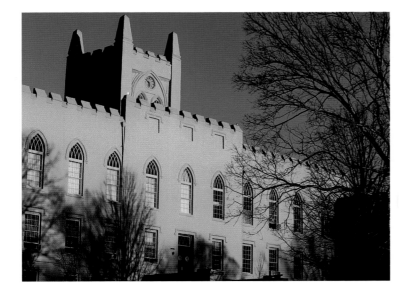

Above: The Hawkinsville Harness Festival saunters into town every spring. ROBB HELFRICK

Left: Before Atlanta was the state capital, Milledgeville was the seat of Georgia government. Seen here is the old State Capitol, now part of the Georgia College campus. ROBB HELFRICK

Facing page: There are few more spectacular sights in Georgia than Tallulah Gorge. Seen here from the north rim, the gorge is nearly 1,000 feet deep and contains some of the most rugged terrain in the Georgia mountains. ROBB HELFRICK

Above: Fallen wisteria blossoms nestle among oak leaves on the rim of Providence Canyon. JAMES RANDKLEV

Facing page: A solitary tree frames a brilliant Lake Seminole sunset. JAMES RANDKLEV

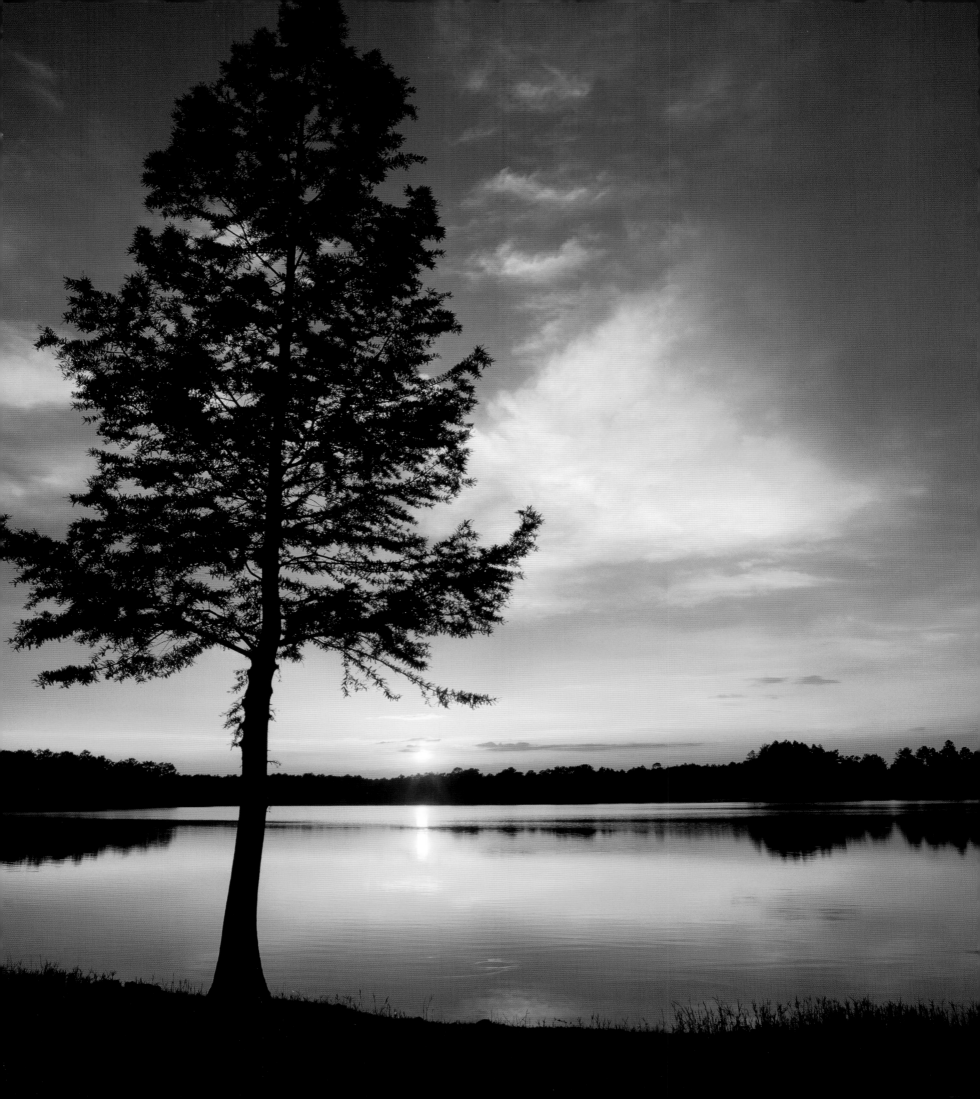

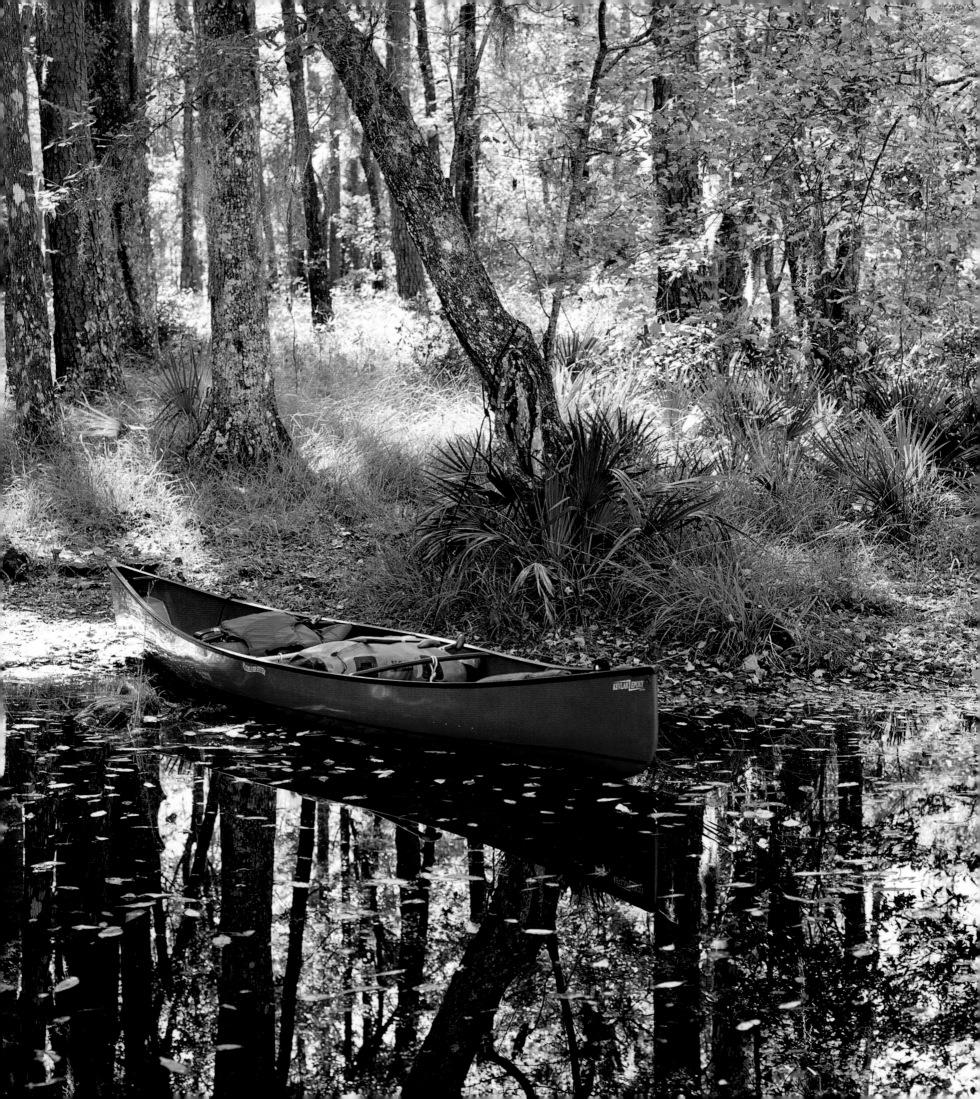

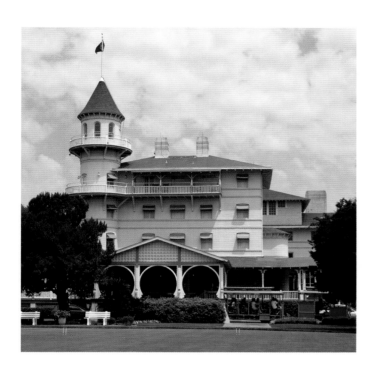

Above: The Jekyll Island Club was built as a private clubhouse for the millionaire industrialists who once owned the island. It is now a hotel enjoyed by all. JAMES RANDKLEV

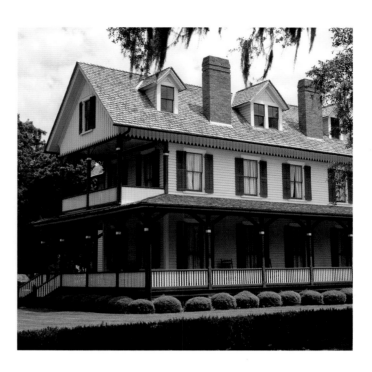

Above: Jekyll Island's historic district has a significant number of historic cottages that showcase the architecture and style, as shown above. JAMES RANDKLEV

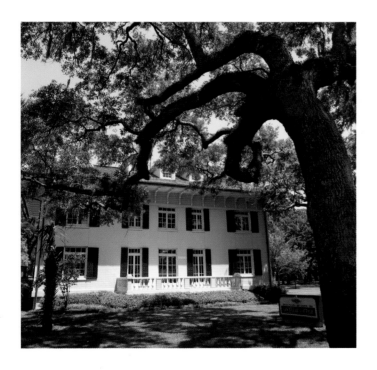

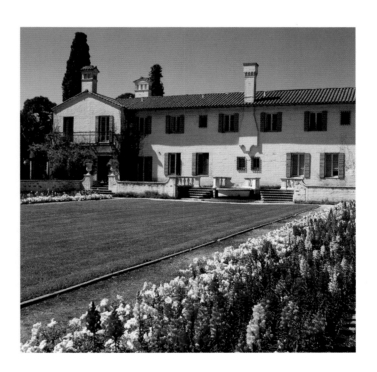

Above: Goodyear Cottage is shaded by the far-reaching limbs of a live oak. JAMES RANDKLEV

Facing page: In the Okefenokee Swamp, Billy's Island is a pleasant day-trip paddle from Stephen Foster State Park. ROBB HELFRICK

Above: Crane Cottage, in the Jekyll Island Historic District, has a lovely garden and green space. JAMES RANDKLEV

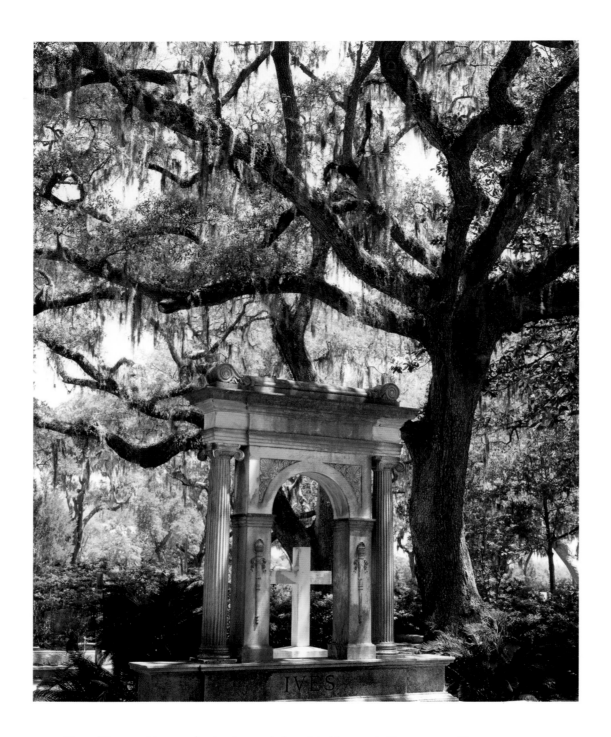

Above: One of Savannah's most fascinating and chronicled haunts is Bonaventure Cemetery, a place where both human and architectural history can be explored. JAMES RANDKLEV

Right: Immortalized in fiction and film, the Chattooga River has a formidable reputation as a fierce whitewater stream. JAMES RANDKLEV

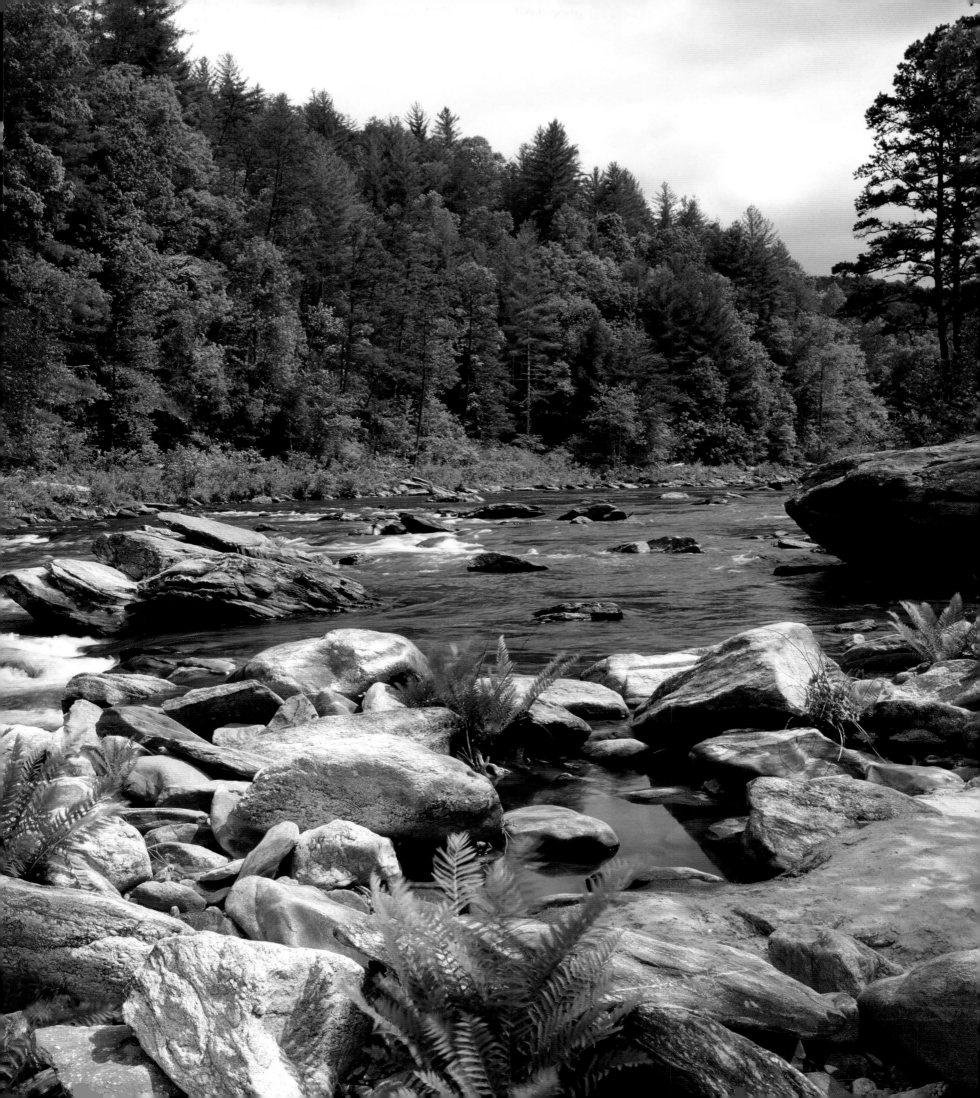

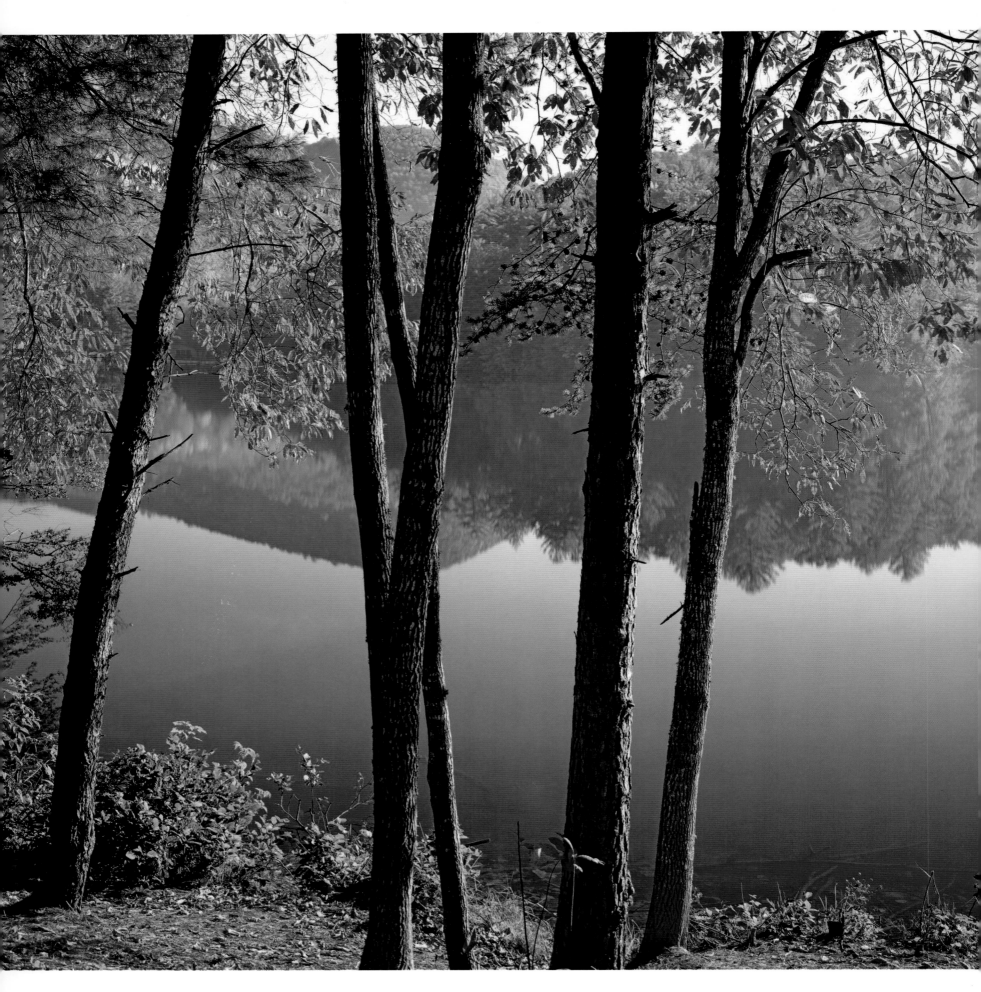

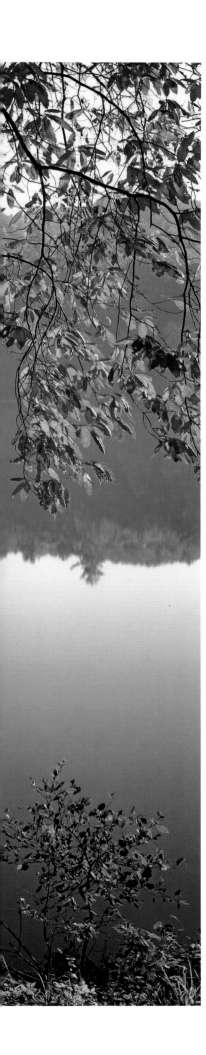

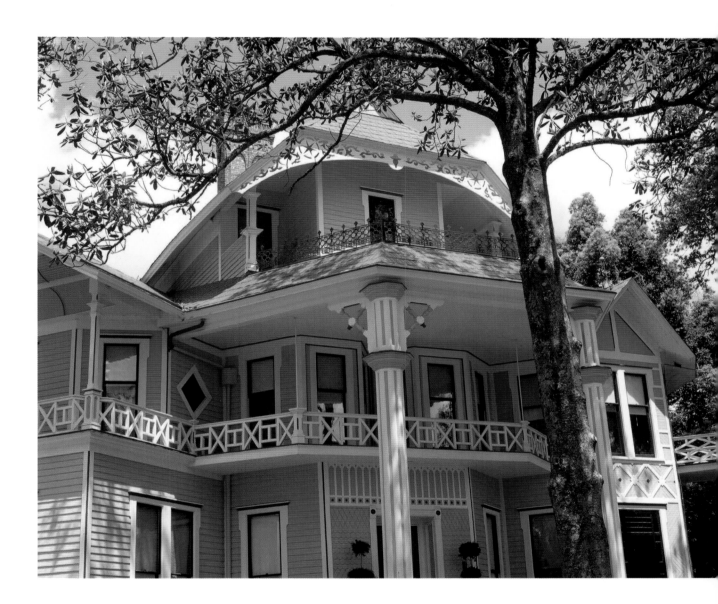

Above: A unique architectural gem in Thomasville, the Lapham-Patterson House is a State Historic Site that offers visitors an experience in Victorian craftsmanship and design. JAMES RANDKLEV

Left: Deep blues and vivid reds paint an autumn scene at Unicoi State Park near Helen. JAMES RANDKLEV

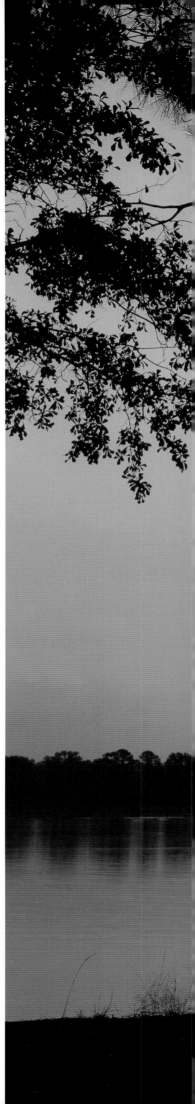

Right: Cotton is still grown in great abundance in southern Georgia fields. ROBB HELFRICK

Far right: A rich sunset is seen through the pines at George Bagby State Park near Fort Gaines. JAMES RANDKLEV

Below: Pebble Hill Plantation is a place of stately architecture and rich history. On the beautiful grounds one can tour the main house or view a collection of vintage carriages. ROBB HELFRICK

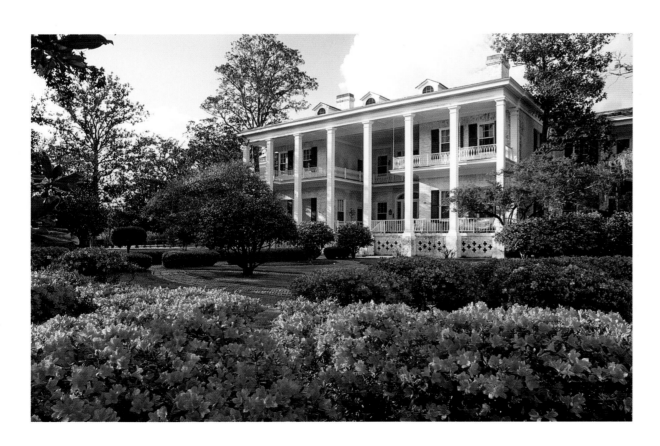

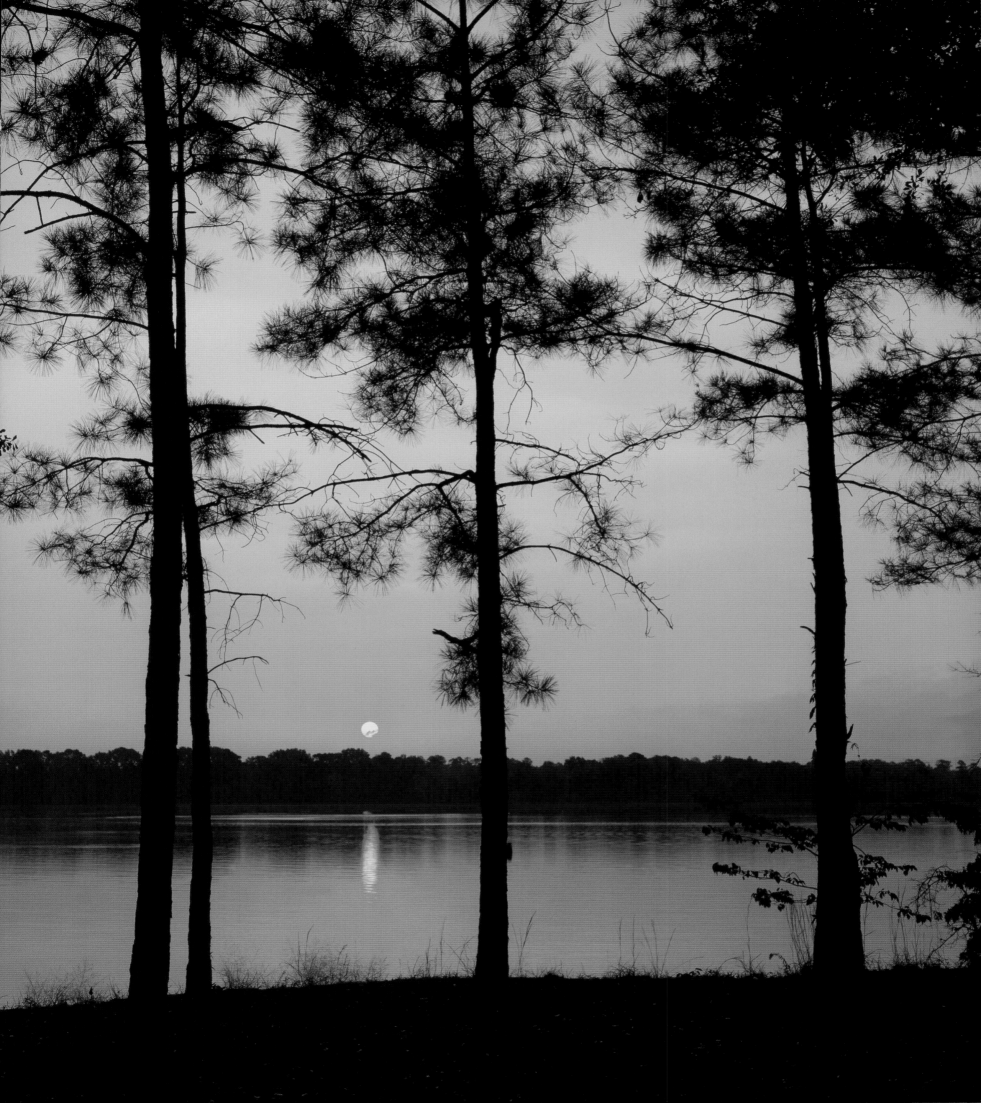

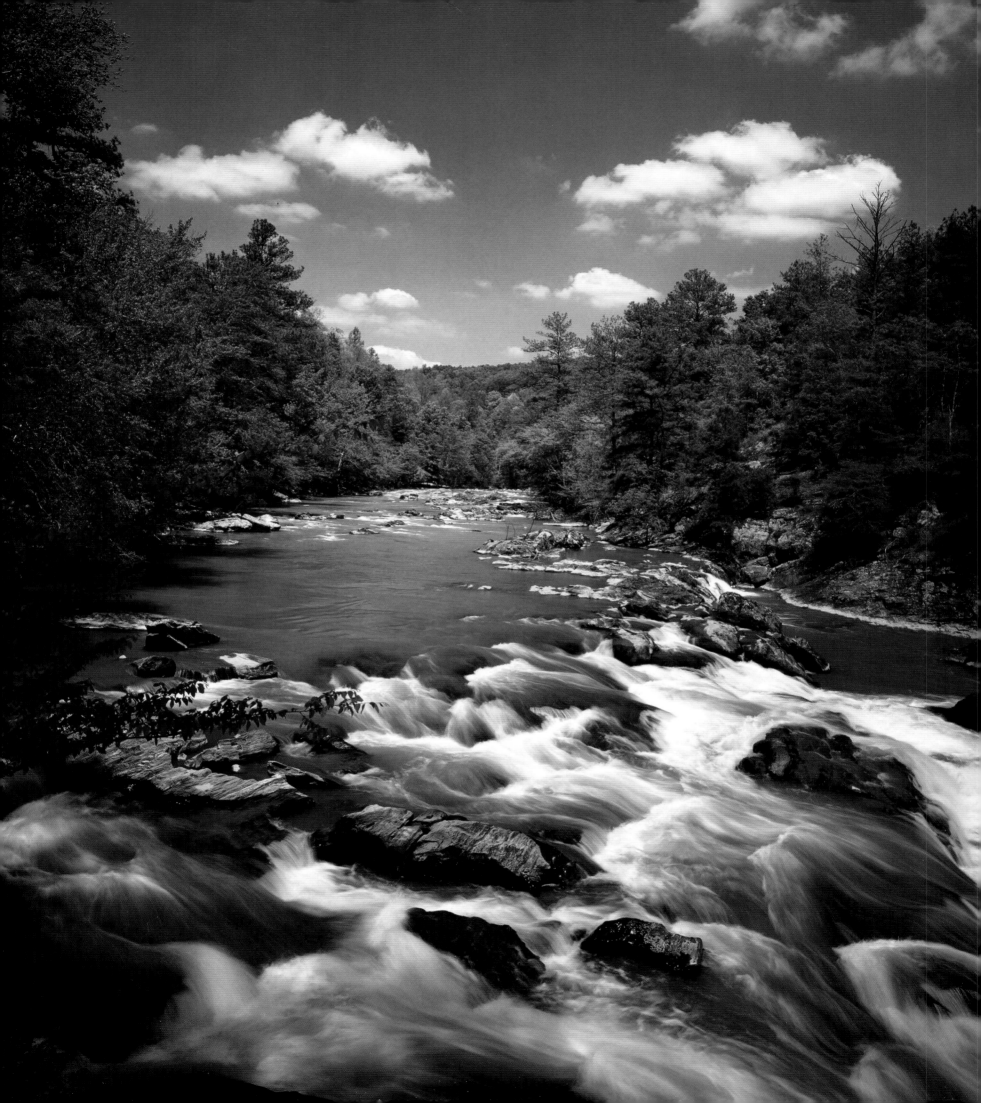

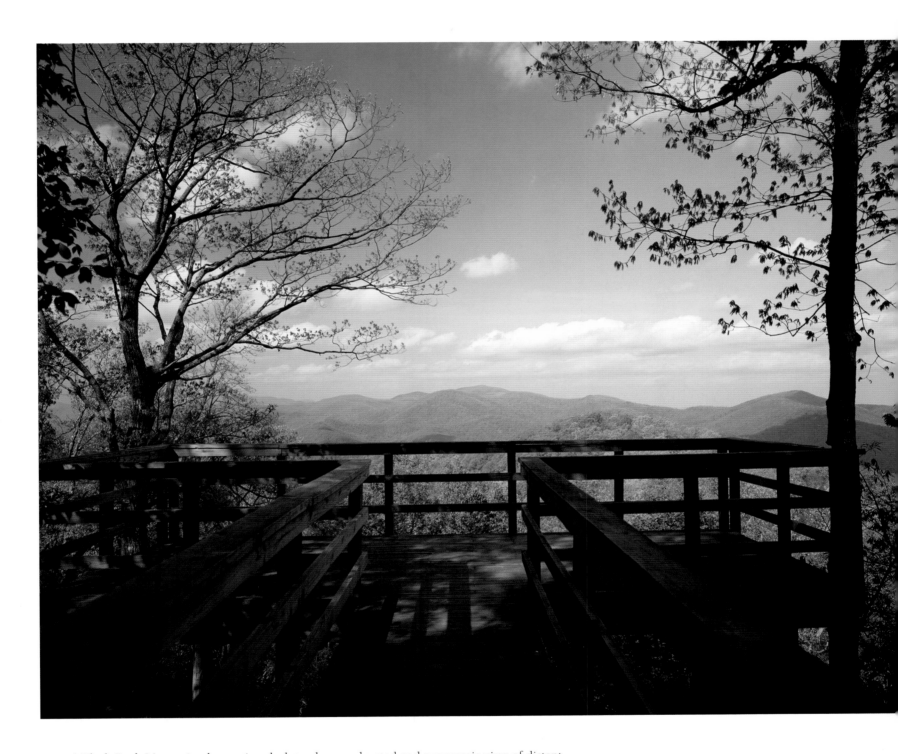

Above: A Black Rock Mountain observation deck tenders an elevated and panoramic view of distant and inspiring mountain scenery. JAMES RANDKLEV

Facing page: The swift current of Sweetwater Creek's Factory Shoals section was once harnessed to power a cotton textile mill. The ruins of that mill are still found alongside the stream today. JAMES RANDKLEV

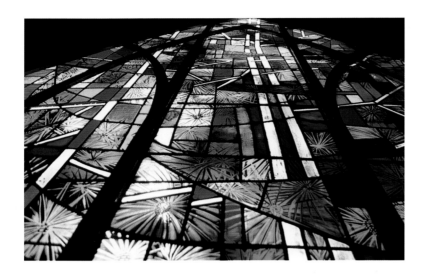

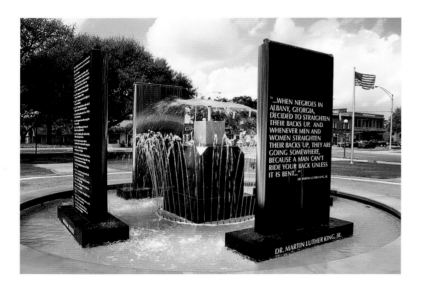

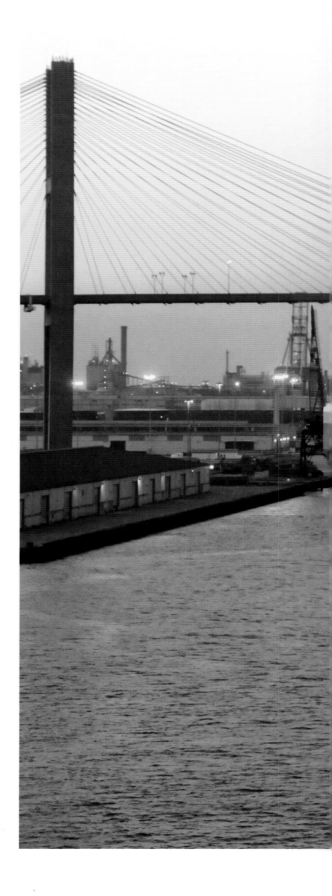

Above, top: The Cason Callaway Memorial Chapel at Callaway Gardens has six unique stained-glass windows that depict southern forests in a progression of seasons. ROBB HELFRICK

Above, bottom: In downtown Albany, a stirring monument with four black marble columns traces the timeline of the civil rights movement. ROBB HELFRICK

Right: With the Talmadge Bridge in its wake, a container ship departs the Port of Savannah for a journey across distant seas. ROBB HELFRICK

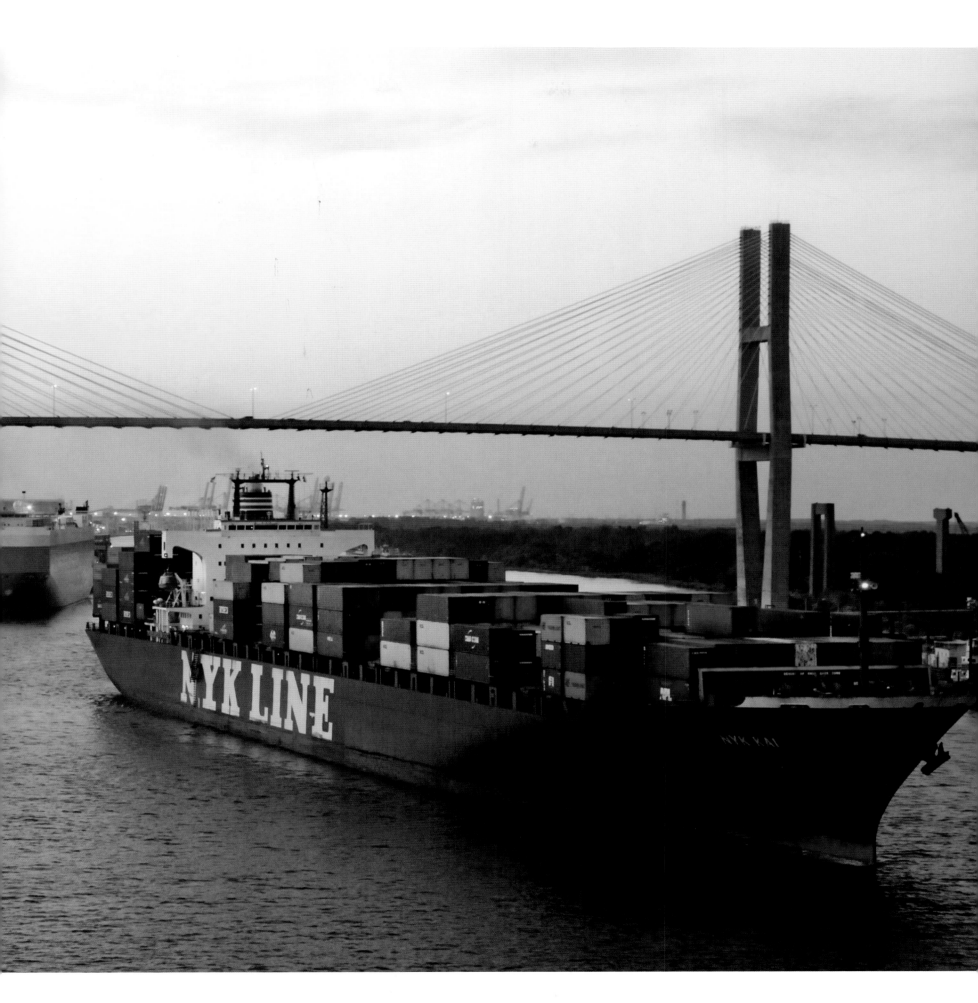

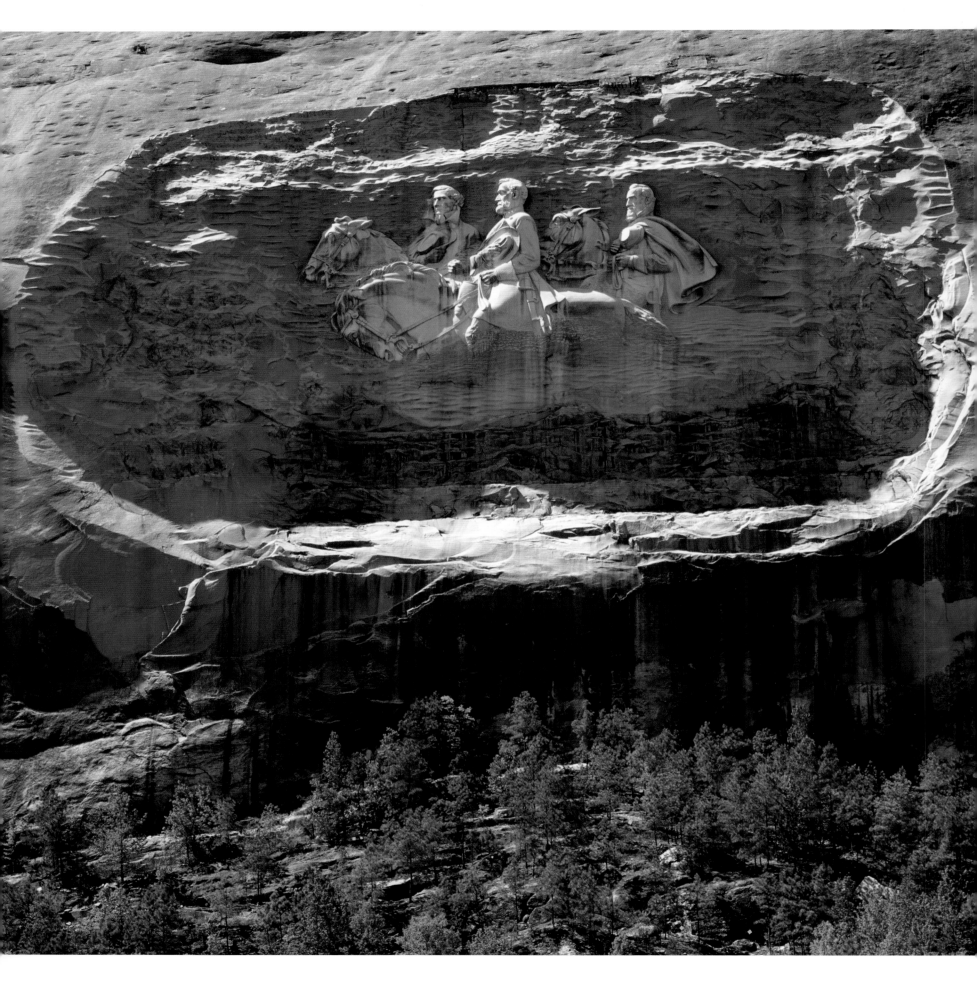

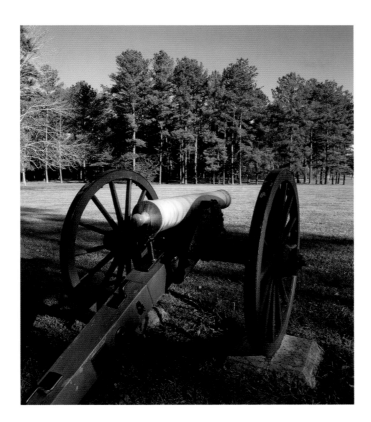

Left: A relic of the South's past, this cannon in Chickamauga National Park, serves as a reminder of the Civil War. JAMES RANDKLEV

Far left: The dimensions of the Confederate Carving at Stone Mountain boggle the mind. It measures 90 feet by 190 feet and towers 400 feet above the ground. The three men depicted on the carving are Robert E. Lee, Stonewall Jackson, and Jefferson Davis. JAMES RANDKLEV

Below: The New Echota State Historic Site is thought to be one of the most significant Cherokee Indian sites in the country and is sadly where the infamous "Trail of Tears" began. ROBB HELFRICK

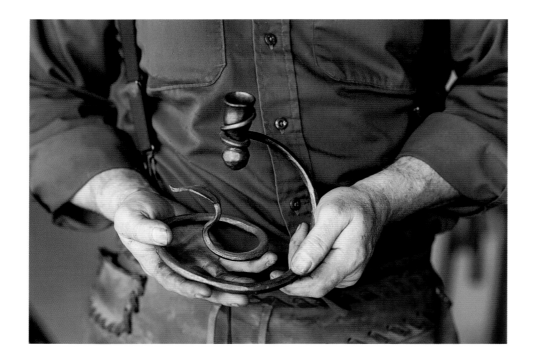

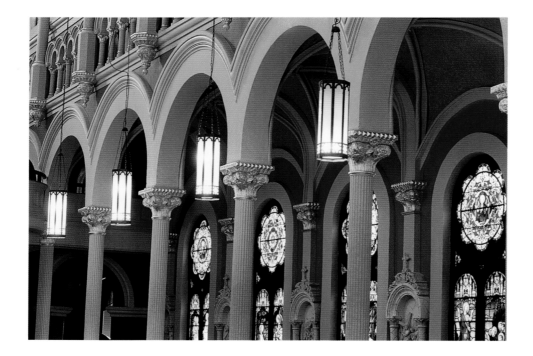

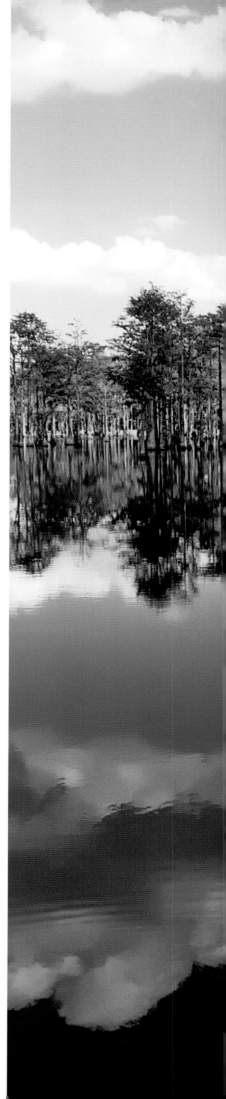

Above, top: Talented craftsmen and artists are abundant throughout Georgia—this blacksmith works with metal near Tallulah Falls. ROBB HELFRICK

Above, bottom: Once a Catholic church, the Sacred Heart Cultural Center is now an art and music oasis in downtown Augusta. ROBB HELFRICK

Right: Cypress trees, black water, and wandering clouds collaborate in a millpond landscape at George Smith State Park near Twin City. ROBB HELFRICK

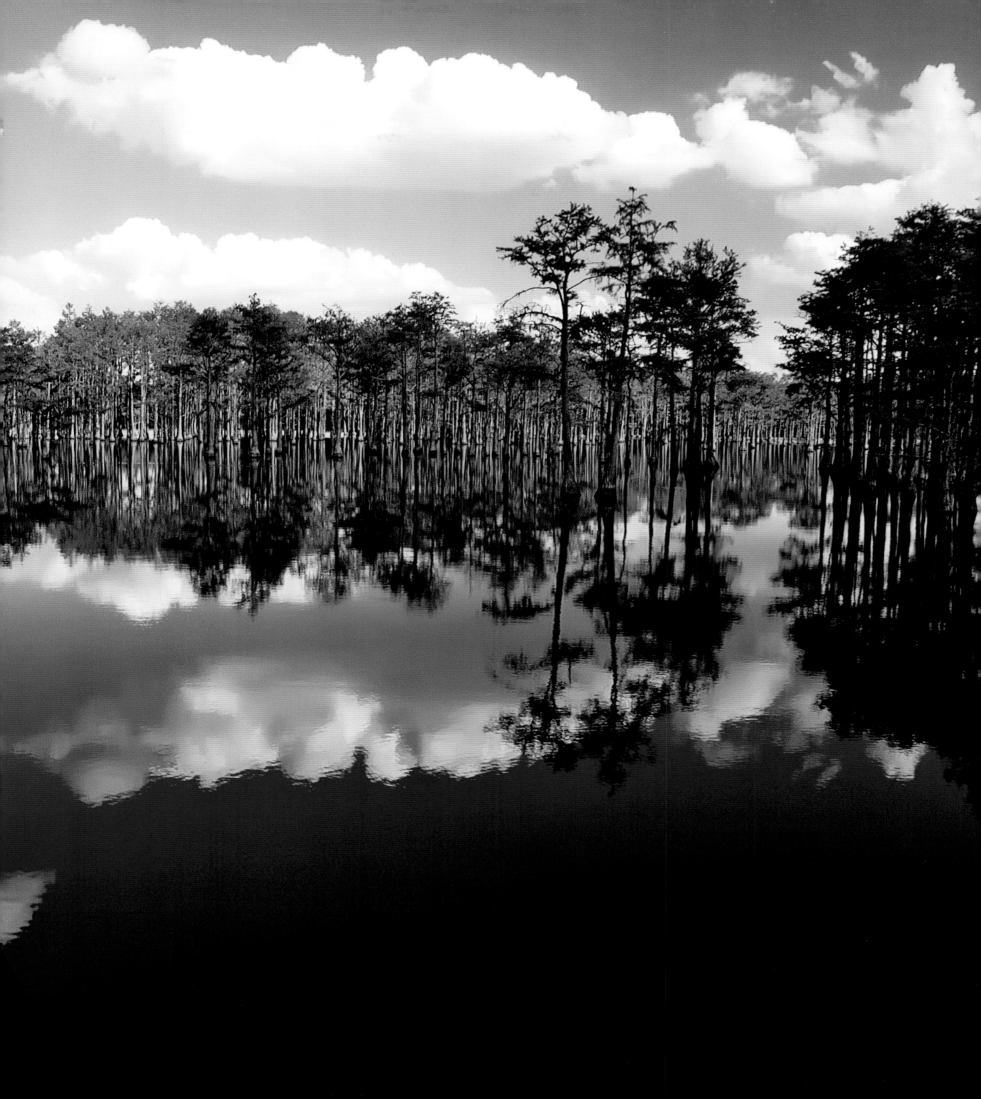

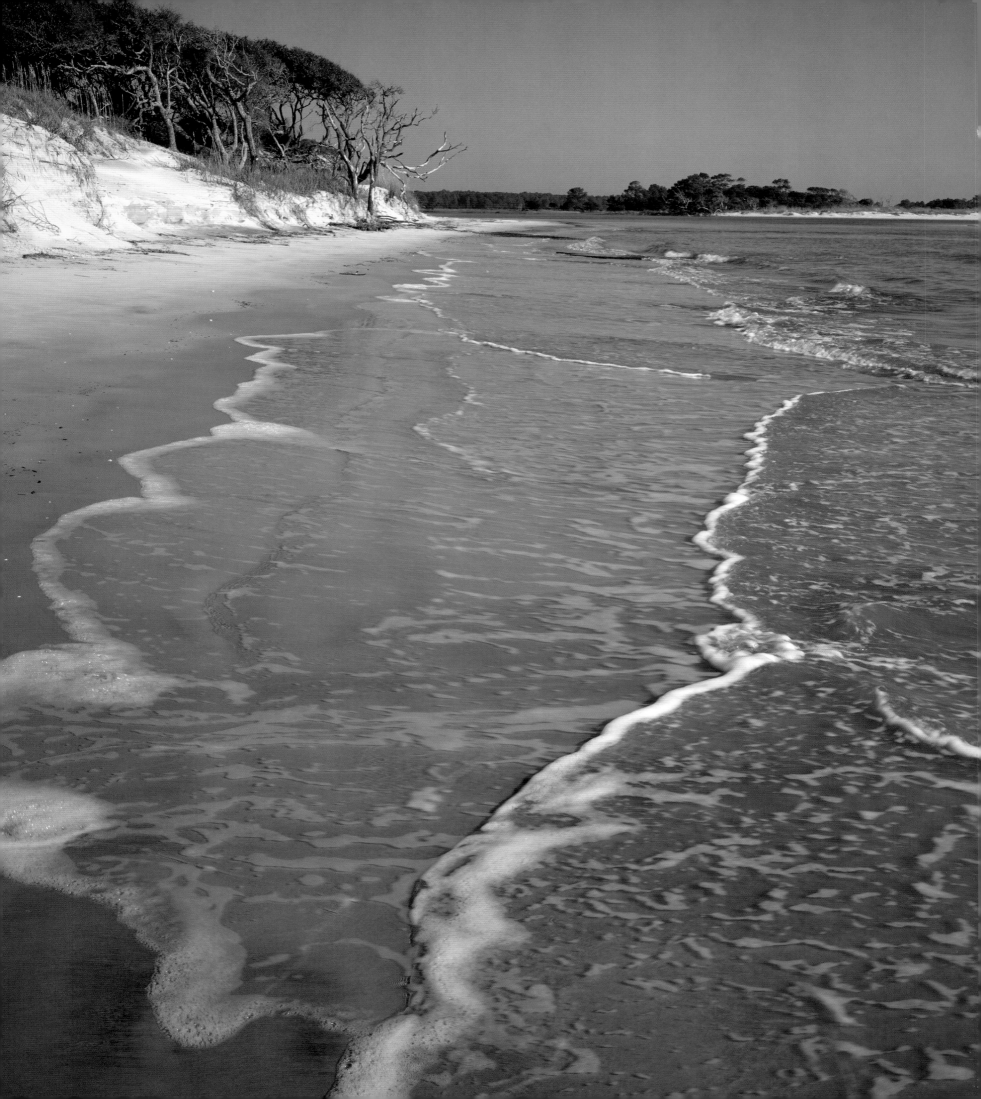

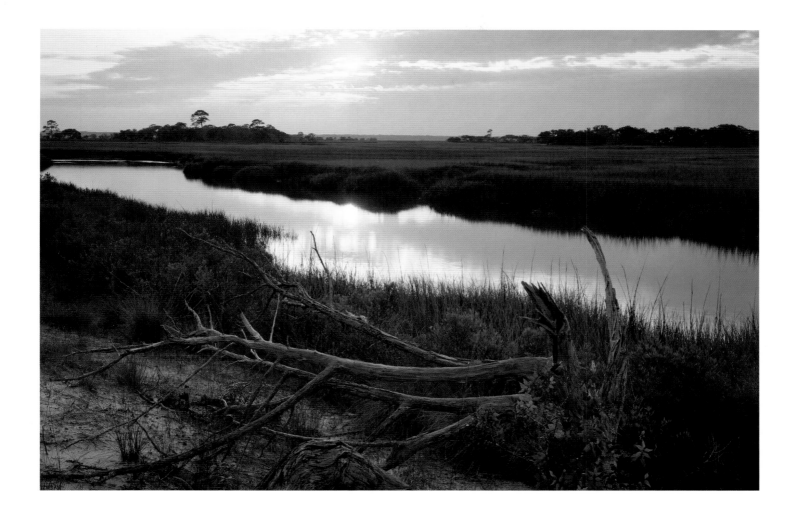

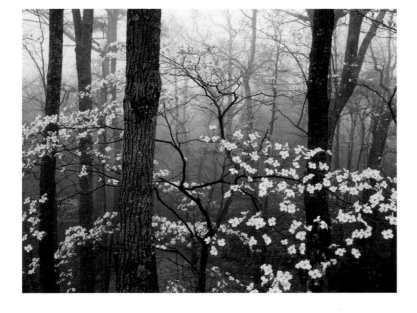

Above: This tranquil scene was found on Little St. Simons Island, a quiet refuge with a setting that is natural and serene. JAMES RANDKLEV

Left: Fog and mist provide a painterly quality to an image speckled with delicate dogwood blossoms at Hogpen Gap. JAMES RANDKLEV

Facing page: The windswept surf of Sapelo Island is the ideal place for a pleasant walk on a secluded beach. JAMES RANDKLEV

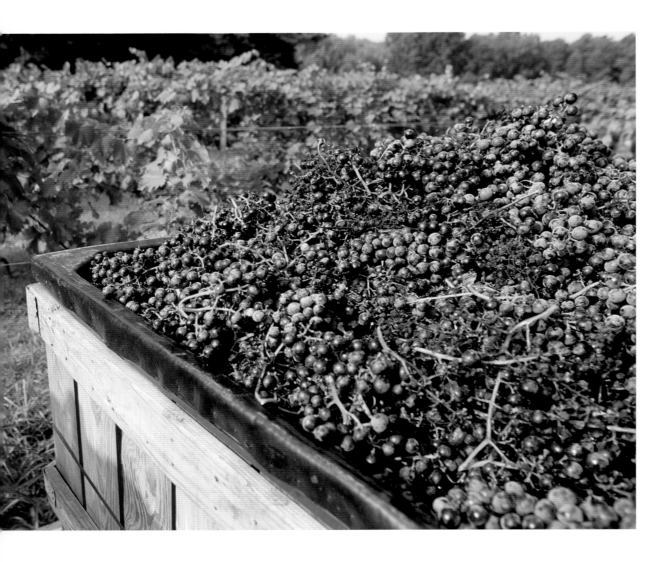

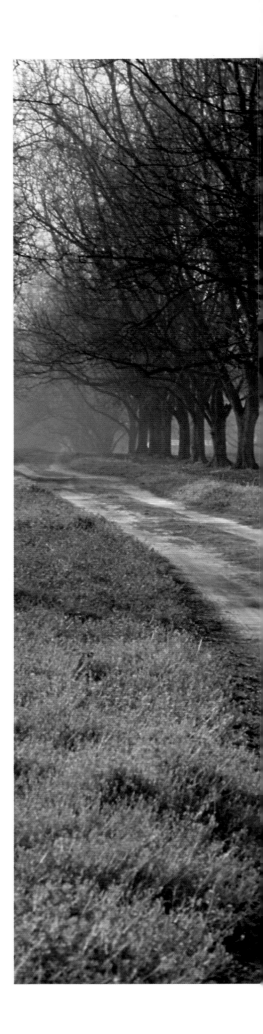

Above: At Chateau Elan near Braselton, lush vines in the North Georgia foothills produce Chardonnay, Riesling, and Cabernet grapes. ROBB HELFRICK

Right: A Fort Valley pecan grove awaits the coming of the next growing season. ROBB HELFRICK

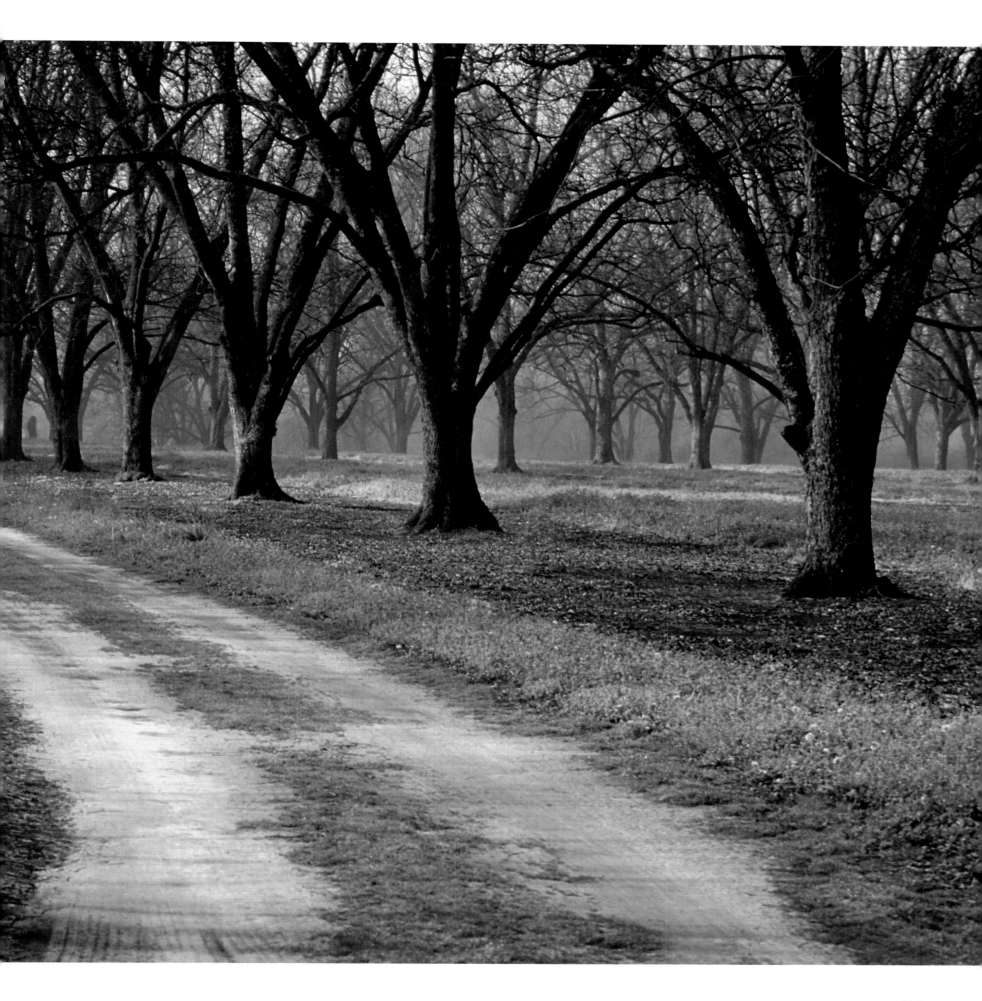

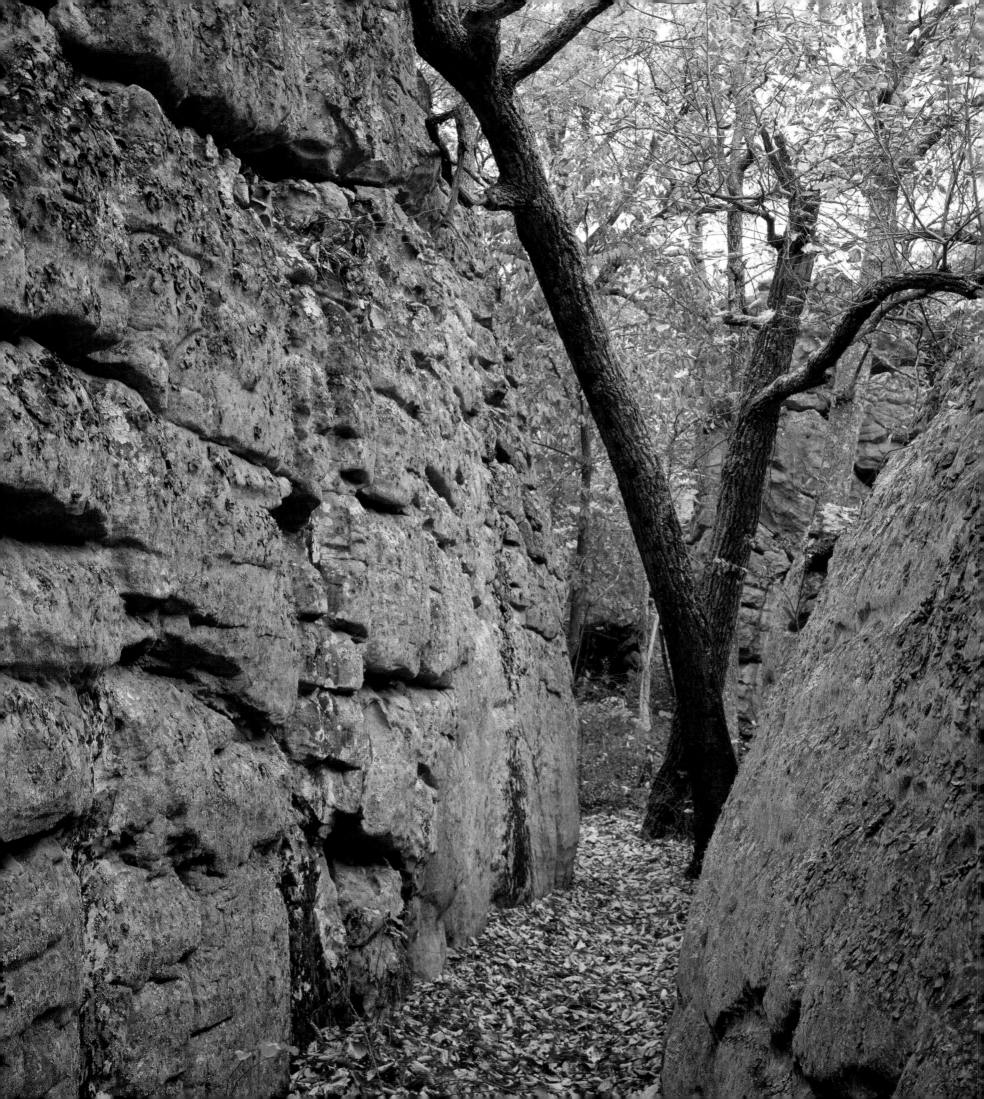

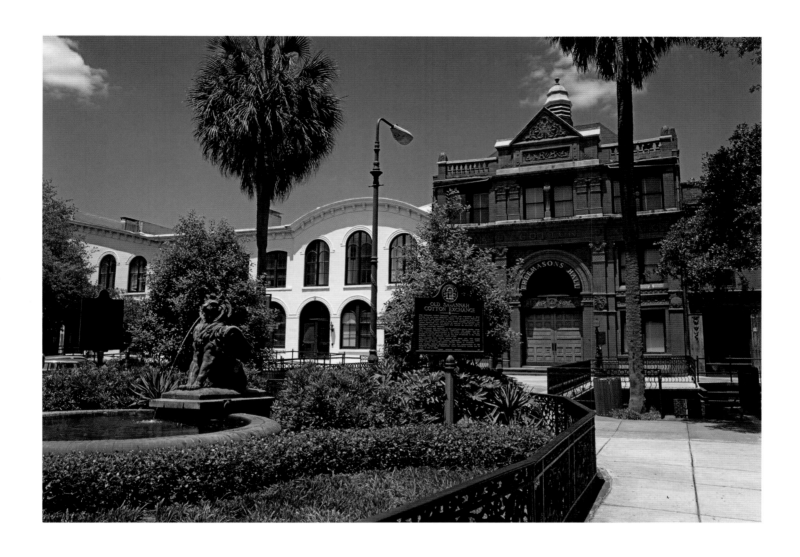

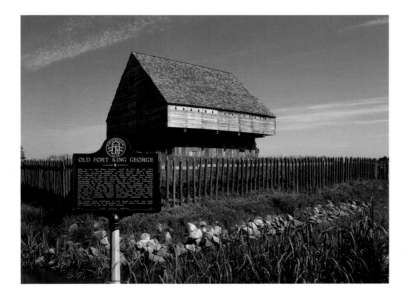

Above: The Cotton Exchange building in Savannah is now a Masonic Lodge, but it remains a lasting symbol of the significance that the cotton industry had to the city and the South. JAMES RANDKLEV

Left: The oldest remaining fort on the Georgia coast, Fort King George was once the southern outpost of the British empire in North America. JAMES RANDKLEV

Facing page: Known for mysterious sandstone shapes and naturally sculpted rock formations, Rocktown is an adventurer's delight on Pigeon Mountain. JAMES RANDKLEV

Following page: Morning dew on wolf spiderwebs resemble footprints leading into a Cumberland Island pine forest. JAMES RANDKLEV

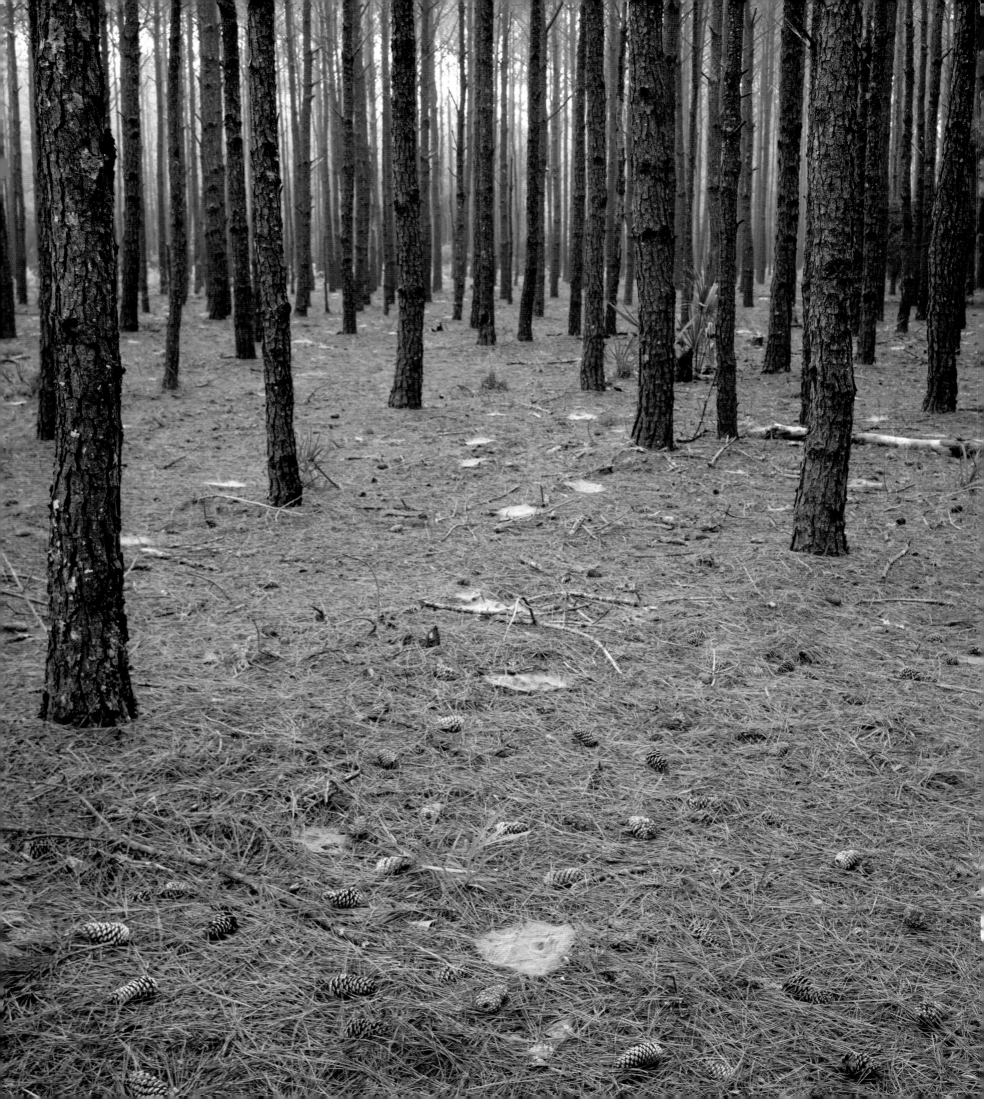